SCIENCE FICTION ART

COMPILED & INTRODUCED BY

BRIAN ALDISS

First President, British Science Fiction Association; Ditmar Award 1969 for Best Contemporary Writer of Science Fiction; Author of 'Billion Year Spree: the History of Science Fiction', etc.

Bounty Books
a division of Crown Publishers, Inc.

This book is for Timothy and Charlotte,
who watched it grow . . . and GROW . . .

*I would like to thank Philip Harbottle, John Eggeling,
Robert Madel, Anthony Frewin and my old friend Philip
Strick for their helpful supply of information, books and
magazines, and Trewin Copplestone Publishing Ltd for
encouraging me in this gorgeous opportunity to ride a
hobbyhorse. Seriously, it was great fun.*

I would also like to acknowledge Michael Moorcock
and Condé-Nast Inc, Popular Publications Inc and
Ultimate Publications Inc for magazine material
reproduced in this book. In many cases, it has proved
impossible to locate owners or successors of various
magazines: to them and to all who contributed to the
creation of Science Fiction Art, we offer our grateful
acknowledgements.

Published by Bounty Books
A Division of Crown Publishers Inc
419 Park Avenue South, New York, NY 10016

Published simultaneously in Canada by
General Publishing Company Ltd

Created and produced by
Trewin Copplestone Publishing Ltd
Design and text
© Trewin Copplestone Publishing Ltd 1975

Filmsetting by Tradespools Limited, Frome
Origination by Hilo Offset Ltd, Colchester
Printed in Spain by
Mateu Cromo Artes Gráficas, Madrid
ISBN 0-517-524325

Library of Congress Catalog Card Number: 75-13823

SCIENCE FICTION ART

Contents

Introduction

Science fiction is a romance with the near-possible. Fantasy is a flirtation with the near-impossible. But science fiction is a part of fantasy; and who knows any longer what is possible or impossible? We are left with romance. Here it is, in a riot of colour and imagination.

Our riot comes from the great stream of sf and fantasy magazines which poured from American and British presses between the 'Twenties and the 'Seventies. The stream is a trickle now – which makes it high time that the general public discovered what a wealth of illustration is in danger of passing them by.

It may look strange at first – it was designed to look strange – yet the pictures in the magazines grew from the pictorial heritage of the past and from the immediate cultural environment.

The Industrial Revolution and the Napoleonic Wars gave a spur to man's ambitions when the new powers of machinery made themselves felt. Mary Shelley's novel *Frankenstein* (1818) embodies the concept of a living being created scientifically by man. Frankenstein brings his monster to life only when he turns from old out-moded authorities and studies modern research – and it is this perception of Mary Shelley's which qualifies her novel to stand as the first true sf novel, although it is also a prime example of the Gothic. The frontispiece to the 1831 edition is pure Gothic, and not an outstanding piece of work.

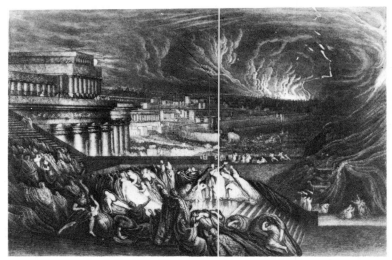

Engraving of John Martin's "The Fall of Nineveh"

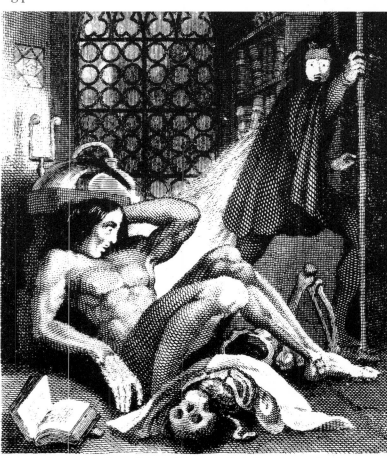

Frontispiece to the 1831 edition of Mary Shelley's Frankenstein, *drawn by T. Holst.*
"By the glimmer of the half-extinguished light I saw the dull, yellow eye of the creature open, it breathed hard, and a convulsive motion agitated its limbs . . . I rushed out of the room."

I have argued in my history of science fiction literature, *Billion Year Spree*, that sf and Gothic are inseparably intertwined. The same holds true for sf illustration.

Many nineteenth-century artists inclined to fantasy. Of recent years, we have seen the restoration to favour of John Martin (1789–1854), once so internationally famed that the adjective 'martinien' was coined in France to describe anything on a grandiose scale. Later, he fell so far from popularity that his paintings were sold off at a few shillings per square yard. Engravings of his more terrifying paintings once hung above the bedsides of many innocent children – including the beds of the small Brontës. Watercolours by Charlotte Brontë, which depict scenes of the imaginary places she wrote about, show Martin's influence – and why not, when even the great J. M. W. Turner imitated him at one period?

Charlotte Brontë, "The Bay of Glass Town"

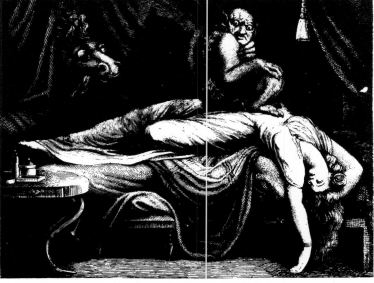

Engraving of Henry Fuseli's, "The Nightmare" (1781)

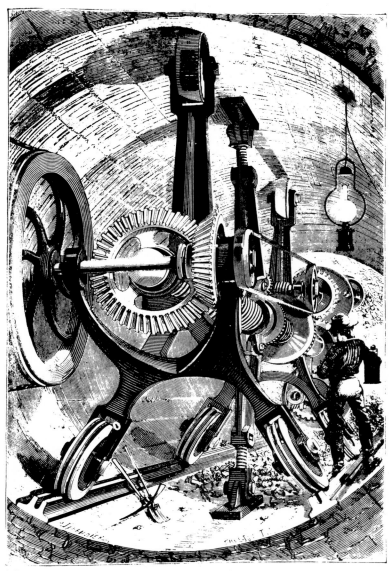

The Brunton tunnelling machine (La Nature, *1874*)

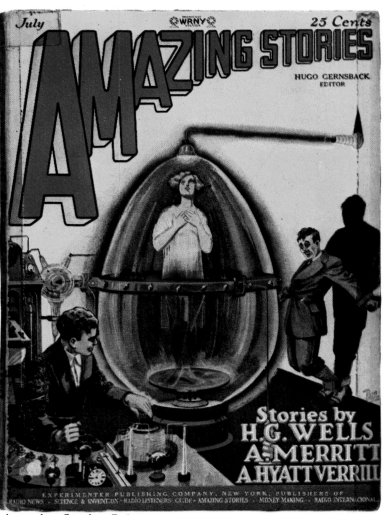

Amazing Stories, July 1927
Cover by Frank R. Paul

Henry Fuseli (1741–1825) was an Expressionist before his time. His most famous canvas is called, appropriately, *The Nightmare*. It was said that he ate raw meat before retiring, in order to give himself bad dreams with which to populate his work. Some of his paintings show a perverse love of spatial disproportion and anomalies of size which would make them ideal for science fantasy covers. There is a limited number of ways in which alien beings can be depicted; they can be different colours, different shapes, or different sizes. And such means were at the disposal of artists long before science fiction received its christening.

Along with distortions of the natural order there lumbered phenomenal machines. The *science* in science fiction received its impetus from the growing technologies of the day. The first magazines of the nineteen-twenties (*Amazing Stories* was published by Hugo Gernsback in 1926) were predominantly technophile in character; but there was no gainsaying the fact that early technologies presented a sooty face to the world which welcomed them. Good and bad rarely come in separate parcels. The excitement of the new has generally outweighed its disadvantages, at least for the young. The faster, the uglier, the noisier, the better. The romance of the first ungainly steam engines, crawling from the coal pits at twenty miles an hour, is echoed in the science fictional lust for bigger and better machines, machines which like Frankenstein's monster will eventually take over from mankind.

Machine-buffs are easy to cater to. Early sf magazines are full of outrageous machines, all cogs and rivets and columns and winking lights and trailing cables, so that the characters are perpetually tripping through a gigantic Meccano landscape. But the relation to reality is not as remote as might be supposed. You invent futures by magnifying pasts. Many outrageous futurist machines derive from a great age of invention, when diabolical engines proliferated – Brunton's drilling machine of the eighteen-seventies, for example, would be perfectly at home in some subterranean horror planet designed by Harry Harrison or John Sladek.

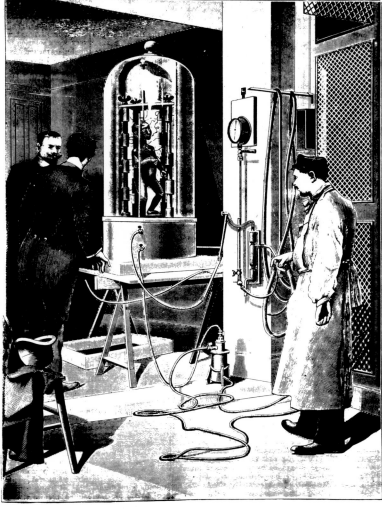

Dr. Varlot's apparatus for electroplating the corpse of an infant (1891)

4

Most inventors cared for invention itself, not the social consequences of the invention; this myopia is what one might call the Frankenstein syndrome. Horrific experiments, like the attempts of a French surgeon to preserve the dead by electroplating them, are the stuff of sf, even when they take place in real life. The illustration of Dr Varlot's experiment which appeared in the *Scientific American* in 1891 is real Mad Scientist stuff, complete with Moronic Laboratory Assistant, and could serve as an *Amazing* cover (indeed, mutatis mutandis, it often did so serve!). To have one's dear ones electroplated by return and at no great cost is not an unreasonable ambition; like much else which might – ironically or not – be termed Progress, the idea seems to encompass hope and fear in roughly equal proportions.

Such mixtures of hope and fear can be successfully transposed into science fictional terms by taking something from everyday and placing it in a novel context, so that the message gets home. Among other things, H. G. Wells's *The War of the Worlds* (as a serial, 1897) features a colonisation war against the British not greatly different from the wars that Britain and other European powers were waging against Africans, Tasmanians and other breeds. When the technophile Gustave Eiffel erected his great iron tower in Paris in 1889 (while Wells was writing an early version of *The Time Machine*), it was an inspiration to technophiles everywhere – so much so, that the tower appeared truncated on a *Wonder Stories* cover some years later as mining equipment on Pluto. The messages were different; the transpositions were similar – and part of the new free-ranging powers granted to the popular mind by cheap newsprint, wider education and the easier access to stimulation enjoyed by the new urban populations.

Although this infusion of fact and conjecture was hardly new – the Elizabethans had experienced something similar – the rate of infusion was new. Printing presses, railroads, telegraphs, steam ships, began to link up the world; the arts as well as trade benefited from the acceleration. "Is Little Nell dead yet?" asked the mid-century longshoreman of New York, as the steamers docked with emigrants from Liverpool.

The new sciences spread as rapidly. One particular Victorian heritage has left its mark extensively: the deciphering of the long-dead past. The evidence of the rocks was pieced together, the great dusty carpet of the past unrolled. As surely as the museums and zoos of the civilised world exhibited exotic specimens – rhinos, giraffes, ostriches, tigers – from the four imagined corners of the globe, so the palaeontologists began to resurrect whole new phyla of fantastic animals which had been extinct for centuries. How many thousands of centuries gradually became apparent.

The testimonies of geology and palaeontology contributed greatly to the philosophical structure of evolution. Darwin, with those who worked before and after him, demonstrated that change was one of nature's consistent principles. Imaginative writers like Wells – a pupil of Darwin's friend, Thomas Huxley – demonstrated that just as time had worked to place the mammal Man at the peak of Creation, so that peak could give way to other great mountain chains still unborn in Earth's history.

These conceptions of Time and Change were utilised to provide science fiction's happiest hunting-ground – the Future. It remains the last great unknown territory on the planet. Moreover, as writers were quick to see, evolutionary principles could be applied to other planets. They took over landscapes hitherto the preserve of mythology, religion and astronomy. It is interesting to see that in sf, Mars has remained as it always was, the Red Planet, the planet of war, and Venus, the evening star, the planet of peace and gentleness. Old ideas die hard.

Jules Verne, the first successful science fiction writer, conducted a four-decades-long romance with Geography, opening up his imagined territories with the aid of an atlas and with machines scarcely ahead of his own time – with submarines which already had shadowy existence in scientific journals, with balloons, with propeller-powered dirigibles, with ironclad steamers, with rockets fired from gigantic pieces of artillery.

Militarism saw to it that the artillery was growing bigger in real earnest. Towards the end of the nineteenth century, rivalry between the Great Powers was intense. War was in the air. In his beautifully researched book, *Voices Prophesying War*, Professor I. F. Clarke shows how closely the science fictions of the last part of the century were related to the imperial intentions of Europe. We remember

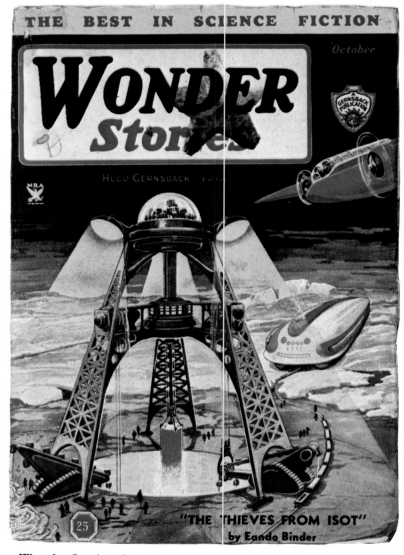

Wonder Stories, October 1934
Cover by Frank R. Paul

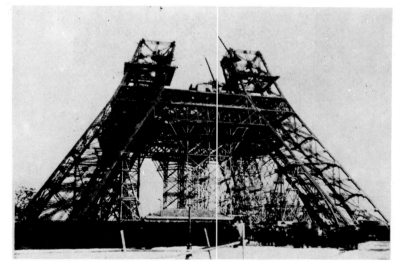

The Eiffel Tower in construction (1888)

The War of the Worlds by reason of its superior imaginative power; but it was the tip of a large iceberg of militaristic literature. The fleets and the guns grew larger all the time. So did the paper armageddons. A French draughtsman, Albert Robida, devoted himself to chronicling *La Guerre au Vingtième Siècle*, illustrating it with his own graphic drawings of the armaments of the future. The first spaceships look much like Robida's submarines, moving through vacuum rather than ocean.

The *fin-de-siècle* spirit was as preoccupied with catastrophe and decline as it was with war. *The Time Machine* is just as *fin-de-siècle* as Huysman's *Là-bas*. Artists like Beardsley, who set his stamp on the age, interpreted it without recourse to machines; he, too, finds his echo in such sf artists as Virgil Finlay and his imitators.

Ferdnand Khnopff, "The Caresses of the Sphinx" (1896)

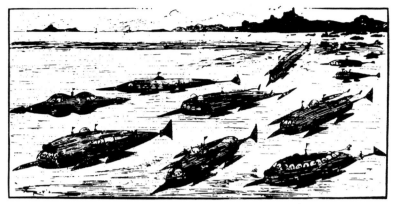

Albert Robida's fantasy of submarine warfare (about 1880)

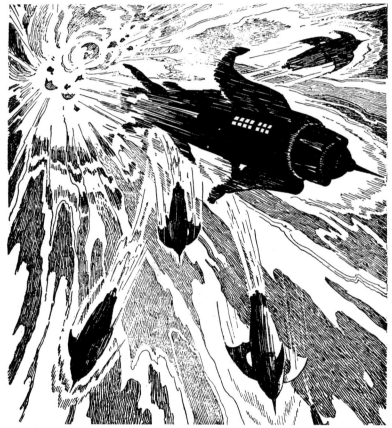

Astounding Science Fiction, March 1939
"Star Crash" by Kent Casey

Although it may seem that science fiction occupies itself mainly with novelties, it is remarkable how easily it accommodates at the same time much that is shadowy in the human spirit.

Fantastic designs for new cities and engineering projects on the grand scale – such as preoccupied John Martin and William Moseley but (like Sant'Elia's later and probably Doxiadis' 'Ecumenopolis' today) were destined never to come to fruition – found an echo with artists of a different persuasion. There were Gustave Moreau's vast shadowy Eastern cities, where one might lose oneself and one's soul amid its erotic splendours. For striking science-fictional examples of such tower-ridden places, I think in particular of Hubert Rogers' great city, built under the seas of Venus (see page 41); it formed the cover of a 1947 *Astounding*, where it illustrated a novel by Henry Kuttner (under the pseudonym Lawrence O'Donnell) which draws on many touches of Decadence for its urban portrait. In the 1940s, Kuttner's city seemed no more inacessible than Moreau's did in his day.

The immemorial miscegenations of species revealed by evolution is perpetuated in sf illustration. Dinosaurs have been accorded pride of place, perhaps understandably. But one also meets vast land-going anemones, weapon-toting mantises, intellectual octopi, spinaches which do not stop at rape, and winged races which alone know the secrets of interstellar drive. Many such creatures are there merely to provide man with a menace (that legendary need); others take symbolic shape. The besiaries of such Symbolist artists as Odilon Redon (1840–1916) and Fernand Khnopff (1858–1921) often bear a strong resemblance to the hybrid fauna of sf. In the year that H. G. Wells's *The Island of Dr Moreau* was published (1896) – that strange tale of half-human animals – Khnopff painted a canvas, 'The Caresses of the Sphinx', which could well serve as an illustration for that novel. Khnopff also created a lonely human-eagle composite to signify solitude.

The concept of living on the Moon or another planet, as Jung has indicated, is itself a symbol of isolation. Often such meanings are used without thought in sf; they can be none the less moving for that.

As for those distant planets! The solar system was pillaged for picturesque versions of Dante's Inferno. It could be said that those versions were based on scientific knowledge. But science itself often proved to be an act of the imagination.

Two examples will show how this came about. In 1917, the great Swedish astronomer Arrhenius published his findings on the planet Venus. His deductions were based in part on a belief in Laplace's Nebular Hypothesis, which provides a model for the solar system in which the outer planets are the oldest and the inner, Venus and Mercury, the youngest (thus the idea got about that Mars is an ageing world – a whisper of decay sf writers have never been able to resist). Basing his deductions entirely on what he could observe through his telescope, Arrhenius concluded that Venus was still in a Carboniferous age, with luxuriant vegetation growing in hot cloudy conditions. "We must therefore conclude that everything on Venus is dripping wet", he said. From this inspired – and totally incorrect – guess have sprung a thousand *Planet Stories* scenarios.

The second example is the inmost planet Mercury, which also provided striking locations. It was believed until the beginning of the 'Seventies, when American probes made close fly-pasts of the planet, that Mercury's day was of the same length as her year – i.e. that she kept one face permanently toward the sun as the moon does toward the Earth. This assumption, in accord with the most rigorous astronomical observations of the day, gave the planet three distinct zones: a nightside, which was regarded as one of the coldest places in the solar system; a dayside, whereon streams of tin and zinc babbled down the ravaged and barren hillsides; and a twilight zone which girdled the planet, a band of habitability between the opposed desolations of extreme cold and extreme heat. Such dramatic locations served many a writer well. They accorded with the science of the day, yet were wholly imaginary.

Our little solar system proved claustrophobic to many writers. Soon the paper spaceships were forging into the galaxy, into other galaxies. Galactic empires were established. The planets the travellers found there were often bizarre, generally bleak. Stuck in a particularly inhospitable region of Italy, the poet Shelley – some of whose work is pervaded by science-fictional imagery – complained that "the imagination cannot find a home in it". On the other hand, his wife Mary's monster instinctively sought the barren places of the globe, while the boisterous but melancholy imagination of the average sf writer is much at home in blighted surroundings. The illustrators followed suit. Where a far planet was not to hand, Earth itself could always be desolated, New York destroyed, the land of the Sphinx inundated by a new Flood. The Atom Bomb proved as adaptable as the Wrath of God and, luckily for the artists, there was no limit to man's ingenuity to man.

Does an aroma of catastrophe hang about these pages? Such an atmosphere is not incompatible with a zest for life, nor will it offend those who subscribe to my own definition of sf as "hubris clobbered by nemesis".

One could easily compile a portfolio of illustrations from more recent artists such as Ernst Fuchs (surely influenced by Moreau), Mati Klarwein, M. C. Escher, Carel Willink and others who could rank as science fiction artists in their own right (not to mention Karel Thole, whose best cover paintings are in the great tradition of surrealism). But the sensibility is there in a previous generation; we have only to look at the haunted buildings of Giorgio de Chirico (who acknowledged a debt to Jules Verne), the distorted life-forms of Max Ernst, the jokey enigmas of Duchamp, the ambiguous objects of Yves Tanguy, or the stark landscapes of Oscar Dominguez and Salvador Dali, to see a thriving type of art which is akin in spirit to objectives the science fiction writers were moving towards. Science fiction, like Surrealism, was once totally unacceptable to the multitude, looked down upon, misunderstood, regarded as mad.

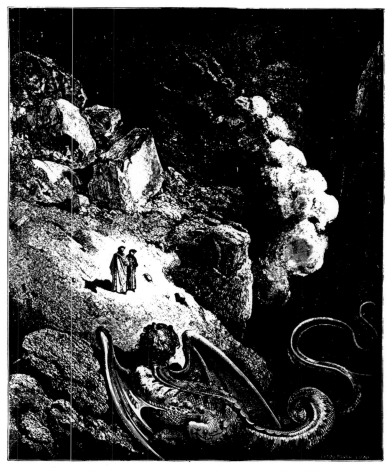

Gustave Doré, illustration to Dante's Inferno, *Canto XVII, 7*

The odd thing is that both writers and illustrators of the popular or "pulp" presses (the adjective refers to the constitution of the paper on which the magazines were printed) remained largely uninfluenced by the experiments of their own day. The *fin-de-siècle*, the *art nouveau*, yes; Surrealism, Expressionism, hardly at all.

The reason for this is to be found in the nature of the pulp operation. We shall not understand what we are looking at here until we understand the pulp jungle. Everything had to be done fast, cheap. *The Pulp Jungle* is in fact the title of a book by Frank Gruber, a writer who lived in New York and sold stories where he could, during the 'Thirties when scores of magazines were published every month.

> A couple of days later I got a surprising call from Rogers Terrill. I had heard of these things happening, but up to this time no-one had ever called me.
>
> It was Friday afternoon. They were going to press the next day, Saturday, and needed a fifty-five hundred word story to fill out the issue of *Operator, No. 5*. Could I write a fifty-five hundred word story overnight? I could, I solemnly assured Rogers.
>
> I sat down at the typewriter. By eight o'clock I had created Captain John Vedders of Military Intelligence. All I had to do now was figure out how he could save the world . . .
>
> By eight o'clock in the morning all fifty-five hundred words were down on paper, eighteen pages. There was no time to retype. I delivered the story at nine o'clock.

If the work was scamped and hasty – and often not even read through by the equally hard-pressed, underpaid editors – it was not to be wondered at. Artists worked under similar pressures. They took the commissions they got, and spelt art with a small "a". Publishers knew that good covers sold the magazines; by luck and hard work, you could live well.

A popular artist like Virgil Finlay (1914–1971), who made his first appearance in print in 1935, commanded $100 per cover from *Weird Tales*. After the war, the fee for covers for *Famous Fantastic Mysteries* and *Fantastic Adventures* was $150; other publishers might pay slightly less. A full-page drawing inside the magazine in black and white would earn considerably less – about $50. As the number of magazines dwindled and pages shrank from traditional pulp to digest size, rates went down instead of up, despite the artist's growing reputation, to $100 per cover or less, with a measly $10 for interior black and white work.

Finlay was a painstaking craftsman. Limited in range, he overworked his few themes. Among the extant 2800 examples of his work, figures, gestures, patterns, inevitably repeat themselves; one observes the same thing in the work of a great nineteenth-century over-producer, Gustave Doré. At his best, working with a thick sensuous line backed by stipple, Finlay is highly effective. But his method required a lot of painstaking work, and he was a man who liked to give value for money and please his fans. The only answer was the answer found in sweatshops throughout the length and breadth of history: to slave away for longer hours. Finlay worked 16 hours, seven days a week, and went without holidays. He was fortunate in having a loving wife who stood by him.

It goes without saying that the artists presented here are unsung among the world's illustrators. There's no justice. This essay is an attempt to do them some justice, however belatedly. Some of the artists had their own following; at least they were repaid by enthusiasm, that special warm devotion which is the living vein of science fiction (and so much at odds with the cruel machines and disasters in which sf often revels). Rogers, that stylish modernist, Schneeman, the great Paul, Emsh, the starry-eyed Orban – these men have been accustomed to seeing their every drawing scrutinised by the fans and generally applauded. Some of the other names appear little known even within the field. I'm thinking of Henry Sharp, Gerard Quinn with his special colour sense, James Stark, the vigorous Rod Ruth, Leydenfrost, a small master of the macabre.

Neglected though the work of these artists may be, their contribution to science fiction is immeasurable. Between them, they evolved a new idiom, a blend of smashing action, bizarre atmosphere and berserk objects, which stimulated a youthful reader just as much as the accompanying text. Many of us began reading sf "because of the pictures", and a grounding in Buck Rogers or Dan Dare was often the foundation of a life-long affection for sf. In many cases, the illustrators rose superior to the clichés inherent in the genre. Take for instance the drawing of the spaceship leaving a planet on page 23. We may guess that the editor of the magazine, Robert Lowndes, merely instructed Fawcette to "do a picture of a rocket-ship taking off". The result was a superb pattern, a coherent whole despite its odd shape, which is like no other illustration in sf.

Elliot Dold was the great pattern-maker. He could so transform a banal scene inside a spaceship that its claustrophobic, obsessional intensity lifted the picture to a plane of its own, rather than remaining an appendage of the story. On the other hand, we have an illustrator like Vestal who remains strictly that – working in *Planet Stories* to present an all-action picture, and doing so brilliantly against an alien background, his scratchy line seeming to express something of the mystery of the circumstances, as he packs the picture with detail that almost certainly is not in the story. In that last respect, he follows in the steps of the illustrious Paul.

Frank R. Paul is the first of the sf illustrators and, by general consensus, the greatest. Well. Howard Brown and Gerard Quinn are more subtle colourists; Emsh is immeasurably better at figure drawing; Schneeman and Rogers have more sublimity; Timmins is more of an *artist*; Brian Lewis is more versatile; many artists have a darker, deeper vision. Yet the laurels do pass to Paul. He practically patented the genre of sf illustration.

Paul was a Gernsback discovery. Gernsback used him in his radio magazine before *Amazing Stories* was launched in 1926. He was a technophile, and his covers and interiors are filled with machines of all kinds, lovingly depicted, often with a female rotundity emerging from among the cogs and pistons. On the covers this is particularly noticeable; the manic technologies of other ages blush in apricot and viridian and pastel blues. In a way, Paul appears rather pedestrian in his approach; his objective seems to be merely to translate as literally as possible the words of the writer into pictures, as if he were translating from one language into another. Moreover, in the Gernsback magazines, he was often anchored to the literal text, a line or two of which would be appended under the illustration in an old-fashioned way. One feels too that, if taxed, Paul would say with Gernsback that machines should take over the world; it is his machines that live, that radiate life, while his human figures are limp and doll-like (though by the 'Forties he had become much more proficient in depicting the human form); his aliens often seem perfunctory, never whimsical like Morey's or nightmarish like Leydenfrost's.

A STREET & SMITH PUBLICATION
ASTOUNDING
STORIES
APRIL 20¢

THE LEGION OF SPACE
by Jack Williamson
A MATTER OF SIZE
by Harry Bates
LO! *by Charles Fort*

HE FROM PROCYON
By Nat Schachner

Astounding Stories, April 1934
Cover by Howard V. Brown

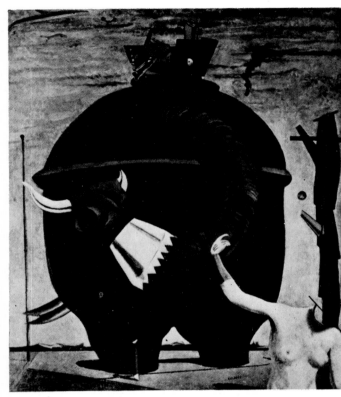

Max Ernst, "The Elephant of Celebes" (1921)

His creed, one might suspect, was utilitarian. Yet an almost mystical vision shines forth from his best covers.

Here, in plodding Gernsbackian prose, is a description of one such cover: "We see the men of the future, with atomic motors strapped to their backs, flying up swiftly to the sphere suspended in the air. The beams from power houses converging upon the sphere support it freely." Very little description of this scene appears in the story. As Anthony Frewin has said in his book *One Hundred Years of Science Fiction Illustration*, "Paul, when illustrating a story, created these monstrous galactic cities, alien landscapes, and mechanical Behemoths entirely himself – the descriptions contained in the stories were never much more specific than, for example, something like 'shimmering towers rising into the clouds from a crystal-like terrain'". Thus Paul made amends for the inadequacies of the writers.

In the cover Gernsback describes above, on the December 1932 issue of *Wonder Stories*, the sphere holds our attention, gleaming like an eyeball, an atom, an enigmatic artefact; everything else in the picture, even the flying figures, contributes to it. Paul thinks it is wonderful, and so do we. The whole is bathed in the warmest colours the Stellar Publishing Corporation could command. Such covers (*opposite*) are masterpieces of their kind.

Paul's training as an architect was certainly helpful. He called forth the science fiction city out of nothing, merging Byzantium, the local Odeon and Durham Cathedral into a weird composite of skyscraper and stately pile. His attention to detail and his wide range of subjects provided a lasting example to the artists who followed or emulated him. He was rivalled, to my mind, only by Emsh in his productive years; but Emsh never showed much care for architecture – Schomburg is his master there, Schomburg with his incomparable finish and shining surfaces. I wish it had been possible to show dozens of examples of the work of such illustrators, instead of a handful.

The decline in the magazines since the 'Fifties and the triumph of the paperback have naturally entailed stagnation in sf magazine standards. Covers are generally clichés, with rocket-ships decorously arranged and Saturn behaving overhead with insipid good taste. The great exception to this has been the emergence in 1974 of the British magazine *Science Fiction Monthly*, the first sf magazine to place such emphasis on the visual. It has exhibited the work of a great many artists whose names and glory belong to the paperback field – Miller, Hardy, Jones, Pelham, Habberfield, and, above all, Bruce Pennington and Chris Foss – but who cannot concern us here; it has also encouraged new artists whose work is as exciting as, and closer to the mainstreams of contemporary art than the artists of earlier generations.

It is interesting to see that artists like Roger Dean – a youthful master of Moorcockian fantasy painting – and Robert Greg design LP record sleeves as well as paperback covers. Sleeves, particularly of progressive groups, now provide a great market for fantasy art.

But a taste for fantastic art is at present reaching a high-tide mark. My hope is that the very special wave of fantastic art presented here will be recognised for what it is: a vital part of, and not an outcast from, more familiar shores of the imagination.

Perhaps I may be pardoned for regarding this book as revolutionary. It is the first attempt to represent the lively field of sf art in any systematic way, and to relate that art to the greater world of art beyond. Since the volume is being published simultaneously in the United States and Great Britain, it should be added that for both countries the claim can be made that much of the artwork has not been published there before. The majority of these magazines achieved no distribution beyond their own national boundaries. While even the more familiar illustrations have never been seen to such advantage before.

THE MAGAZINE OF PROPHETIC FICTION

December 1932

HUGO GERNSBACK
Editor

WONDER Stories

"THE TIME EXPRESS"
by Nathan Schachner

NOW
15¢

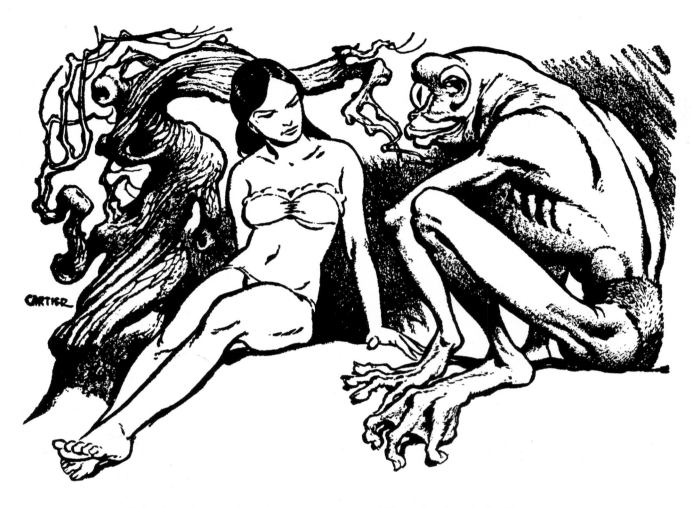

The arrangement of the book is a simple one. The opening section is devoted to a parade of artists, and this forms the major part of the volume. Such a parade has not been attempted before; its advantage is that it allows us to appreciate how individual the artists were, both in approach and execution. As it is, there has been room for only thirty artists; the number might have been double, while, of course, those represented here have had to make do with only a few examples to their name. Although we have naturally tried to include many of the famous, inclusion or exclusion rests less on merit than on conditions of availability.

After a brief interlude on the great comic strips – so gaudy and so unlikely even in present company – comes a section on some of the main themes in magazine sf. It affords an opportunity to study further some of the illustrators already introduced as well as a chance to admire new ones.

Next we indicate the way in which two science-fictional ideas developed. The illustrators held a dialogue between them, just as the writers did.

Such dialogue is largely a thing of the past. It would be interesting to study the development of the spaceship in pictures – and it would require a book to itself.

The volume concludes with a gallery of the magazines of the past, the failures as well as the successes. It strives more for variety than completeness. Where a magazine has undergone dramatic changes of format, different phases of its existence are sometimes represented.

The Artists' Gallery

★ *Paul* ★

☆ *When Hugo Gernsback discovered him, Frank R. Paul was working on illustrations for a provincial American newspaper. Like Gernsback, Paul's origins lay in Europe: Gernsback was born in Luxemburg, Paul in Austria. Paul's drawings and cover illustrations dominated the early Gernsback magazines AMAZING STORIES, AMAZING STORIES QUARTERLY and SCIENCE WONDER STORIES.*

His early training as an architect stood him in good stead when it came to designing alien cities. So did his methodical mind. He set about inventing a 1920s version of the future as painstakingly as had Albert Robida towards the end of the nineteenth century. Although he was without Robida's dash, Paul seized on the principle of multiplication of image – which presumably he saw in the mass-production all round him – and many of his more effective illustrations are achieved by a multiplicity of images, as in the ranked vehicles on this page, and the serried buildings in the City of the Future overleaf. Many sf artists took their cue from Paul.

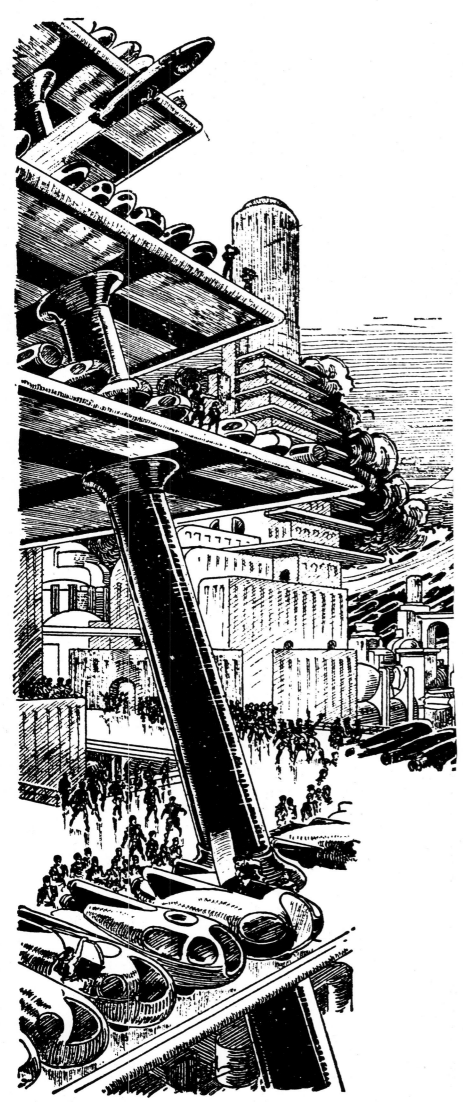

Science Fiction, March 1939
"The Sea Things" by Guy Arnold

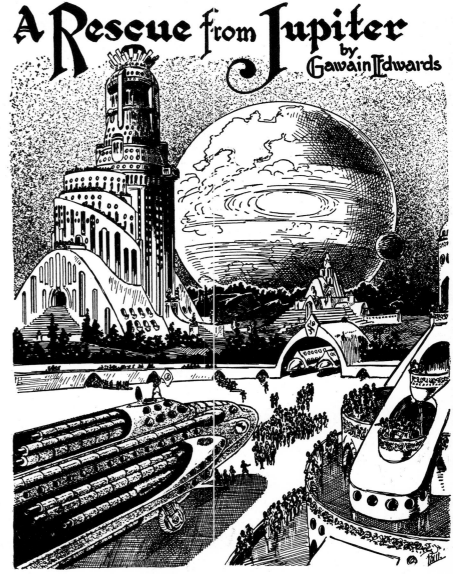

Science Wonder Stories, March 1930
"A Rescue from Jupiter" by Gawain Edwards

11

CITY OF THE FUTURE

What will the city of tomorrow be like? Here is the giant plastic, metal, and unbreakable glass city of the 21st century. A city of science, of atomic power, of space travel, and of high culture. See page 240 for complete story.

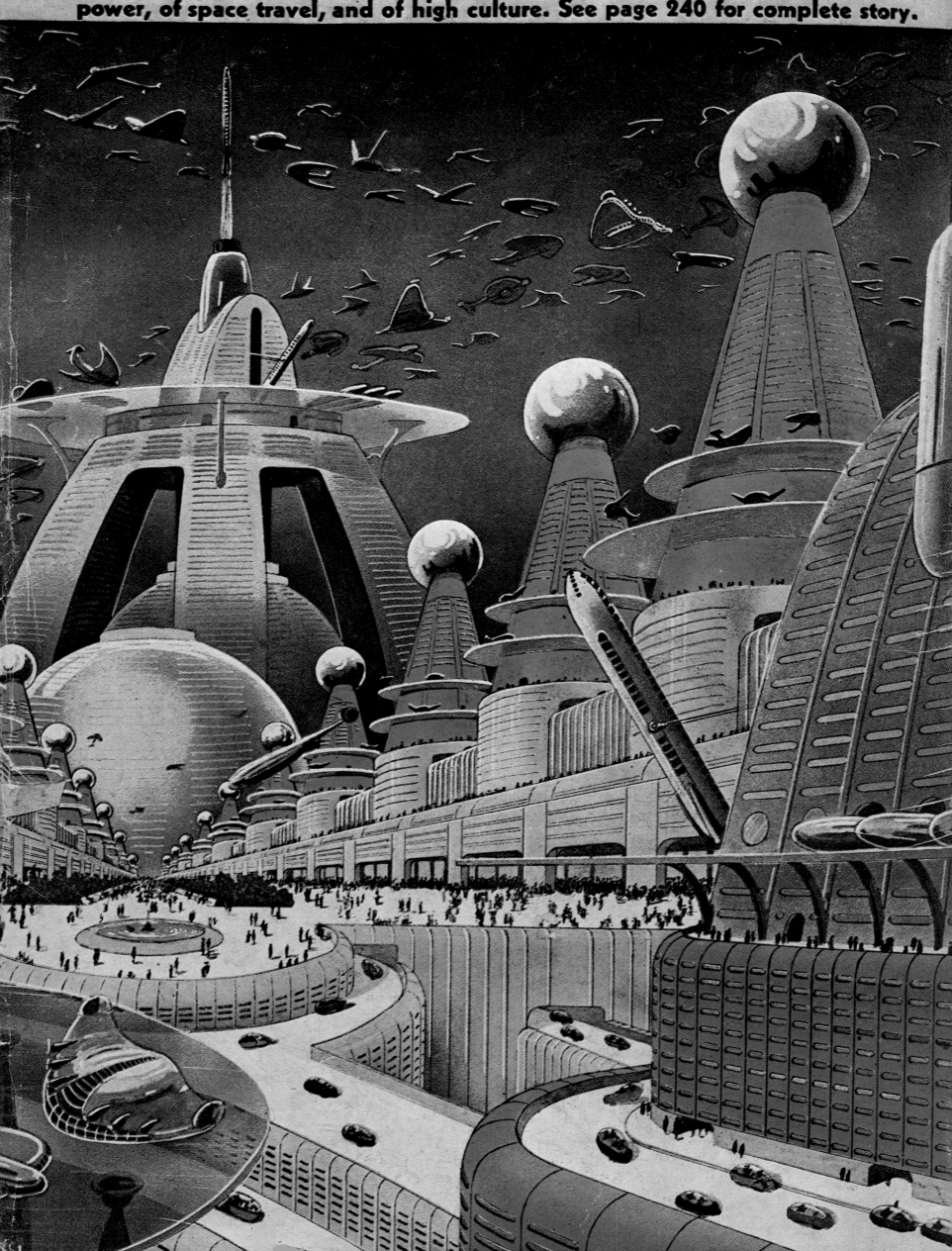

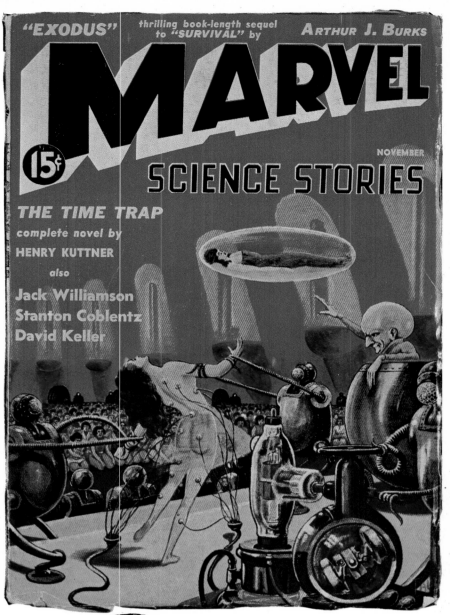

"EXODUS" thrilling book-length sequel to "SURVIVAL" by ARTHUR J. BURKS

MARVEL
SCIENCE STORIES

15¢

NOVEMBER

THE TIME TRAP
complete novel by
HENRY KUTTNER
also
Jack Williamson
Stanton Coblentz
David Keller

In This Issue THE ROBOT TECHNOCRAT

NOW 15¢

WONDER
Stories

HUGO GERNSBACK
Editor

March

Other Science Stories In This Issue

"DWELLER IN MARTIAN DEPTHS" by Clark Ashton Smith "WANDERERS OF TIME" by John Beynon Harris "THE MAN WHO AWOKE" by Laurence Manning

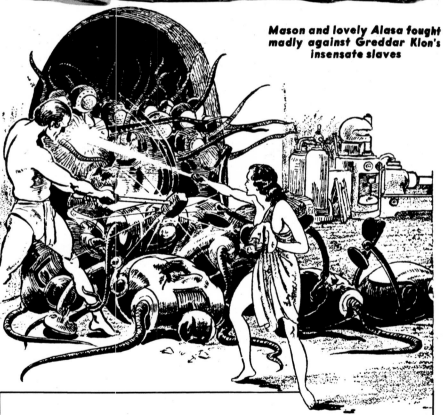

Mason and lovely Alasa fought madly against Greddar Klon's insensate slaves

THE TIME TRAP
by HENRY KUTTNER
Author of "Avengers of Space," etc.

STARTLING BOOK-LENGTH NOVEL OF MEN AND WOMEN DRAWN FROM TIME-SECTORS FIVE HUNDRED CENTURIES APART AND HURLED INTO CIVILIZATION'S DAWN-ERA!

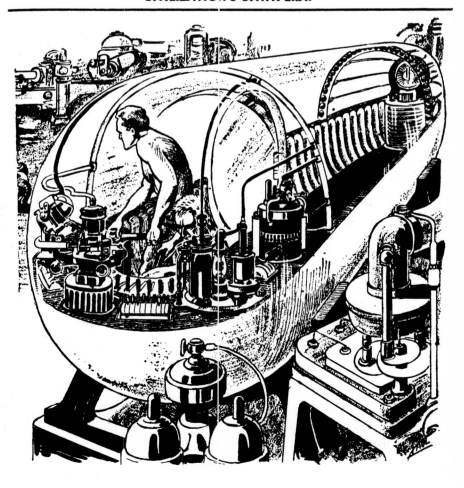

Paul was no mean colourist. Even scenes of menace are rendered innocuous by his soft tones. A dream-like quality often prevails. It is hard to believe that the lady time-explorer on the WONDER STORIES cover will come to serious harm.

His aliens were as unconvincing as his machines were inarguable. He was no great hand at human figures, but improved greatly towards the end of his fertile career. One of the best interior illustrations, for Kuttner's "The Time Trap", shows how he had progressed by the late 'Thirties.

This illustration has all that an sf fan could desire: fantastic machines, malignant robots, a half-dressed girl, and a dash of brute force. The galaxy presented few problems that a sledge-hammer could not solve . . .

top left and above: **Marvel Stories, November 1938**

top right: **Wonder Stories, March 1933**

opposite page: **Amazing Stories, April 1942** (back cover)

**Planet Stories,
Spring 1942**
"Black Friar
of the Flame"
by Isaac Asimov

Schneemann

★ ★

GRAY LENSMAN

Astounding Science Fiction, June 1938
"The Legion of Time" Part I, by Jack Williamson

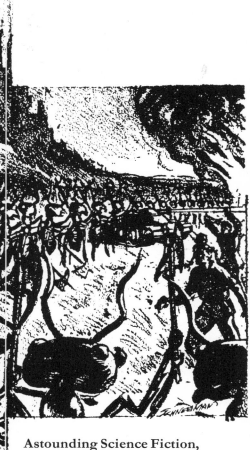

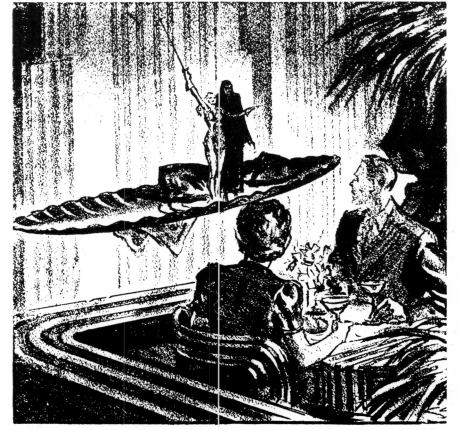

Astounding Science Fiction, November 1939
"Gray Lensman" Part II, by E. E. Smith, PhD

Astounding Science Fiction, May 1938
"The Legion of Time" Part II, by Jack Williamson

Gerald Quinn ★

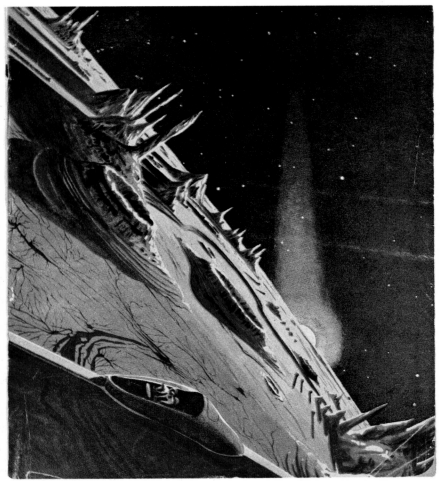

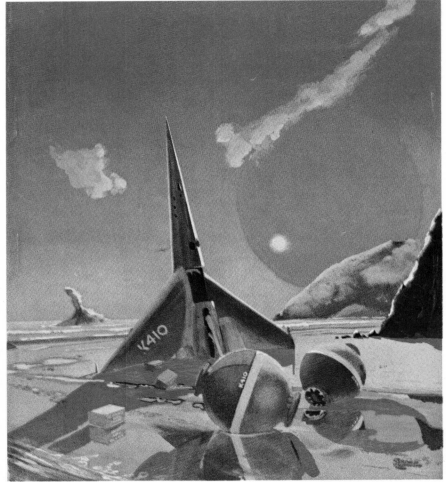

above: **New Worlds 1955** below: **New Worlds, February 1955**

above: **New Worlds, June 1953** below: **New Worlds, June 1954**

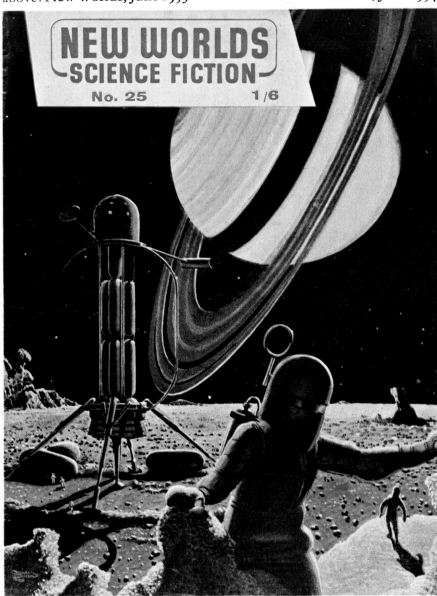

NEW WORLDS
SCIENCE FICTION
No. 25 1/6

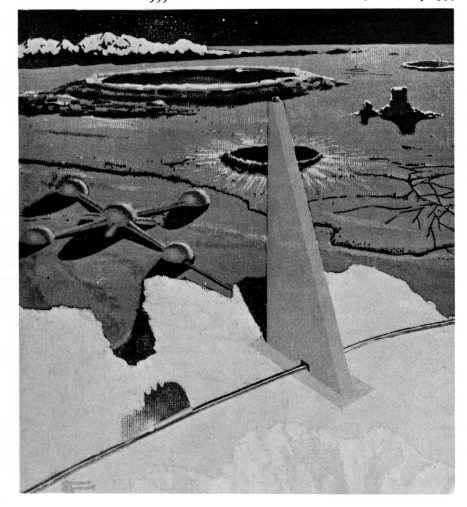

☆ *Many readers were drawn to science fiction through astronomy, as a preponderance of astronomical covers indicates. One of the best British artists to use astronomical themes was the Irishman, Gerald Quinn, for many years a favourite of* NEW WORLDS, *when it was edited by Ted Carnell. The four covers reproduced here show a monorail on the Twilight Zone of Mercury (a setting which the Mariner space-probes have proved to be as fictitious as the canals of Mars) ; exploration of a moon of Saturn ; an imaginary planet of a binary sun ; and a scene on the Moon, with colonisation on the way.*

Malcolm ★ ★ Smith

☆ *Many sf artists are identified with one particular magazine. Malcolm Smith's name is associated with* IMAGINATION, *a magazine which flourished in the 'Fifties and was known affectionately as "Madge". It was digest-sized. This illustration shows it in all its glory, at four times its original size.*

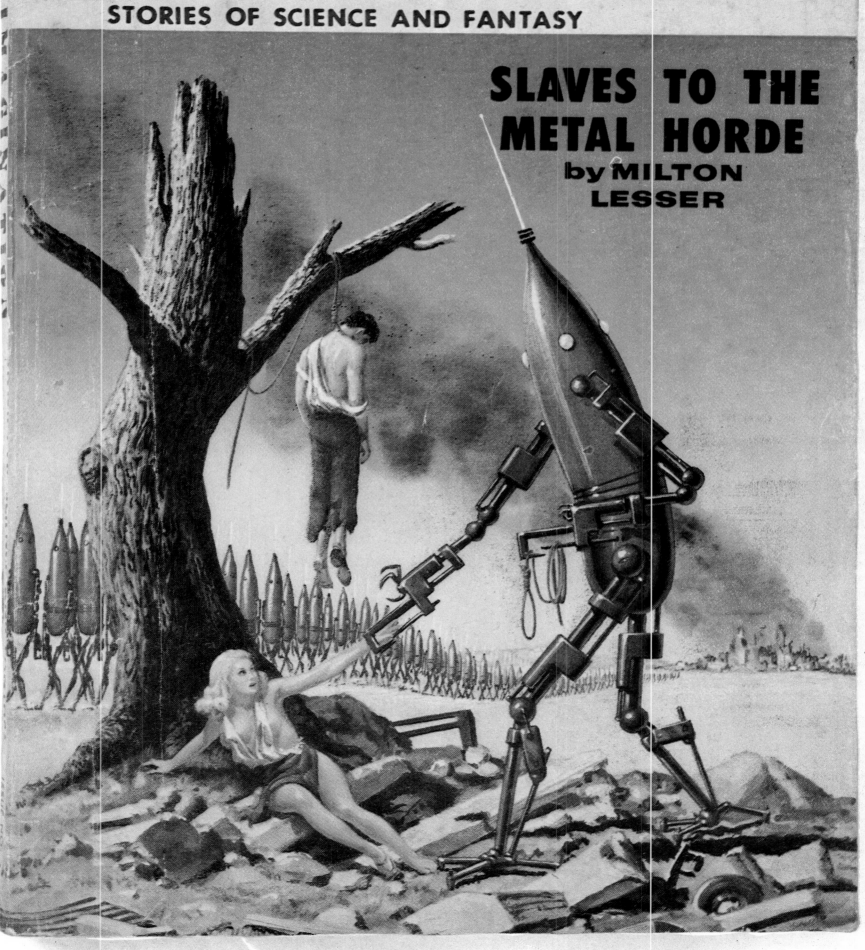

ANC

IMAGINATION

STORIES OF SCIENCE AND FANTASY

JUNE, 1954

35¢

SLAVES TO THE METAL HORDE
by MILTON LESSER

★ Dold ★

☆ *Elliott Dold and his brother Douglas may have been influential in persuading the publisher, William L. Clayton, to add a science fiction magazine to his chain of pulp titles in 1929. Be that as it may, when Clayton's* ASTOUNDING STORIES OF SUPER-SCIENCE *appeared (the first issue dated January 1930, a fitting inauguration of a new decade), sf's most famous magazine was launched, and Elliott Dold became one of its finest draughtsmen.*

Many of the stories he illustrated have faded into unreadability with time, but Dold emerges with renewed strength. His enigmatic patterns reinforce the primitive ideas of science fiction—man against nature, man against alien, above all, man against machines, or man with and part of his machines. Dold's archetypal illustration is of man as a figment of technological culture; not so much dwarfed by that culture as integrated with it. His world-picture includes man as a unit of a pre-ordained cosmos governed by the second law of thermodynamics. Dold's grand patterns have a bleakness not always achieved by the authors of the stories he illustrated.

Astounding Science Fiction, February 1938
"The Rainbow Bridge" by Herbert C. McKay

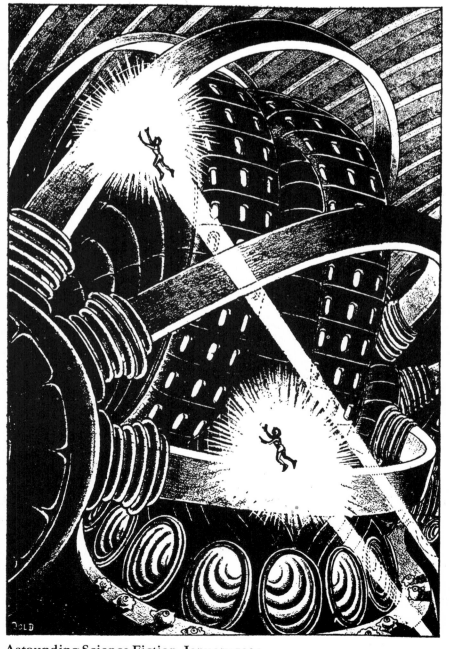

Astounding Science Fiction, January 1935
"The Skylark of Valeron" by Edward E. Smith

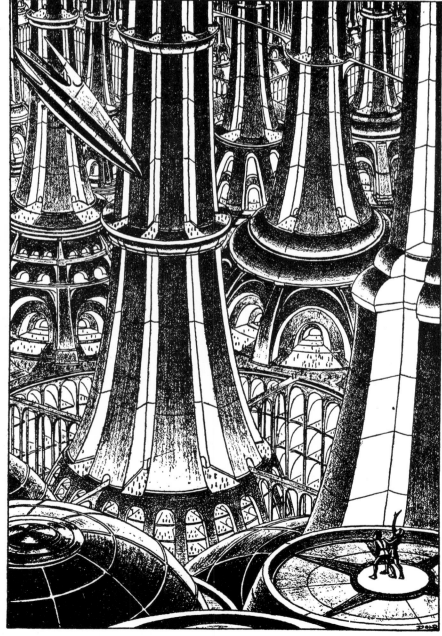

Astounding Science Fiction, September 1936
"Little Hercules" by Neil R. Jones

Astounding Science Fiction, January 1935
"The Skylark of Valeron" by Edward E. Smith

Astounding Science Fiction, June 1938
"Seeds of the Dust" by Raymond Z. Gallun

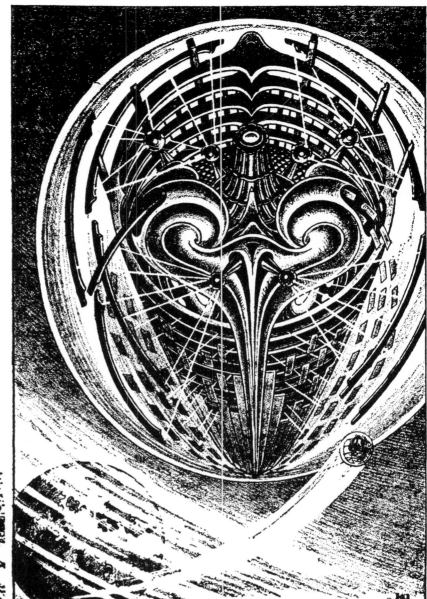

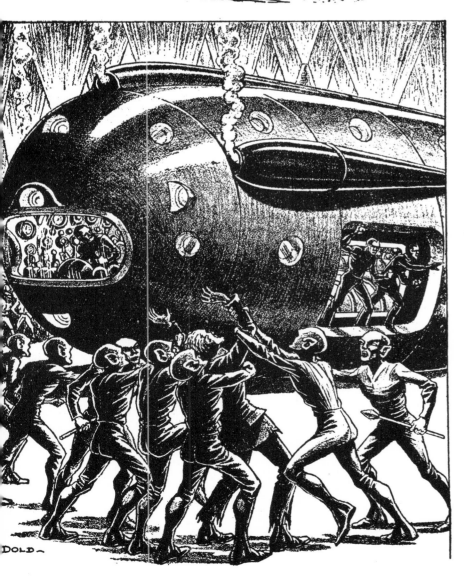

Astounding Science Fiction, October 1938
"The Sun-World of Soldus" by Nat Schachner

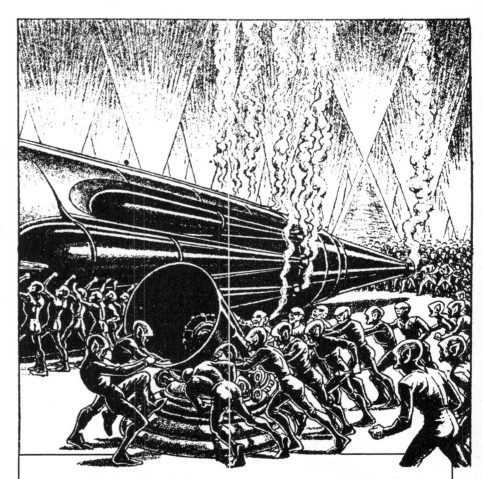

E. E. "Doc" Smith was the sf writer who first broke out beyond the confines of the solar system into the galaxy. He remains as popular today as when he began writing in the 'Twenties. Doc Smith wrote big. He specialised in inexplicable machines and inscrutable forces. Dold was ideal for Doc Smith's sagas. The two illustrations reproduced from Smith's "Skylark of Valeron" show him embodying Smith's concepts in typically bold patterns.

Astounding Science Fiction, November 1937
"Marinorro" by Warner Van Lorne

Astounding Science Fiction, May 1938
"Island of the Individualists" by Nat Schachner

Astounding Science Fiction, August 1937
"Jupiter Trap" by Ross Rocklynne

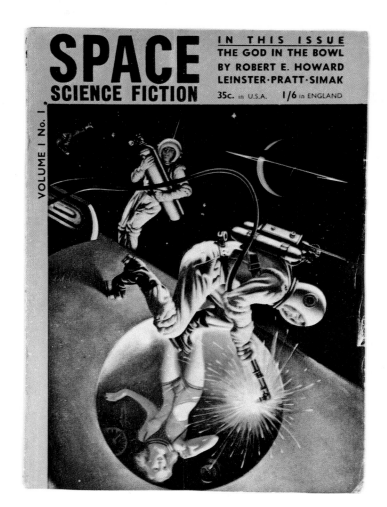

Space Science Fiction,
No. 1 1952 (1st issue)

Bergey

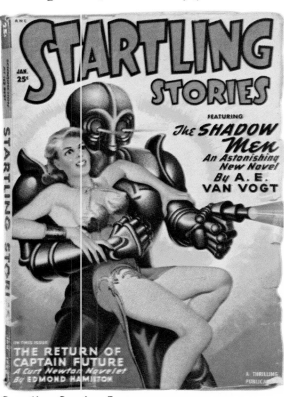

Startling Stories, November 1949

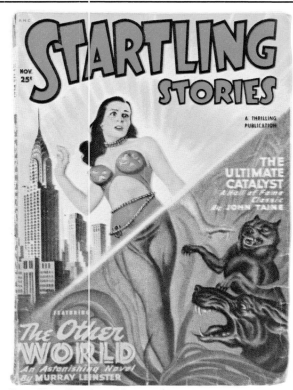

Startling Stories, March 1951

Startling Stories, January 1950

Fawcette

★

☆ *Among the many artists who worked on the numerous sf magazines, Gene Fawcette has a special place. He was a superb, though variable, black- and-white pattern-maker. Since his work often appeared in the less eminent magazines, his name has been unjustly neglected.*

The illustration on the right, for instance, shows Fawcette occupying an awkward page-space to great effect. Sf illustrations had an incalculable influence on readers. So moved was I by Fawcette's amazing aliens that I read the rather modest story they adorned several times, simply to fortify the strangeness of the picture.

NO GREATER WISDOM

By Rog Phillips

When men are made out of metal, women are still going to ask one question: how will he respond to soft music and a full moon?

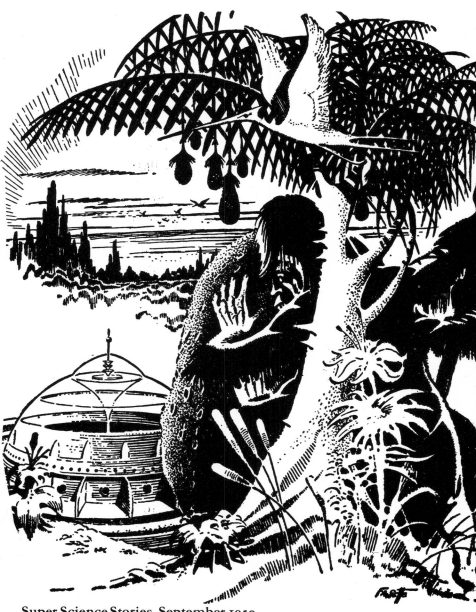

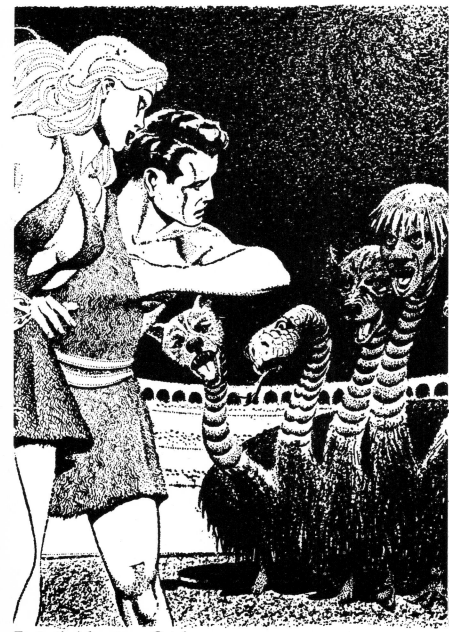

Fantastic Adventures, October 1951
"Medusa was a Lady" by William Tenn

Super Science Stories, September 1950
"The First" by Kris Neville

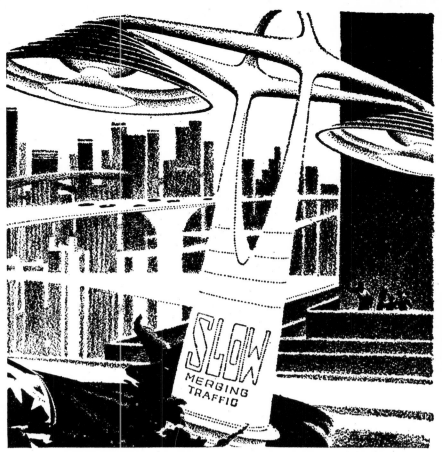

He was dead, of course; but instead of blood and bone, Marge saw only coils and springs!

Amazing Stories, January 1952
"No Greater Wisdom" by Rog Phillips

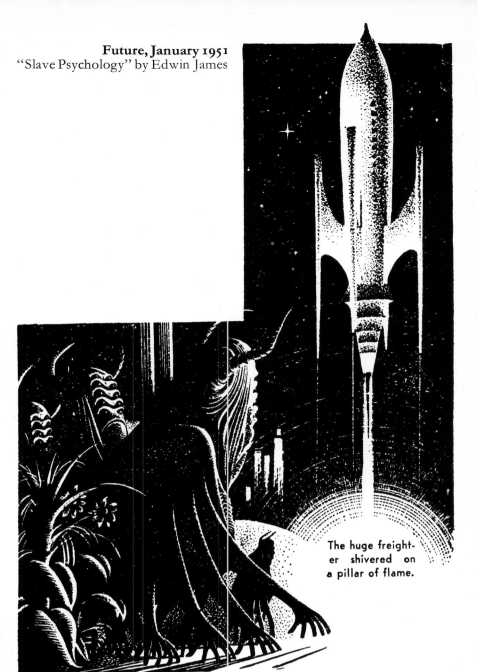

Future, January 1951
"Slave Psychology" by Edwin James

The huge freighter shivered on a pillar of flame.

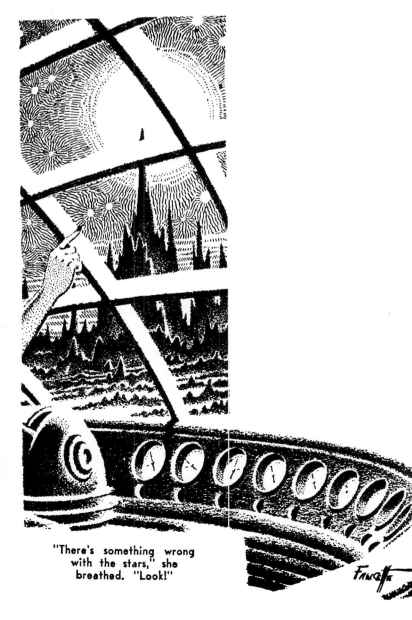

"There's something wrong with the stars," she breathed. "Look!"

Future, January 1951
"The Everlasting Exiles" by Wallace West

Timmins

☆ *Although William Timmins dominated the covers of ASTOUNDING from 1944–46, he was not always the most popular of artists. His shaggy style was in marked contrast to Rogers' well-groomed illustrations. I always valued this roughness. His striking use of colour harmony for the Van Vogt novella, "The Chronicler" (with the Timmins Building superscription boldly proclaiming itself a monument to the artist), is especially to be prized. Ah, 1946! What a vintage year it was for ruins, as the rigours of World War II turned into the desolations of the Cold War.*

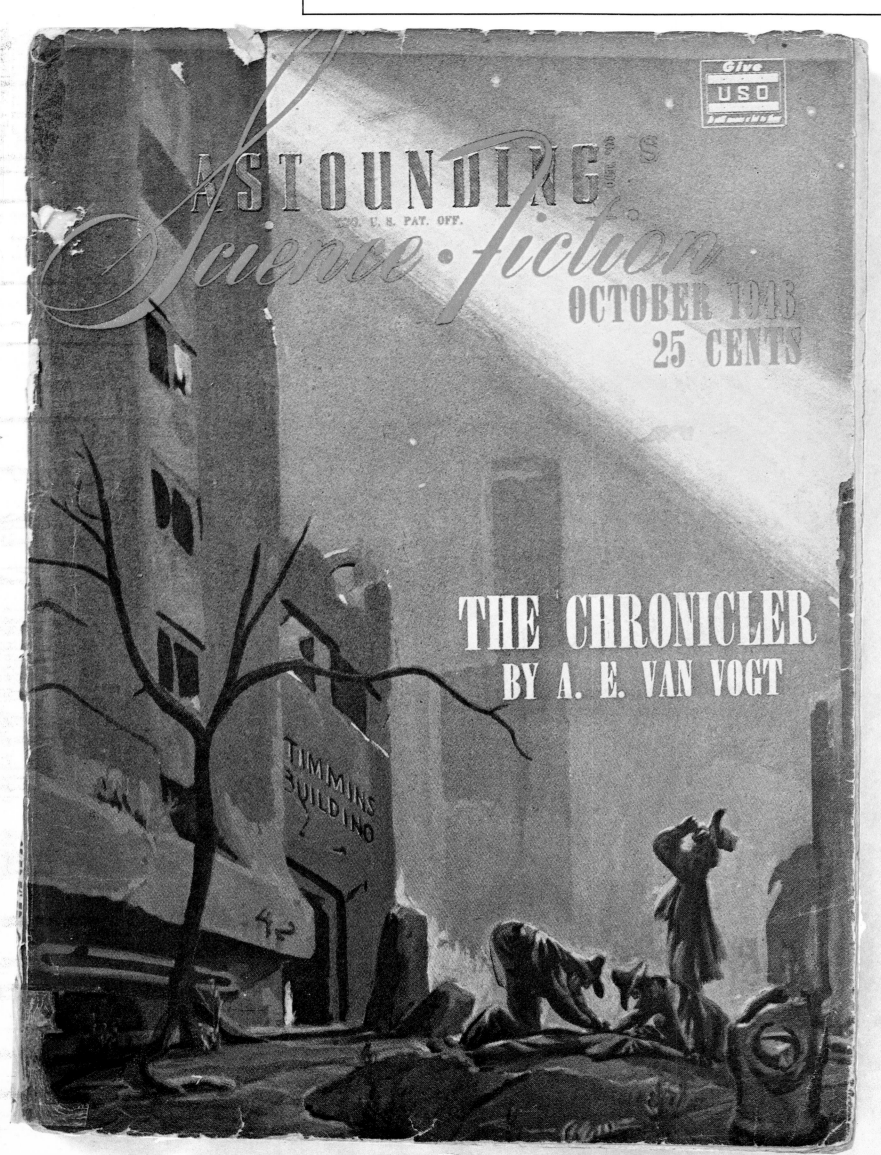

ASTOUNDING
REG. U.S. PAT. OFF.
Science Fiction
OCTOBER 1946
25 CENTS

THE CHRONICLER
BY A. E. VAN VOGT

TIMMINS
BUILDING

★ Edd Cartier ★

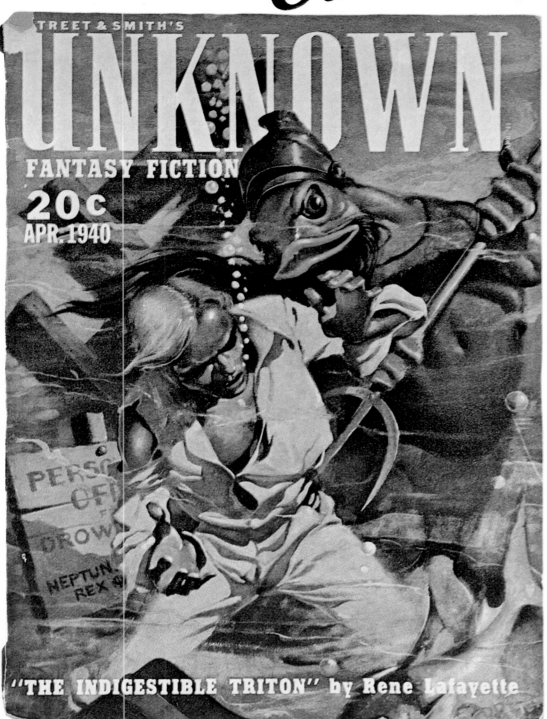

"THE INDIGESTIBLE TRITON" by Rene Lafayette

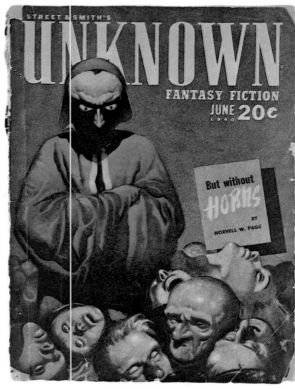

Unknown, June 1940

☆ *All the sf artists were something special, and Edd Cartier was something particularly special. His clean line-work alone would have guaranteed his prestige, but he had the extra good fortune to illustrate a particularly special magazine, UNKNOWN, edited by the renowned John W. Campbell.*

Cartier's covers for UNKNOWN have never been excelled in their genre. The cover for "The Indigestible Triton" is very effective; cognoscenti could recognise it as Cartier's work by the lettering on the sunken notice alone. (René LaFayette, incidentally, was a pen name of L. Ron Hubbard, the founder of "Dianetics" and "Scientology")

Unknown, December 1940
"Darker than you think" by Jack Williamson

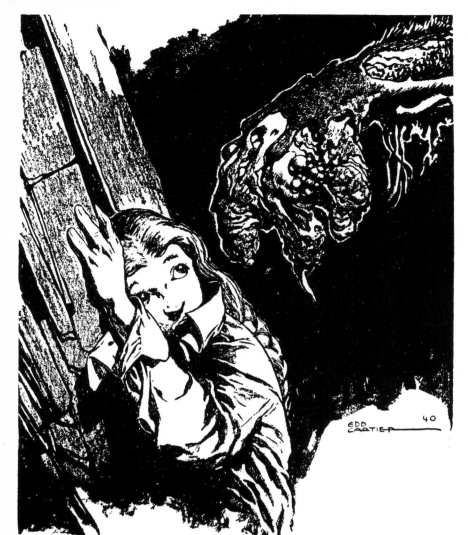

Unknown Fantasy Fiction, August 1940
"It" by Theodore Sturgeon

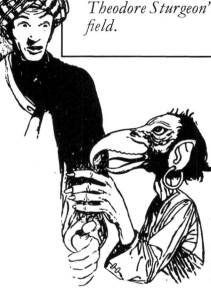

Later in its short career, UNKNOWN, *retitled* UNKNOWN WORLDS, *used typographical covers. Cartier then produced beautiful interior illustrations for it and its sister magazine,* ASTOUNDING.

Cartier was an expert on weird forms of transport. He was also lucky enough to illustrate "It", the story that made Theodore Sturgeon's name in the fantasy field.

Unknown
April 1941
"The Castle of Iron"
by L. Sprague de Camp
& Fletcher Pratt

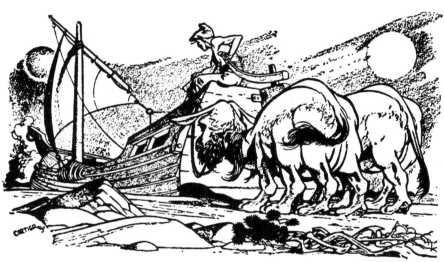

Astounding Science Fiction, October 1950
"The Hand of Zei" by L. Sprague de Camp

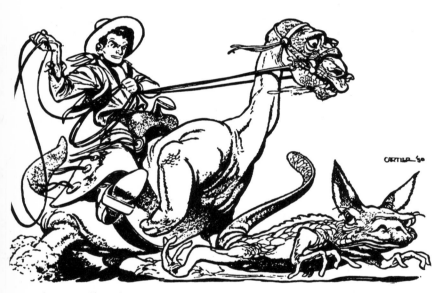

Astounding Science Fiction, August 1950
"Git Along!" by L. Sprague de Camp

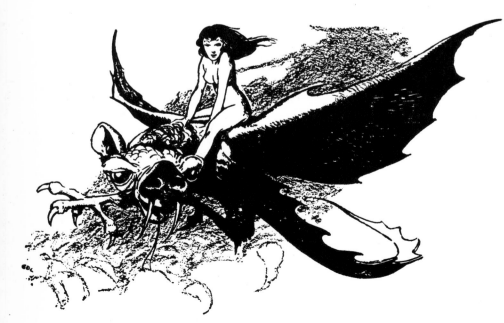

Unknown, December 1940
"Darker than you Think" by Jack Williamson

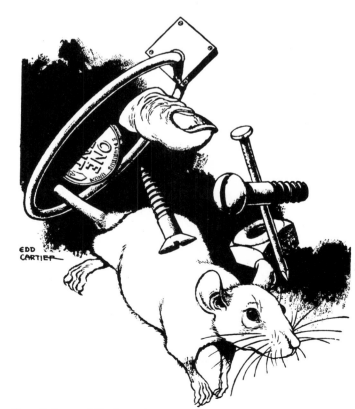

Astounding Science Fiction, August 1947
"Rat Race" by George O. Smith

★ *Binder* ★

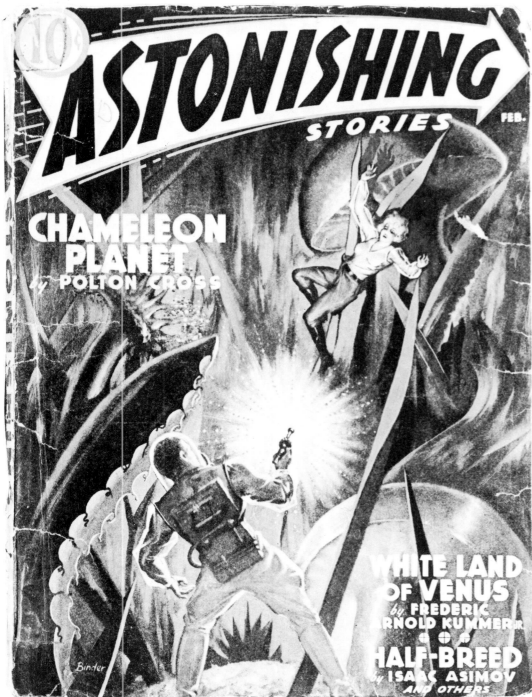

Astonishing Stories, February 1940

Astounding Science Fiction, May 1938
"The Incredible Visitor" by Clifton B. Kruse

Astounding Science Fiction, October 1938
"The Command" by L. Sprague de Camp

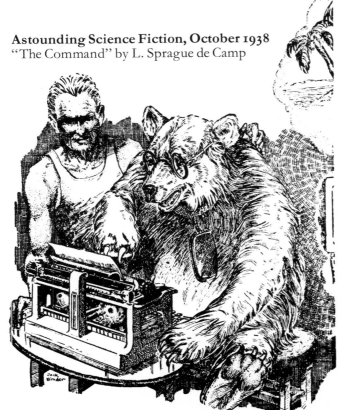

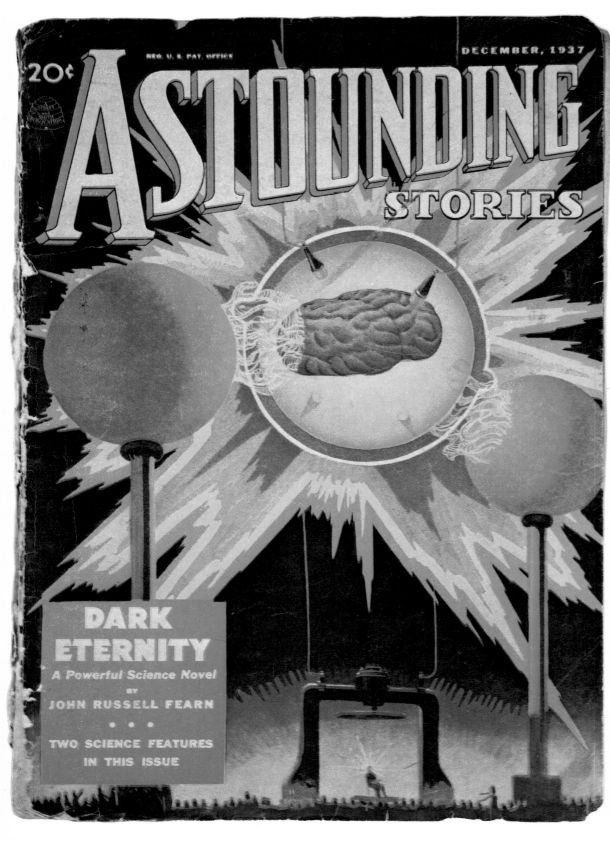

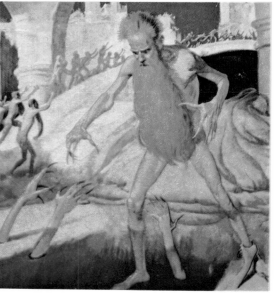

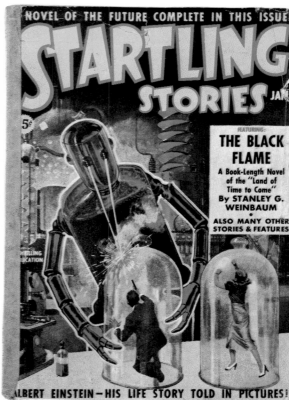

☆ ASTOUNDING STORIES OF SUPER-SCIENCE *ceased to be a Clayton magazine in 1933 and was re-launched by the Street & Smith pulp chain as* ASTOUNDING STORIES *(the first in a series of title changes which led to the present-day* ANALOG*). Its new cover artist was Howard V. Brown. His execution was childish at first, but he went on to great things.*

His most striking covers are delightfully complex, with plenty of detail and a splendid colour sense. Like others among renowned sf artists such as Wesso, Paul and Emsh, Brown deserves a monograph to himself. Some of his best work was not for ASTOUNDING *but for* STARTLING.

above left:
Astounding Stories, December 1937

top right:
Astounding Stories, September 1936

middle right:
Astounding Science Fiction, April 1938

right:
Startling Stories, January 1939

★ ★ Bok

☆ Together with Finlay and Lawrence, Hannes Bok is one of the masters of the macabre. His reputation in the United States, where a Bok Foundation has been established, is still growing.

As the examples show, his colour work for covers was somewhat uncertain, but there is no denying the force of his highly stylised black-and-white designs.

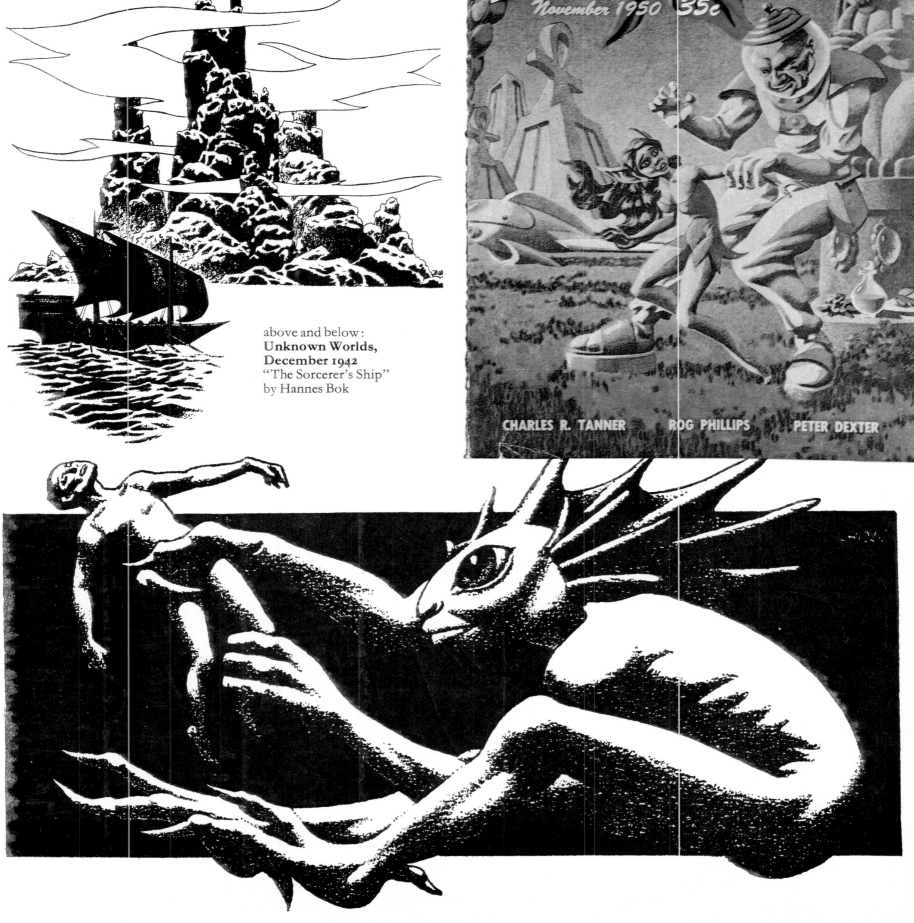

above and below:
Unknown Worlds, December 1942 "The Sorcerer's Ship" by Hannes Bok

Bok enjoyed an unfair advantage over many of his rivals. He wrote as well as illustrating. Two of the examples here are from his own novel, "The Sorcerer's Ship", since published in paperback form. His cover for the famous and long-lived WEIRD TALES is undeniably elegant, and accommodates title-logo and text in a manner rarely equalled.

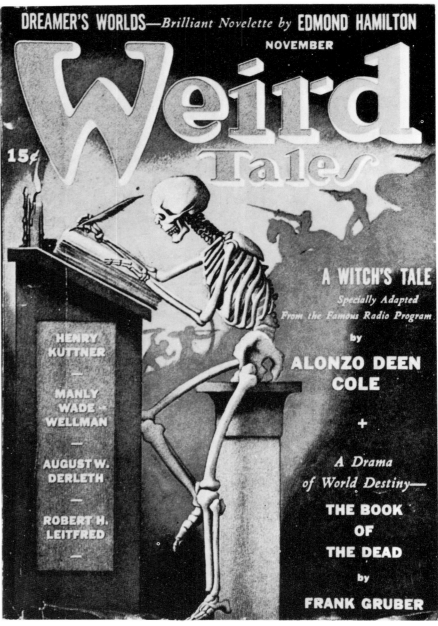

The WHEEL of TIME

above:
Super Science Stories, March 1950
"The Wheel of Time" by Robert Arthur

right:
Unknown Worlds, December 1942
"The Sorcerer's Ship" by Hannes Bok

★ 'Wesso' ★

☆ *The Polish artist Hans Waldemar Wessolowski was always known as Wesso. His fame in sf circles is secure: he executed each of the thirty-four covers of the Clayton ASTOUNDING. He began in a naive way but soon graduated towards more sophisticated work. At his best, as in the two ASTOUNDING covers here and overleaf, he shows a powerful ability to create abstracts from such standard sf themes as space battles.*

Astounding Stories, March 1933
"Lords of the Stratosphere" by Arthur J. Burks

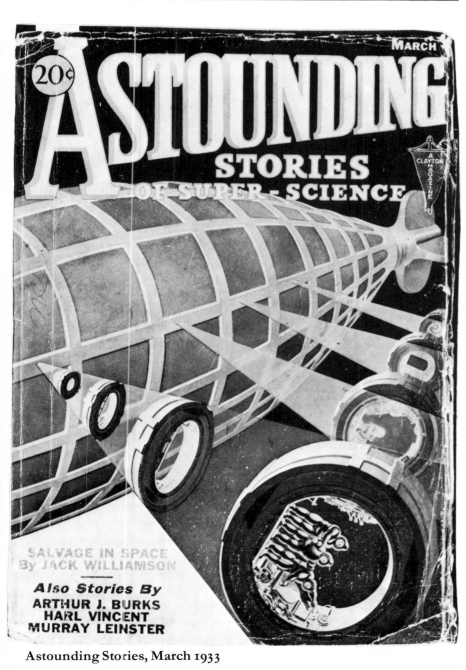

Astounding Stories, March 1933

Astounding Stories, August 1937
"Released Entropy" Part I, by Jack Williamson

AMAZING STORIES

June, 193
25 Cents

Murder by Atom
by
Joseph W. Skidmore

Miles J. Breuer, M.D.
George H. Sheer, BS., E.E.

AMAZING STORIES

MARCH
1935

25 Cents

Earth Rehabilitators
by Henry J. Kostkos
Other Science Fiction by:
Neil R. Jones
John W. Campbell, Jr.
Miles J. Breuer, M.D.

AMAZING STORIES

APRIL
1935

25 Cents

P D 4

The Sunlight Master
by E. J. Van Name
Other Science Fiction by:
Henry J. Kostkos
J. Harvey Haggard

★ *Morey* ★

☆ *The cover artists, like the writers, had their orders. They often had to pack their page with detail or add a half-naked girl, according to editorial whim. Leo Morey was apt to overcrowd his covers. The examples here show him struggling to maintain balance; in March 1935, he gets everything beautifully right, combining proportions with a fine, subdued colour scheme which must have contrasted oddly with the garishness rampant elsewhere on the news-stands.*

top left: **Amazing Stories**, June 1937

top right: **Amazing Stories**, March 1935

left: **Amazing Stories**, 1935

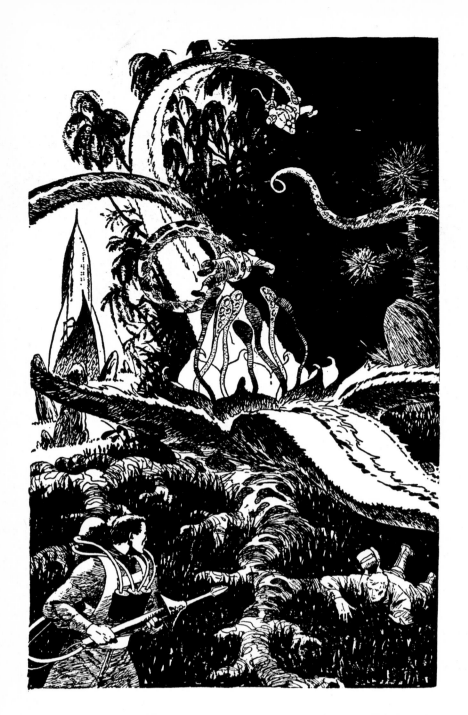

★ *Vestal* ★

☆ *Science fiction comes in many different kinds. There is the serious sort that deals in global over-population, the metaphysical sort that deals in the future of mankind, the doomy sort that deals in nuclear warfare . . . and the swashbuckling sort that deals in interplanetary adventure. That variety comes a long way down any intellectual list, yet it is probably the most popular kind of sf.*

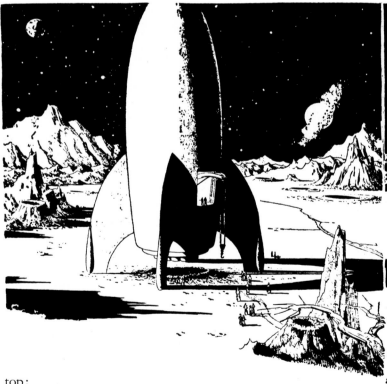

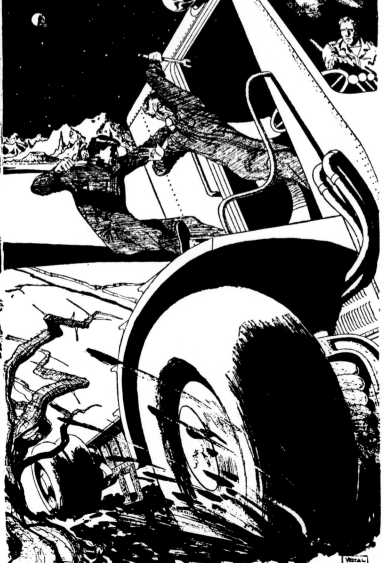

top:
Planet Stories, November 1952
"As It Was" by Paul L. Payne

above:
Planet Stories, July 1951
"Slave Ship to Andrigo" by Ross Rocklynne

opposite page, top:
Planet Stories, November 1951
"The Pit of Nympthons" by Stanley Mullen

opposite page, bottom:
Planet Stories, September 1952
"The Slaves of Venus" by Edwin James

Once there were whole magazines devoted to interplanetary adventure. Foremost among them were STARTLING STORIES and PLANET STORIES. Herman Vestal was the artist of interplanetary adventure.

In issue after issue, Vestal's nervous, scratchy line delineated the various hells to be discovered on strange planets. He is the maestro of the outré shape, the revolting life-form—all of them about to be subjugated by a clean-cut American from the skies.

Vestal's speciality was a crowded scene. Forgotten cities, marauding rocket ships, sentient volcanoes, carnivorous forests—all jostle for the attention of the man with his finger on the blaster trigger.

The SLAVES of VENUS

By EDWIN JAMES

They overthrew him on Earth. They booted him out of Mars. So wily Alex Dekker rocketed his peculiar brand of freedom to the swampmen of Venus . . . and prayed for one unholy miracle.

THROUGH the thin, cold upper atmosphere of Venus, above the clouds, a bulky object fell toward the distant surface. It tumbled over and over, straightened, and tumbled again, a dull-black oddly-shaped thing, only faintly visible in the light of the burning sun. Its speed was too slow for a meteor, and the shape was all wrong. There were projections, some round or oval, some long and pillar-like.

★

Vidmer

☆ *With the 'Fifties came such new magazines as* GALAXY, *edited by H. L. Gold, and* THE MAGAZINE OF FANTASY AND SCIENCE FICTION, *edited by Anthony Boucher. The fiction in the new magazines laid less emphasis on nuts and bolts and on adventure than their predecessors (or, indeed, some of their successors), while their artwork also became more sophisticated. This cover by René Vidmer is a fine example from the mid-'Fifties. The scene was entitled "Hunting on Aldebaran IV".*

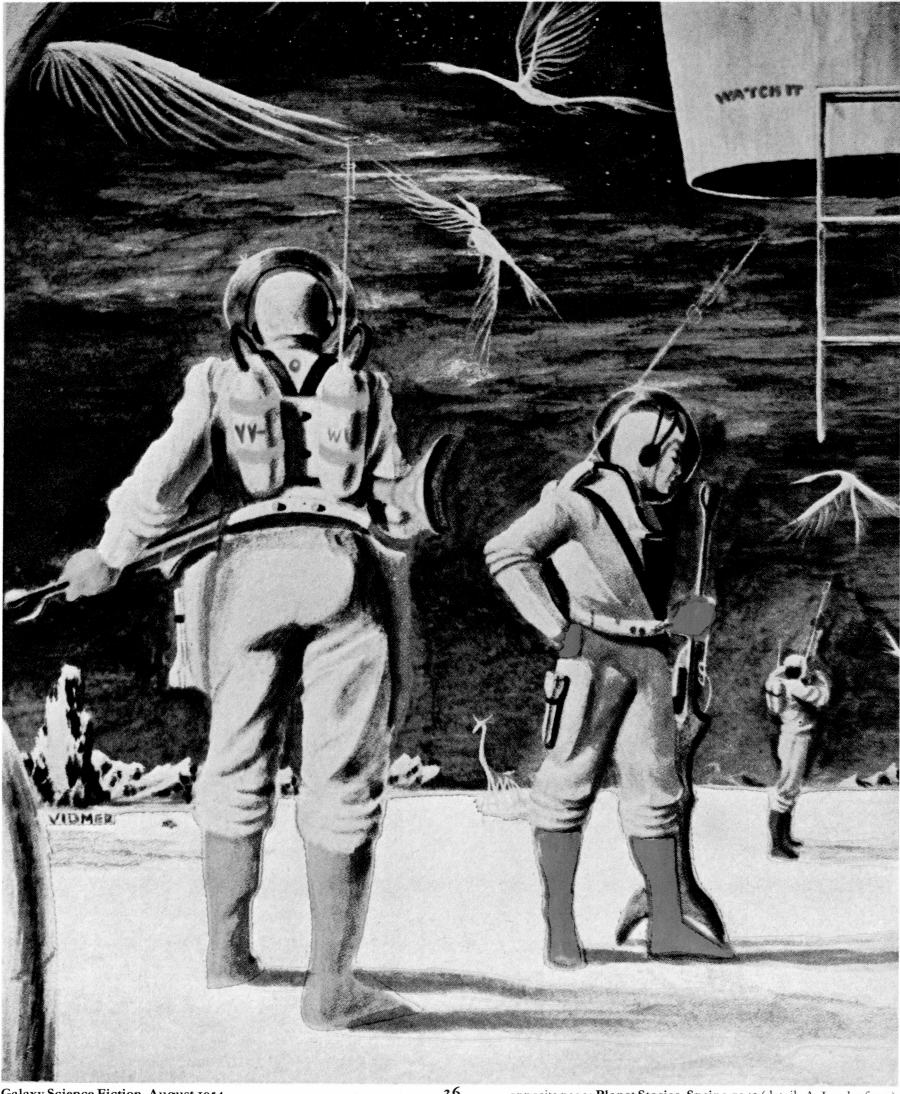

A. Leydenfrost

★ ★

Planet Stories, Spring 1942
"Child of the Sun" by Leigh Brackett

☆ *Another minor master. The horror element in sf as a whole tends to be over-estimated, probably because many of Hollywood's attempts at science fiction movies until the late 'Sixties contained strong horror additives. But when horror is needed, Leydenfrost is the inspired conjurer. His leaping forms spread across the dark page. His bridge for "Mirror Maze" is a creation which appears to combine serpent and stone. It was first reproduced in the June 1954* FAMOUS FANTASTIC MYSTERIES, *a magazine which also fostered Finlay and Lawrence.*

Chitin and tendon intermingle in Leydenfrost's relativistic universe. Stones are strangely plastic, bone has undergone geological processes. Leydenfrost's name would be better known if his work had appeared in more eminent magazines, but it was frequently the lower-paying pulps which featured the more exciting artwork.

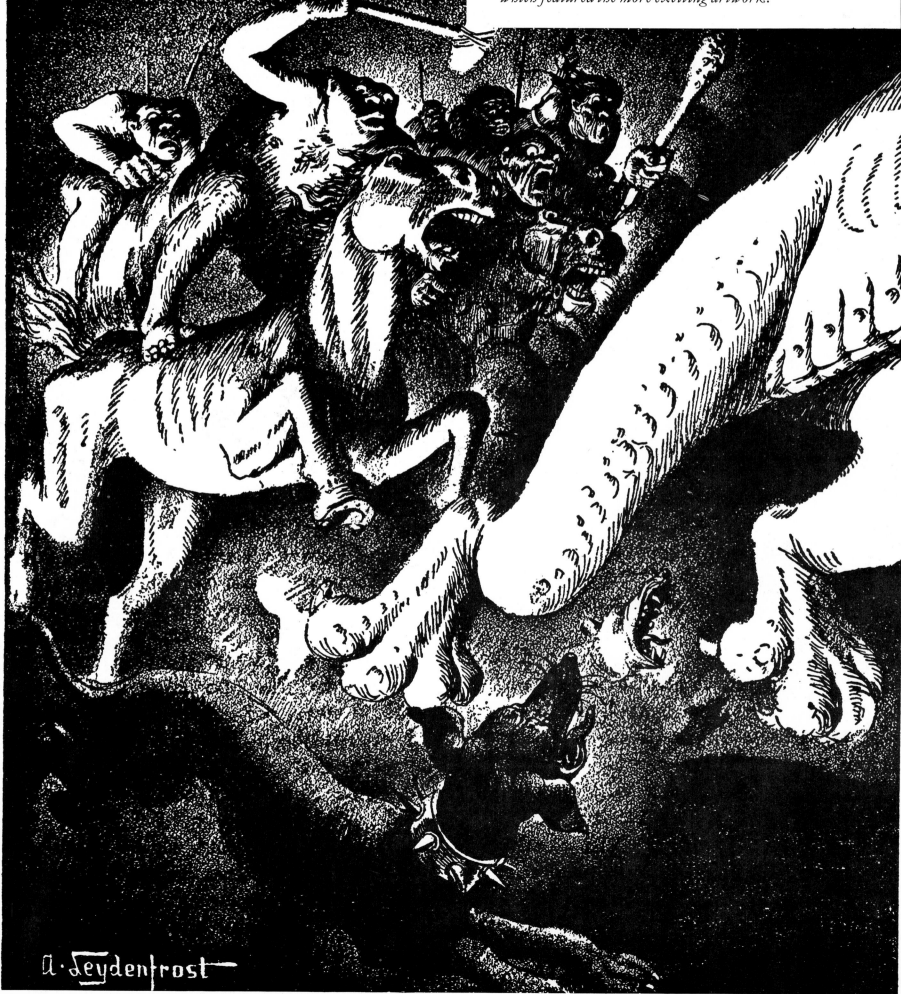

A. Leydenfrost

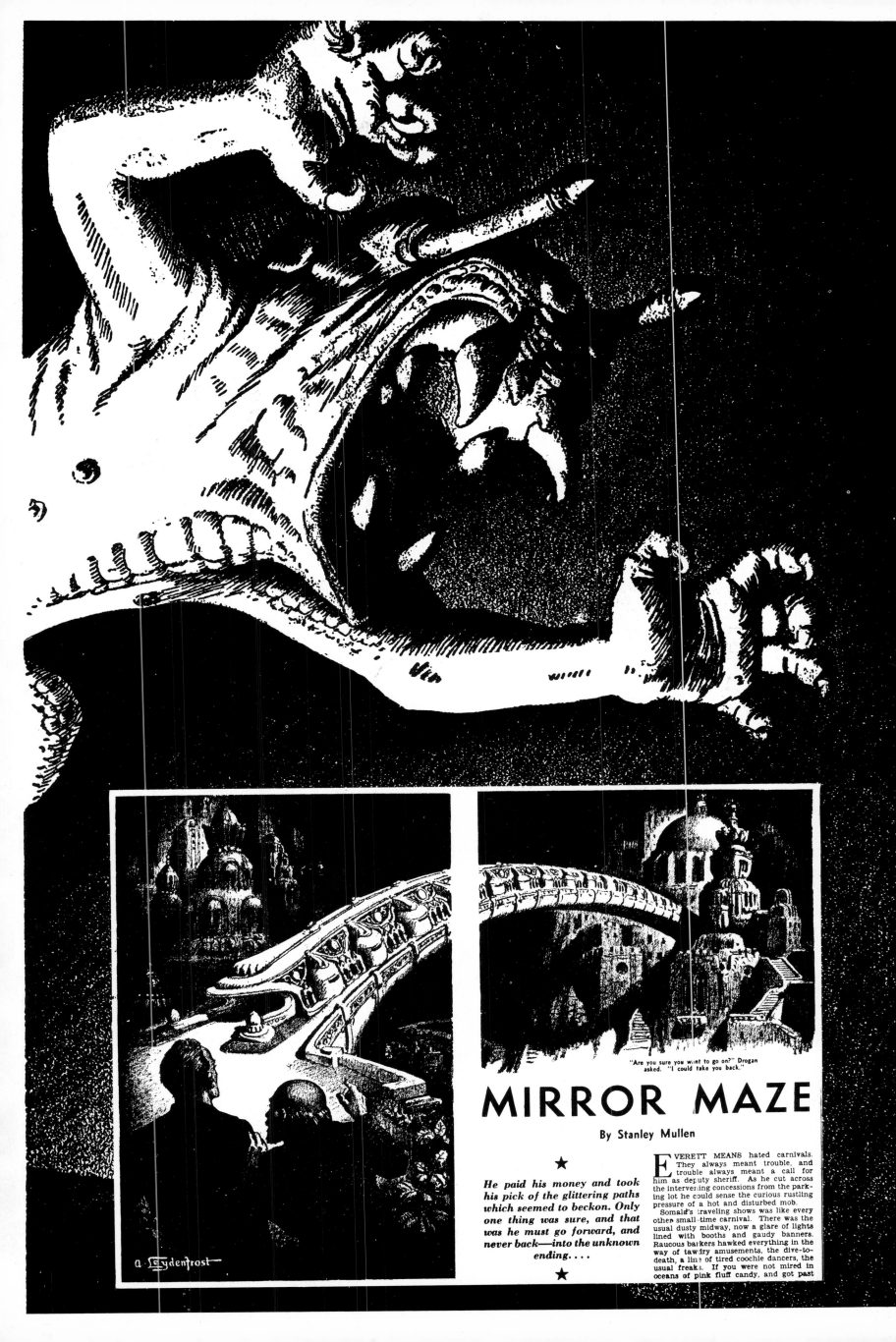

"Are you sure you want to go on?" Drogan
asked. "I could take you back."

MIRROR MAZE

By Stanley Mullen

★

*He paid his money and took
his pick of the glittering paths
which seemed to beckon. Only
one thing was sure, and that
was he must go forward, and
never back—into the unknown
ending....*

★

EVERETT MEANS hated carnivals.
They always meant trouble, and
trouble always meant a call for
him as deputy sheriff. As he cut across
the intervening concessions from the park-
ing lot he could sense the curious rustling
pressure of a hot and disturbed mob.

Somald's traveling shows was like every
other small-time carnival. There was the
usual dusty midway, now a glare of lights
lined with booths and gaudy banners.
Raucous barkers hawked everything in the
way of tawdry amusements, the dive-to-
death, a line of tired coochie dancers, the
usual freaks. If you were not mired in
oceans of pink fluff candy, and got past

a Leydenfrost

Rogers

Astounding Science Fiction, June 1940 (detail)

☆ *With the arrival of John W. Campbell in the editorial chair, ASTOUNDING went into top gear. During 1938, as war clouds gathered in Europe, a new logo and a new title, ASTOUNDING SCIENCE FICTION, were adopted. They signified the changes taking place within. It was the start of what fans call The Golden Age.*

The artwork of Hubert Rogers is closely associated with both the period and the magazine. He had been doing covers for the Street & Smith magazines for some years. Nothing seemed more thrillingly modern than the paintings he executed for Campbell in the early 'Forties—for instance, the transport cops from "The Roads Must Roll", one of Robert Heinlein's early successes.

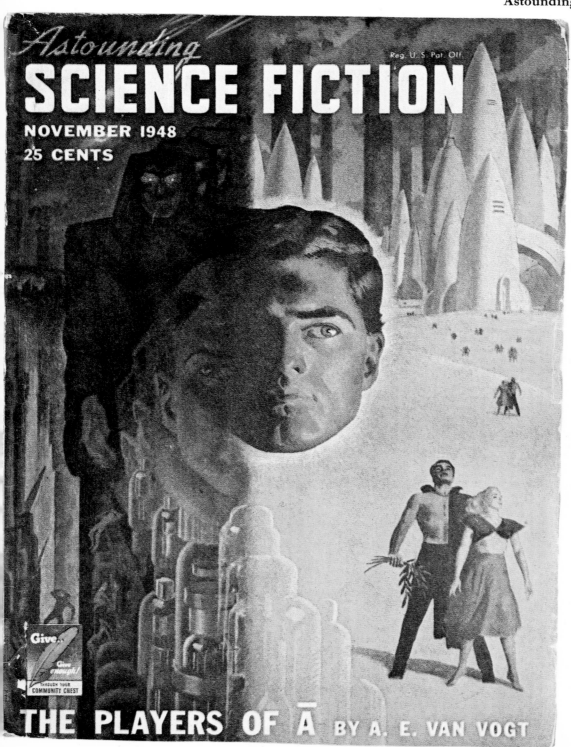

Astounding Science Fiction, November 1947 (detail)

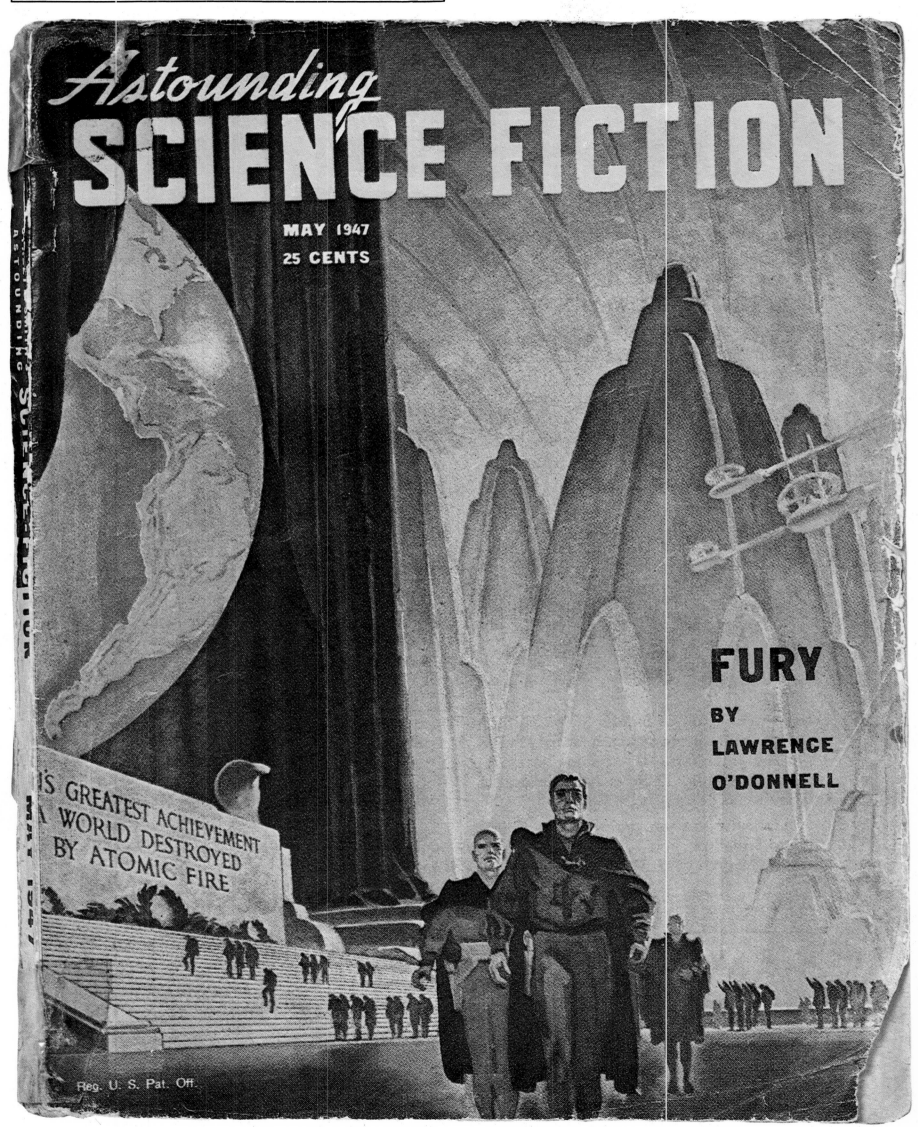

Astounding

SCIENCE FICTION

MAY 1947
25 CENTS

IS GREATEST ACHIEVEMENT
A WORLD DESTROYED
BY ATOMIC FIRE

FURY

BY
LAWRENCE
O'DONNELL

Reg. U. S. Pat. Off.

Roger's cover for November 1939 encapsulates the modernism of the 'Thirties. Here the influences of Bauhaus design and the sets for the Korda/H. G. Wells film "Things to Come" (1936) combine to give a vivid impression of a galactic war-room, with attacking space-fleets shown on a gigantic screen.

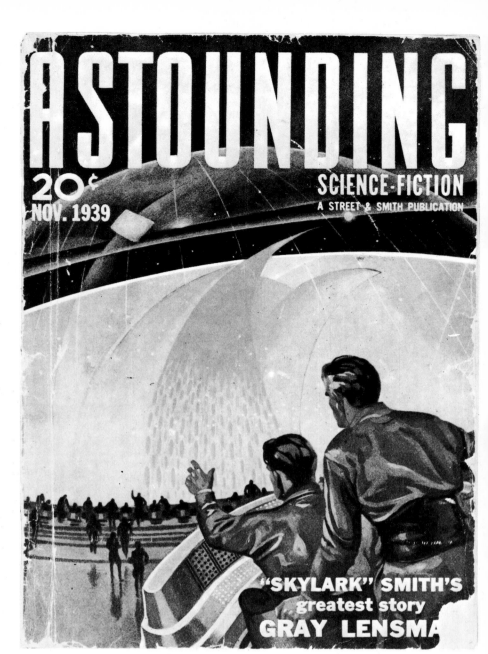

ASTOUNDING
SCIENCE-FICTION
A STREET & SMITH PUBLICATION
20¢
NOV. 1939

"SKYLARK" SMITH'S
greatest story
GRAY LENSMA[N]

Astounding Science Fiction, May 1948
". . . And Searching Mind" by Jack Williamson

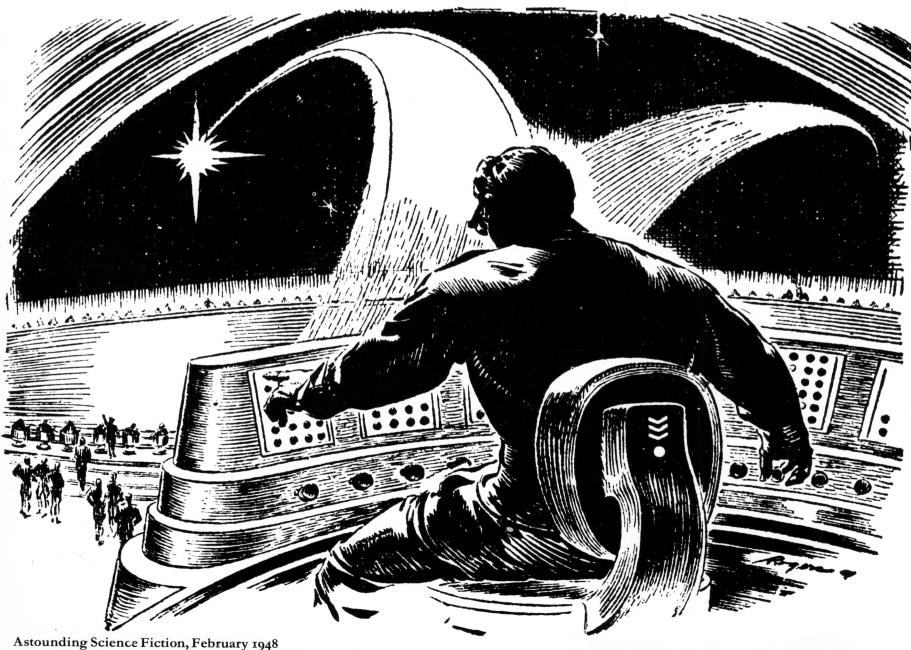

Astounding Science Fiction, February 1948
"Children of the Lens" (conclusion) by E. E. Smith

Startling Stories, Spring 1955
"Too Late for Eternity" by Bryce Walton

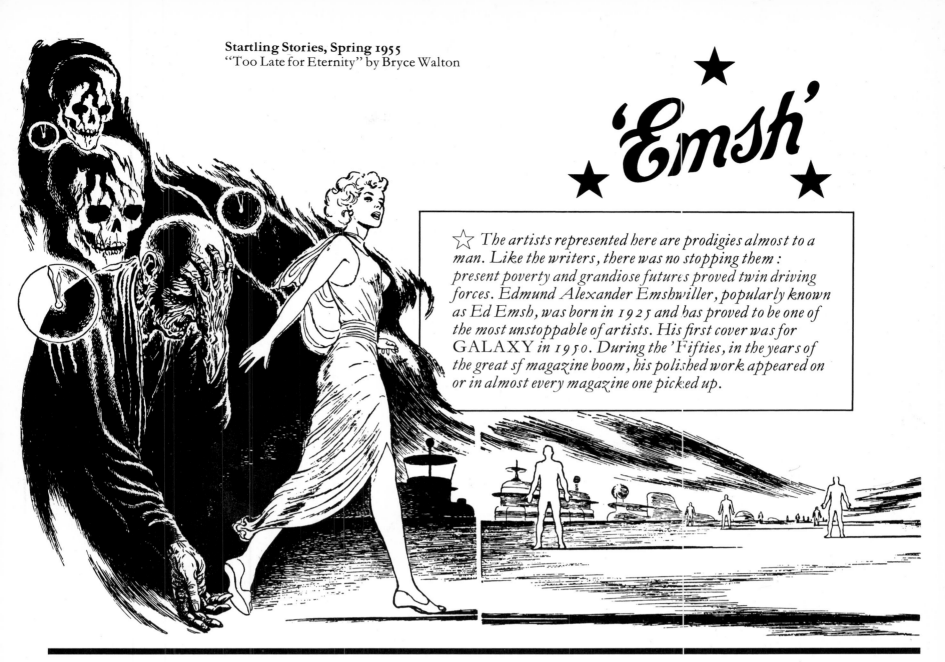

★ ★ ★ 'Emsh' ★ ★

☆ *The artists represented here are prodigies almost to a man. Like the writers, there was no stopping them : present poverty and grandiose futures proved twin driving forces. Edmund Alexander Emshwiller, popularly known as Ed Emsh, was born in 1925 and has proved to be one of the most unstoppable of artists. His first cover was for* GALAXY *in 1950. During the 'Fifties, in the years of the great sf magazine boom, his polished work appeared on or in almost every magazine one picked up.*

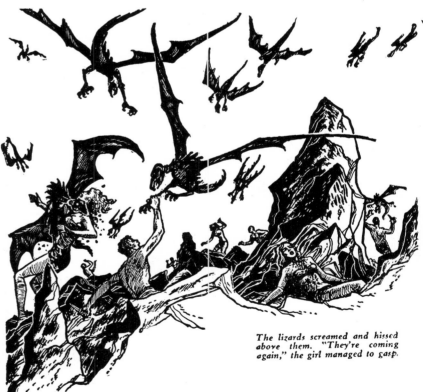

The lizards screamed and hissed above them. "They're coming again," the girl managed to gasp.

Planet Stories, November 1952
"Shannach—the Last" by Leigh Brackett

As this page indicates, he had a strong taste for the macabre—shared, I imagine, by most sf readers. He also had a lighter touch, and a gift for comedy. Emsh is the great all-rounder of sf art. A well-chosen folio of his drawings would be a thing to treasure.

Emsh is fortunate in having for a model his attractive wife Carol, a short story writer.

The Original Science Fiction Stories, July 1956 (detail)

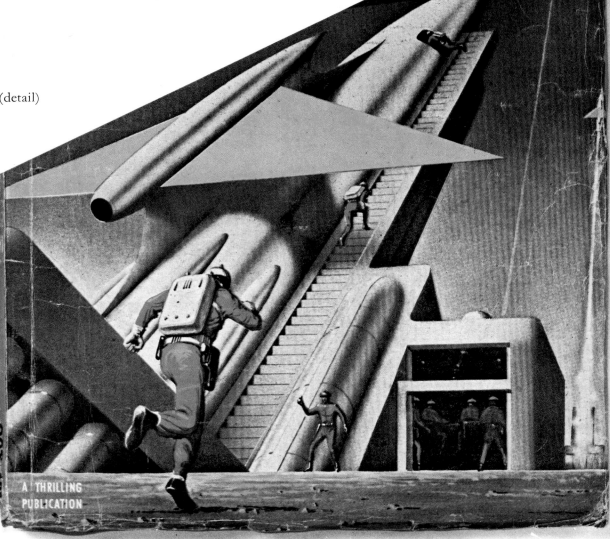

Space Stories, October 1952 (detail)

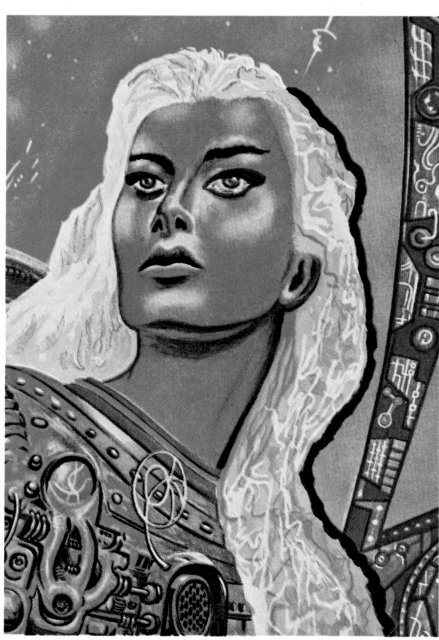

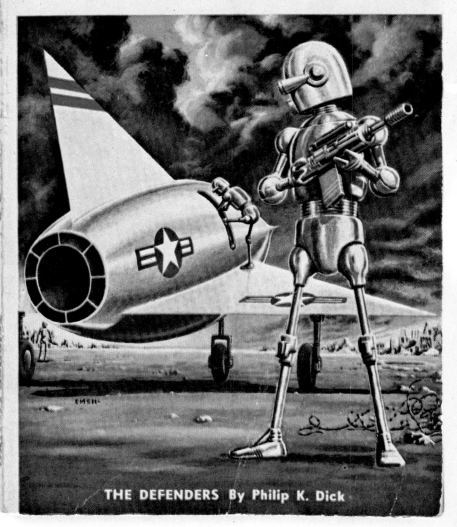

Fantasy and Science Fiction, May 1961 (detail)

Galaxy Science Fiction, January 1953

Brian ★ ★ Lewis

☆ *For a period in the late 'Fifties, the breezy and attractive artwork of Brian Lewis dominated the British Nova magazines, NEW WORLDS, SCIENCE FANTASY and SCIENCE FICTION ADVENTURES (an American magazine which survived its transplant across the Atlantic even after the parent magazine had faded and died).*

One of Lewis's most striking covers was for John Brunner's "Earth is But a Star". Whereas a rather strict representationalism had always been the rule in the United States—a rule successfully defied on occasions by Wesso, Richard Powers, and Emsh—Lewis produced, with editor Carnell's encouragement, a series of semi-abstract covers. Three of them are shown here. They, and others overleaf, have a light wit about them which is rare in magazine work.

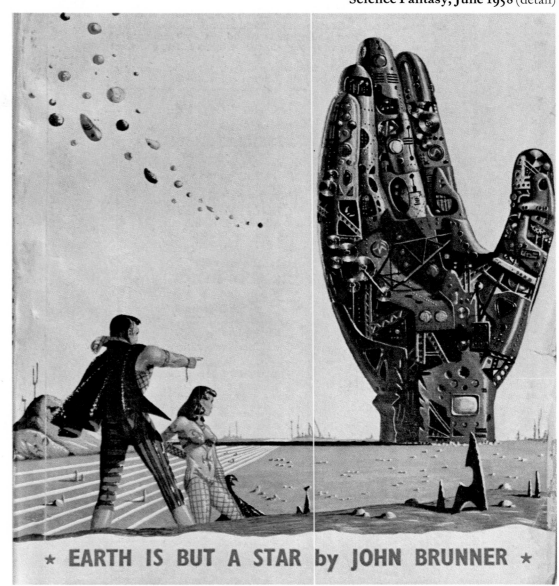

★ EARTH IS BUT A STAR by JOHN BRUNNER ★

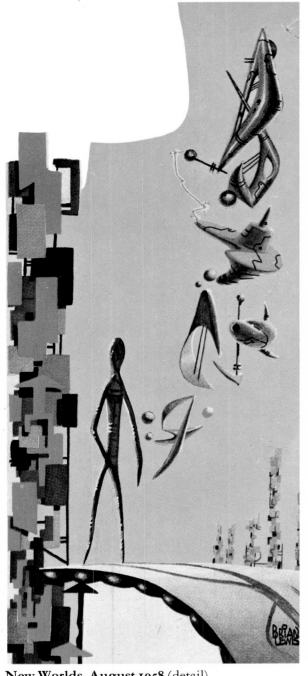

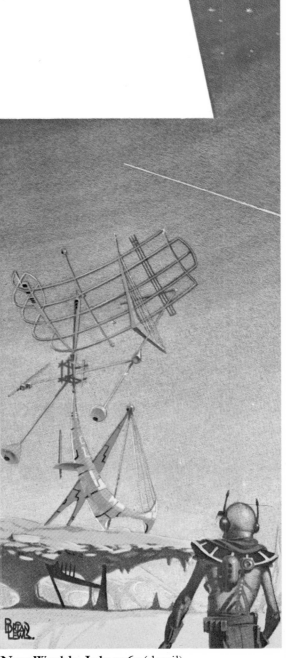

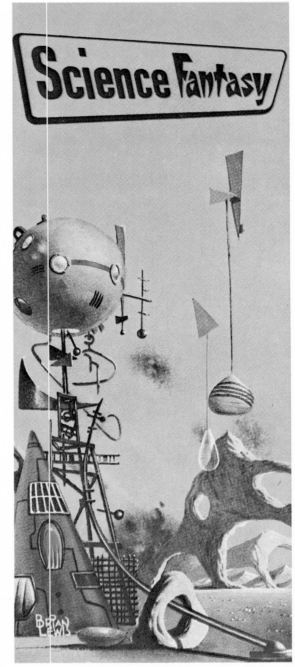

New Worlds, August 1958 (detail)

New Worlds, July 1960 (detail)

Science Fantasy, August 1959 (detail)

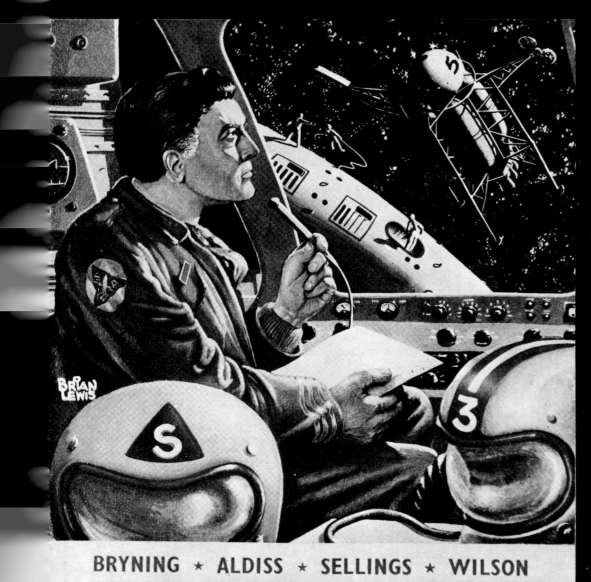

BRYNING ★ ALDISS ★ SELLINGS ★ WILSON

New Worlds Science Fiction, July 1957 (detail)

New Worlds Science Fiction, October 1959 (detail)

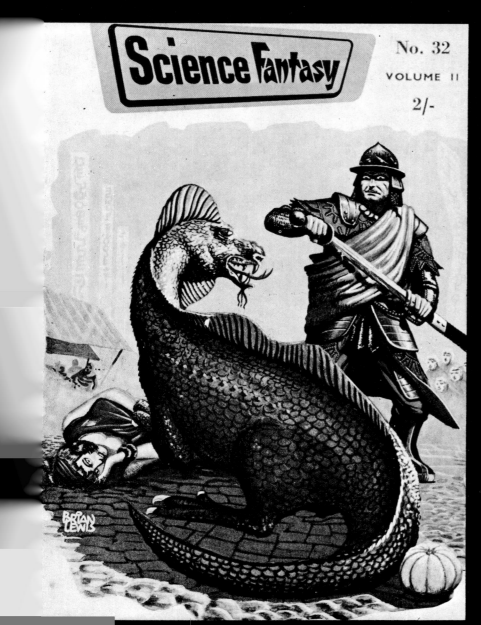

Science Fantasy

No. 32

VOLUME II

2/-

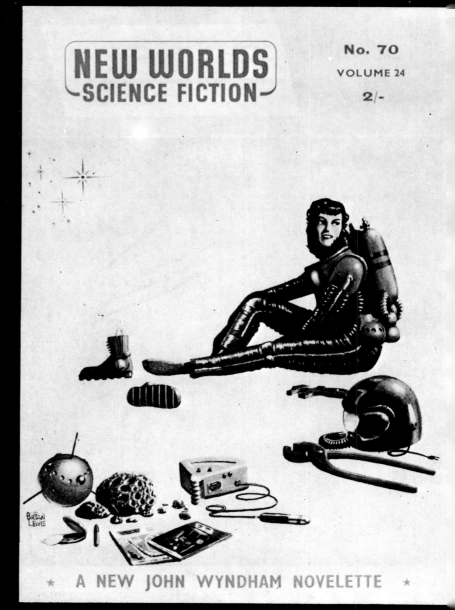

NEW WORLDS
SCIENCE FICTION

No. 70

VOLUME 24

2/-

★ A NEW JOHN WYNDHAM NOVELETTE ★

...asy, Decemł

Alex Schomburg ★

Thrilling Wonder Stories, October 1951

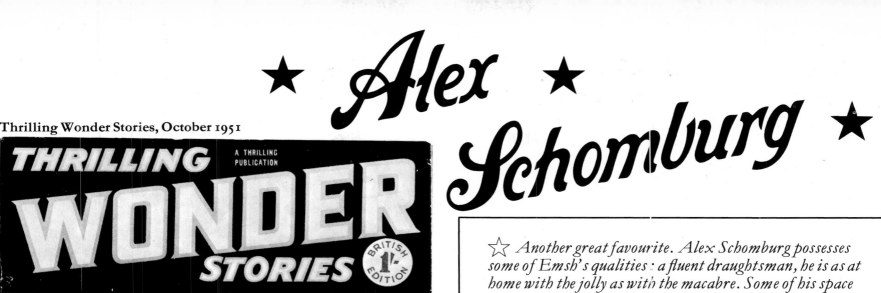

☆ *Another great favourite. Alex Schomburg possesses some of Emsh's qualities : a fluent draughtsman, he is as at home with the jolly as with the macabre. Some of his space scenes—like the beautiful satellite station for* THRILLING WONDER *reproduced here—have an uncluttered modernism which conveys a longing for the machines of the future.*

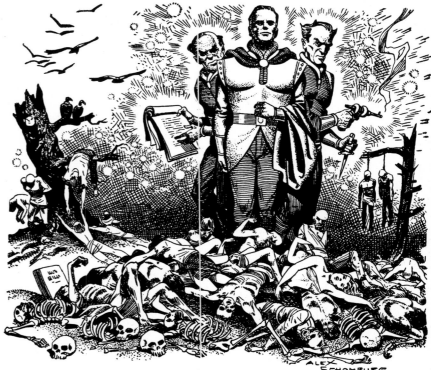

Startling Stories, August 1952
"The Hour of the Mortals" by Kendell Foster Crossen

Thrilling Wonder Stories, December 1952
"The Caphian Caper" by Kendell Foster Crossen

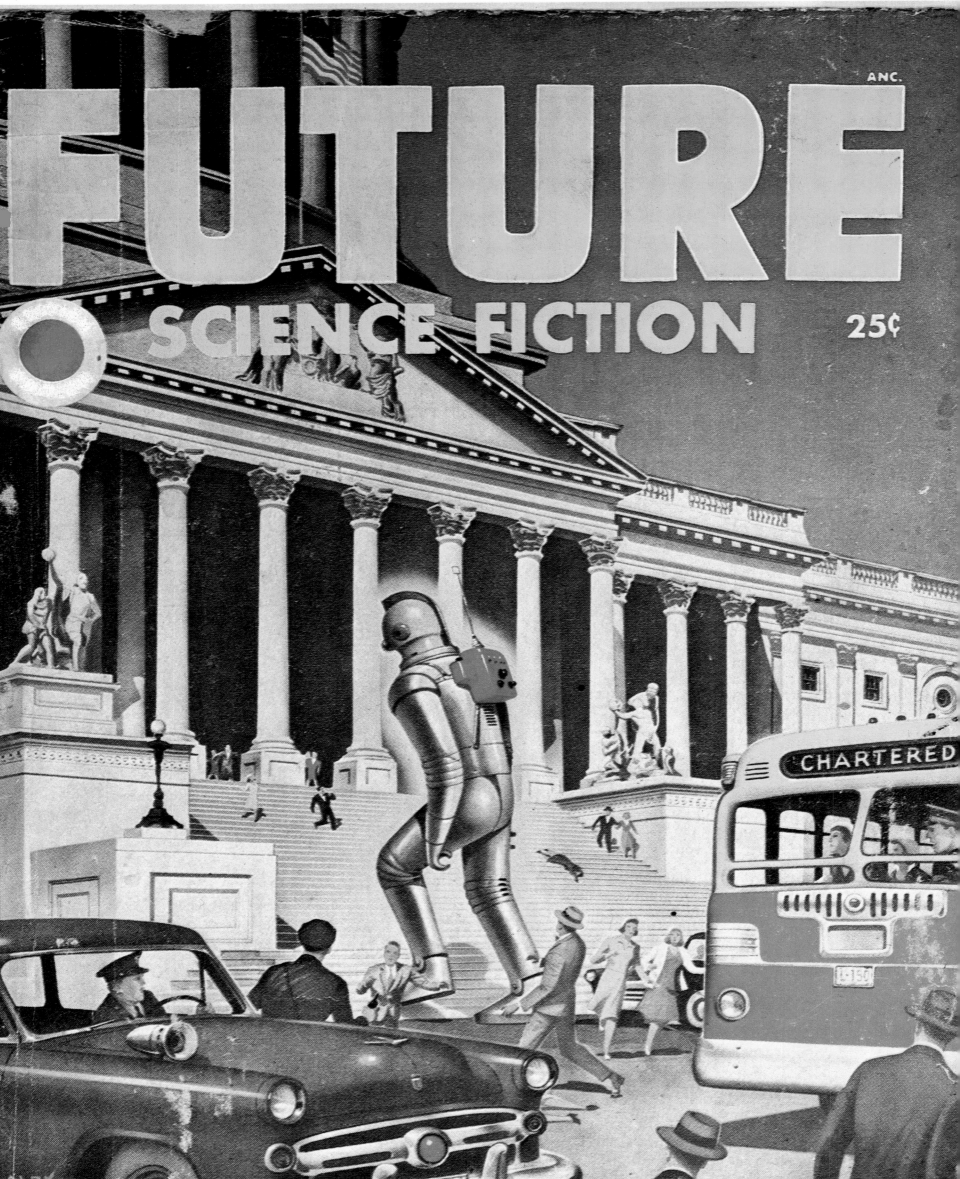

FUTURE
SCIENCE FICTION

25¢

CHARTERED

ULTIMATUM!
by ROBERT SHECKLEY

ALL STORIES NEW

A DOUBLE-ACTION MAGAZINE

R. G. Jones

★ ★ ★ ★ ★

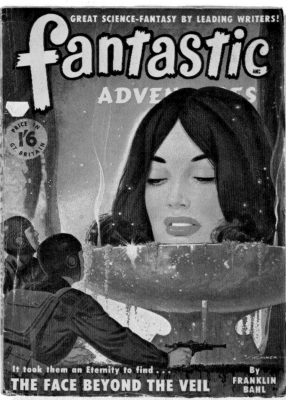

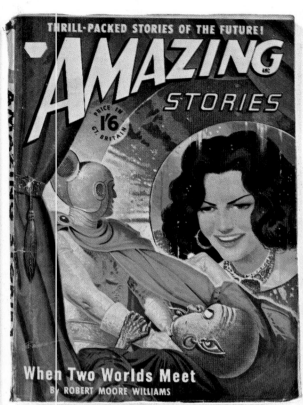

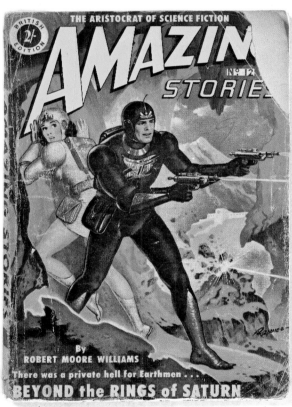

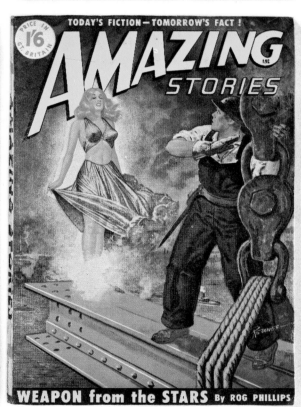

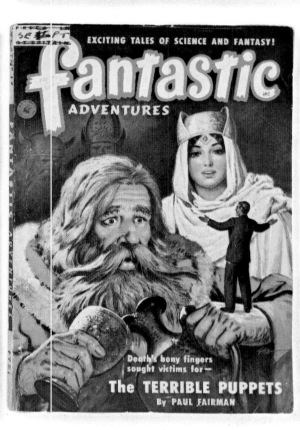

upper row: **Fantastic Adventures, December 1951**

Fantastic Adventures, April 1950

Amazing Stories, April 1950

lower row: **Amazing Stories, March 1951**

Amazing Stories, October 1950

Fantastic Adventures, September 1951

☆ *As dashingly as any artist, Robert Gibson Jones makes champagne of the myth of technological progress: the wish that frontiers far beyond the Moon will yield adventure, power and romance.*

Jones' fantasies on the Sense of Wonder appeared mainly on FANTASTIC ADVENTURES *and* AMAZING STORIES *during the early 'Fifties.*

Virgil Finlay

☆ *Virgil Finlay's was the sensuous approach. Born in 1914, he was self-taught, like many other artists and writers in the sf and fantasy fields. His work first came to notice in WEIRD TALES in the 'Thirties, where he soon took over the cover spot. He was enormously popular and enormously prolific. Despite the demand for his work, Finlay never abandoned the stipple technique which is one of his hallmarks, time-consuming though it was. He died in 1971, but his following continues to grow.*

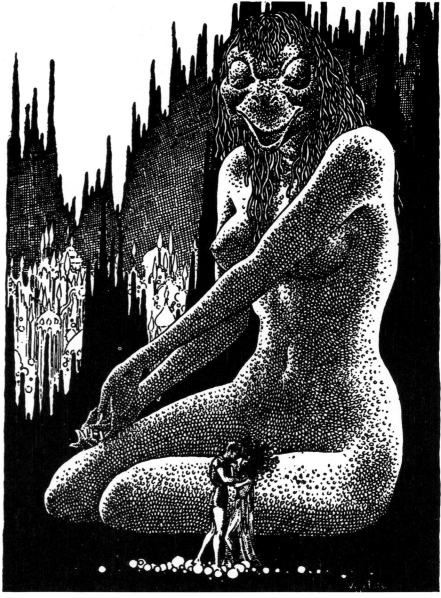

Fantastic Novels, November 1940
"The Snake Mother" by Abraham Merritt

Startling Stories, July 1952
"Passport to Pax" by Kendell Foster Crossen

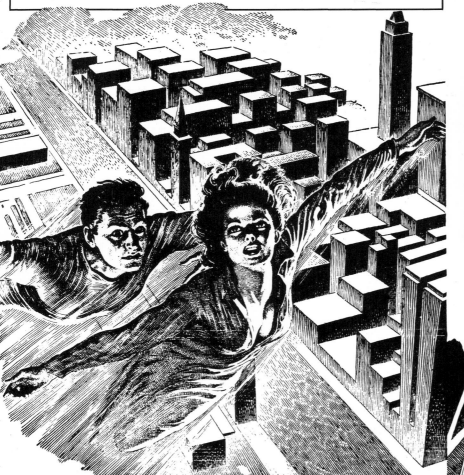

Billions were spent in advertising . . . but the Antareans simply wouldn't buy McFinister Hats! Now it was Jerry Ransom's job to find out why . . .

THINGS OF DISTINCTION
—wear McFinister Hats!

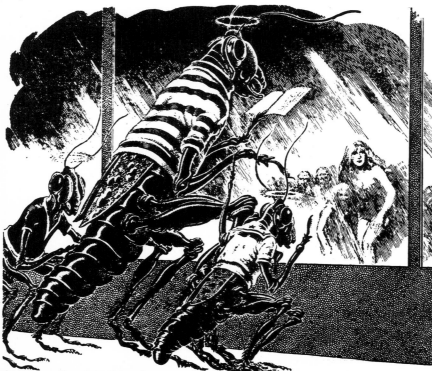

Startling Stories, March 1952
"Things of Distinction" by Kendell Foster Crossen

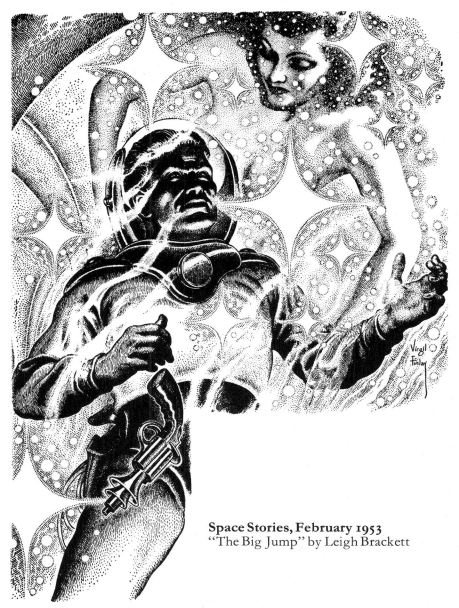

Space Stories, February 1953
"The Big Jump" by Leigh Brackett

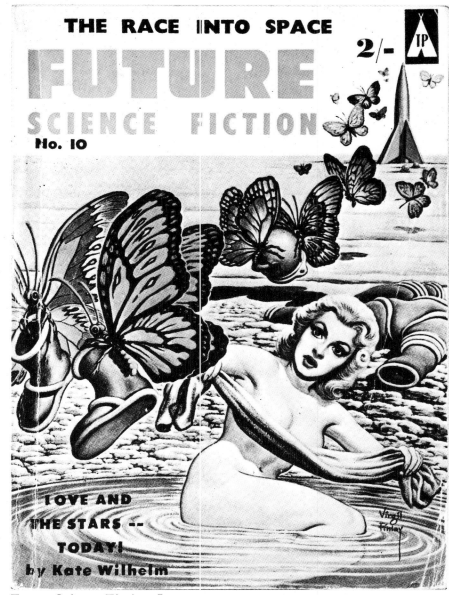

THE RACE INTO SPACE

2/- 1P

FUTURE
SCIENCE FICTION

No. 10

LOVE AND THE STARS -- TODAY!
by Kate Wilhelm

Future Science Fiction, June 1959

Hollywood on the Moon

CHAPTER I

Camera: Ether Eddy

MARE IMBRIUM is the most desolate spot on the Moon. It is a bleak fantastic inferno of jagged rocks and volcanic ash, airless and frigid.

The monotony of the scene is broken only by craters of varying sizes, ominous reminders of the meteors that plunge like bullets through the void, a deadly, ever-present menace to the Earthman hardy enough to venture there. Yet in this lunar no-man's-land two figures in bulky spacesuits were racing desperately toward a high outcropping of stone.

Though apparently nothing pursued them there was stark horror in the glances they threw over their shoulders. One was a girl, her dark hair a cloudy mass within the transparent helmet. The other was a man whose face was curiously expressionless, and whose movements somehow failed to match the animation of the girl's.

Yet when she stumbled and fell he paused and helped her to her feet. About to resume her flight the girl's mouth gaped in an open square of terror. She flung up a pointing glove.

The shining thing had sprung into existence without warning. Its brilliance eclipsed the dim globe of the Earth, low on the horizon, and the white splendor of the stars.

It seemed to be a gigantic shell of flame, spinning madly in a blaze of glaring colors, the poles of its axis elongated into two thin

A Hall of Fame Novelet by
HENRY KUTTNER

Drive along Lunar Boulevard and dine at the Silver Spacesuit with Tony Quade, cinema expert of the future!

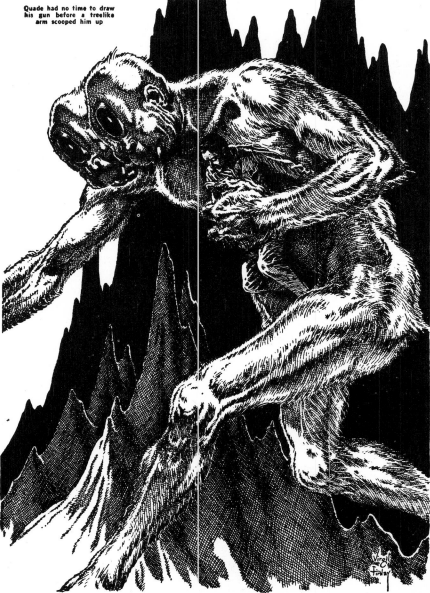

Quade had no time to draw his gun before a treelike arm scooped him up

Startling Stories, July 1949

Chesley ★ ★ ★ *Bonestell*

☆ *The fuzzy red supergiant of a sun lowering on the horizon is Antares. The view is from a hypothetical planet about 3240 million miles from the primary.*

Chesley Bonestell specialises in astronomical paintings which observe all the scientifically established facts.

Although he painted some covers for ASTOUNDING, *his highly finished work appeared mainly in such magazines as* COLLIER'S *and* LIFE. *There have been several books which include his art, most notably* THE CONQUEST OF SPACE *(1949), with Willy Ley.*

Beyond the Solar System (1964) by Chesley Bonestell & Willy Ley

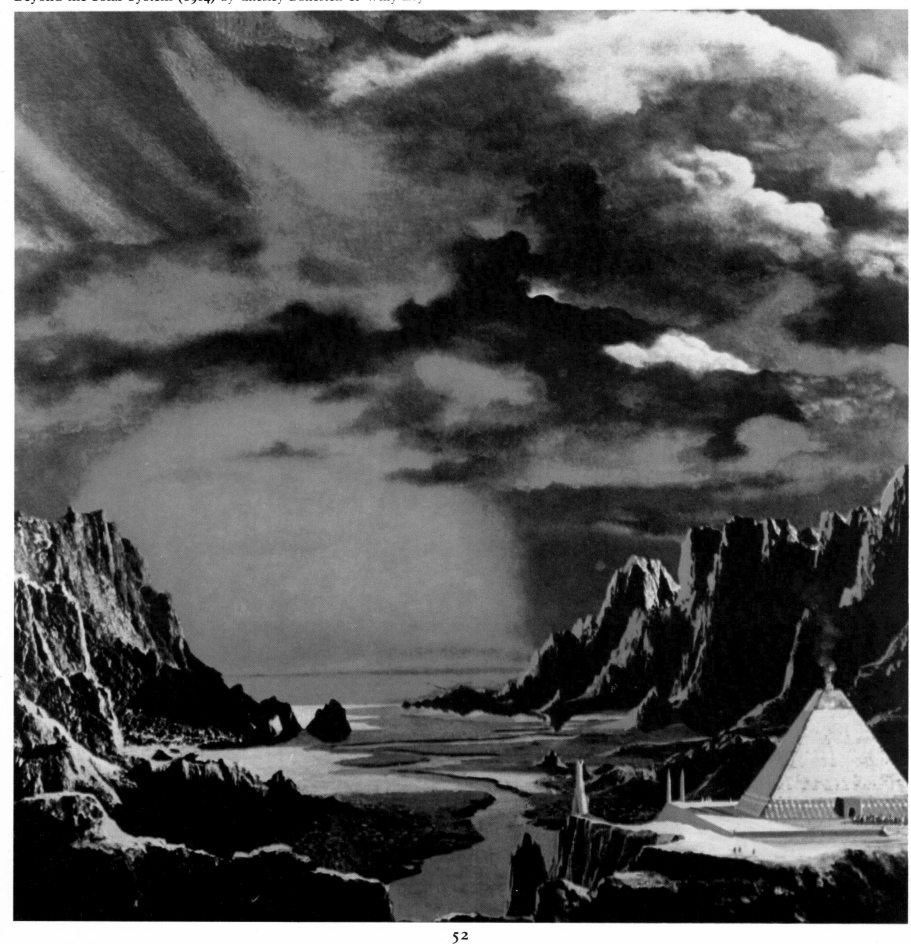

Raymon ★ ★ Naylor

☆ "Queen of the Panther World"! Titles are more restrained nowadays. This short novel by Berkeley Livingston featured a planet where women ruled. The interior illustrations, full of verve, were by Rod Ruth at his most inspired. Raymon Naylor's equally spirited cover marks one of his rare appearances.

Ruth and Naylor seem to have worked almost exclusively for AMAZING and FANTASTIC ADVENTURES.

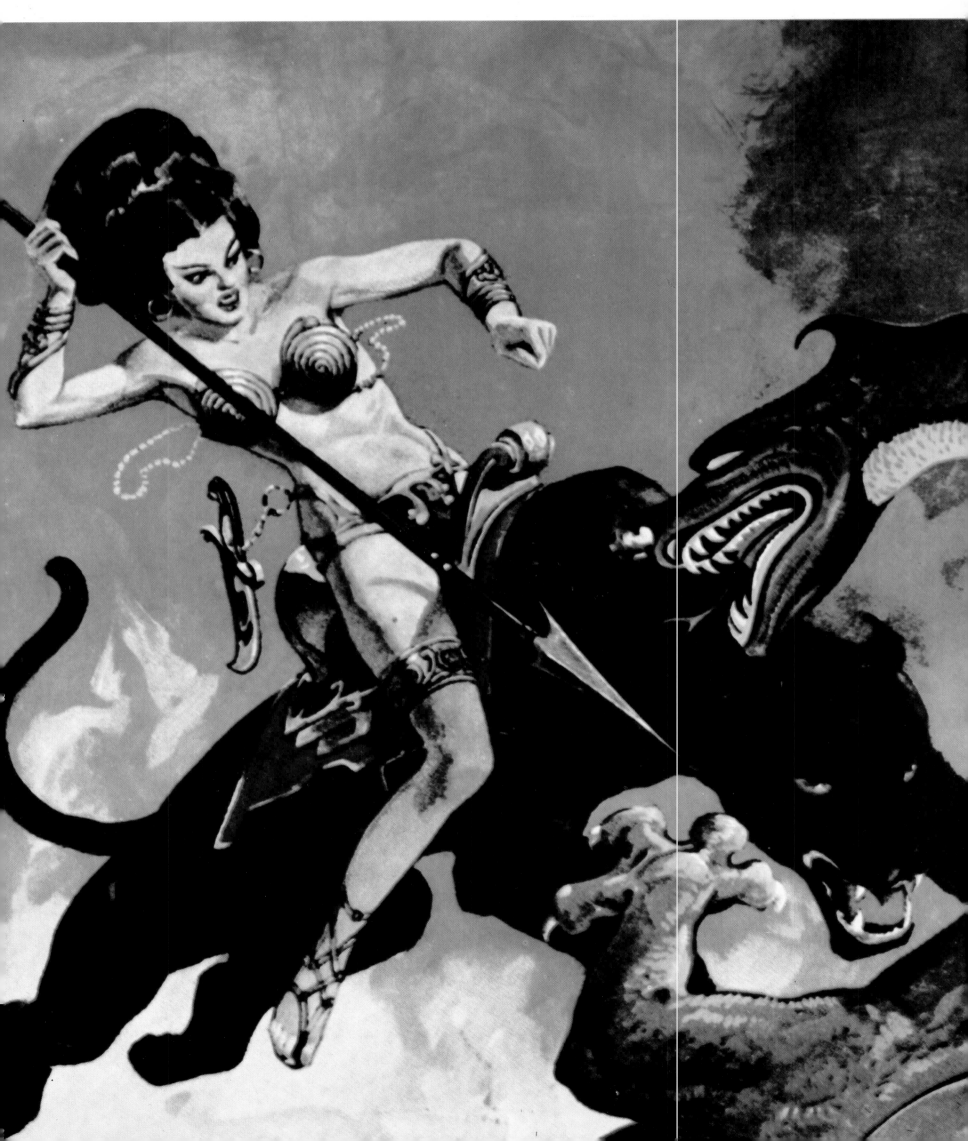

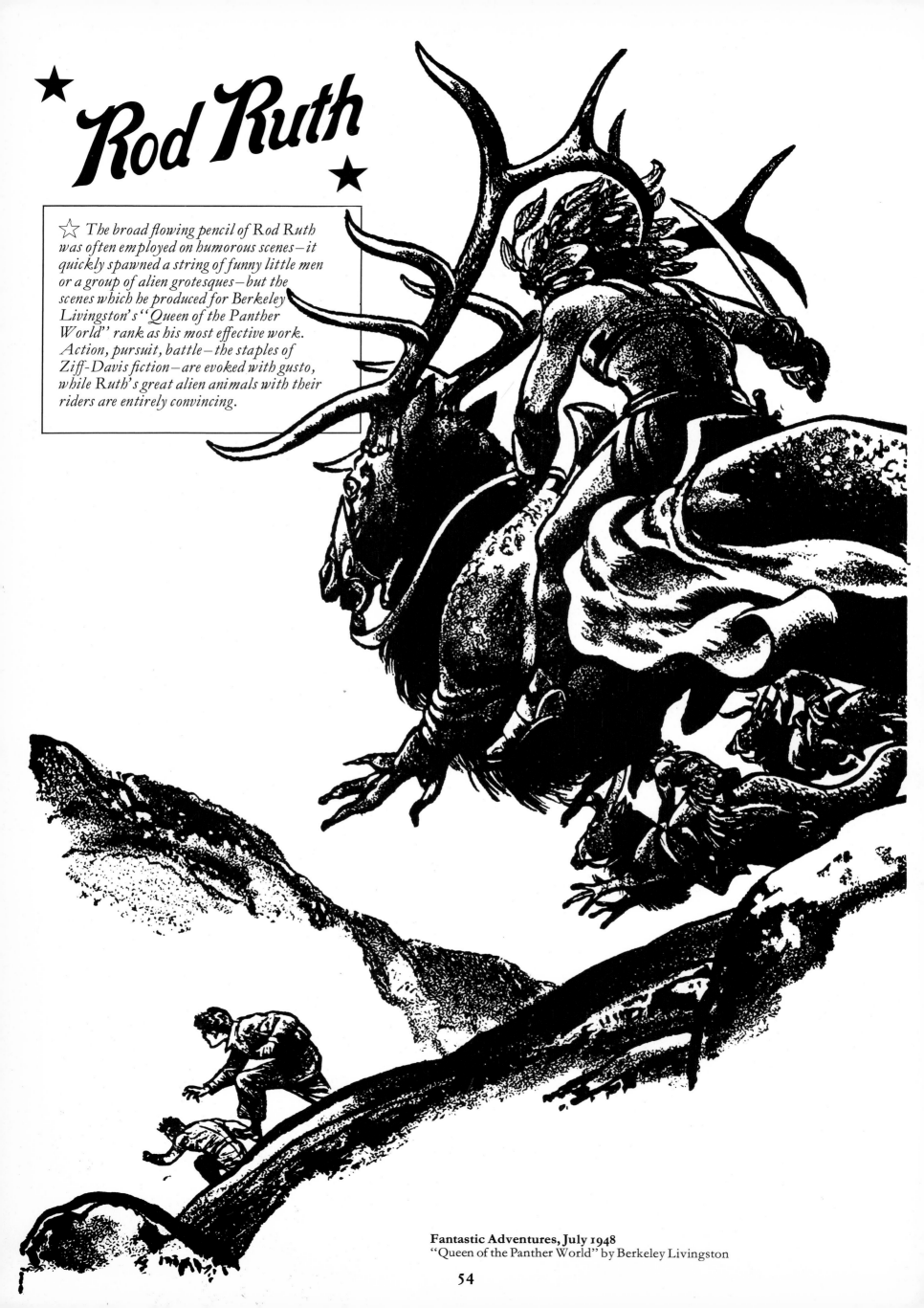

★ Rod Ruth ★

☆ *The broad flowing pencil of Rod Ruth was often employed on humorous scenes—it quickly spawned a string of funny little men or a group of alien grotesques—but the scenes which he produced for Berkeley Livingston's "Queen of the Panther World" rank as his most effective work. Action, pursuit, battle—the staples of Ziff-Davis fiction—are evoked with gusto, while Ruth's great alien animals with their riders are entirely convincing.*

Fantastic Adventures, July 1948
"Queen of the Panther World" by Berkeley Livingston

54

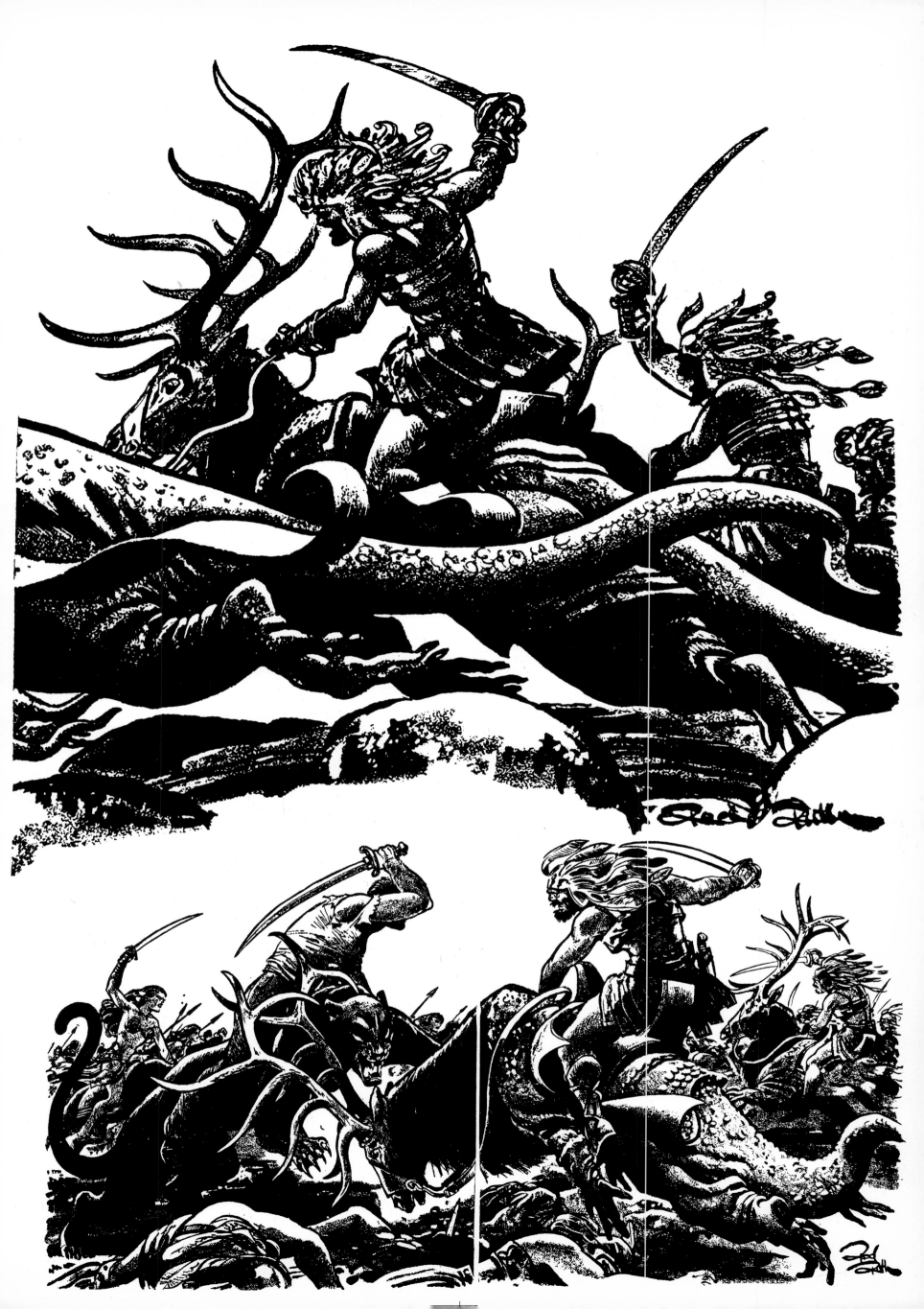

★ Orban ★

Startling Stories, July 1949
"The Unwilling Hero" by René LaFayette

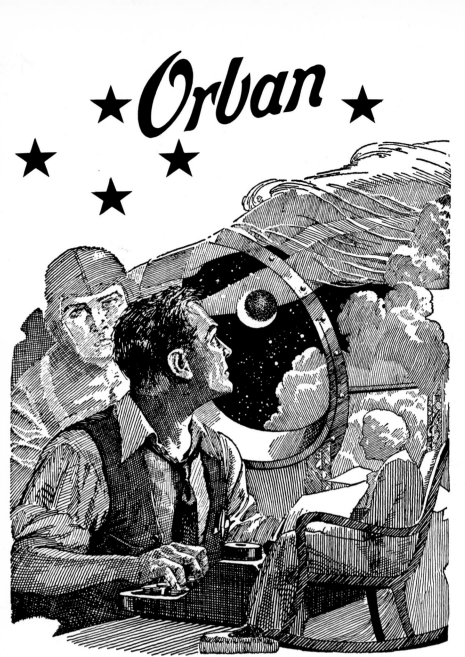

☆ *Paul Orban was an incurable romantic in a field of incurable romantics. Under the trappings of technology, he expressed more perennial things—unending quests, great aspirations, long farewells and a welcoming pair of arms on the far side of light. His helmeted figures and scantily dressed damosels did much to welcome many readers into science fiction. Much of his work appeared in the Street & Smith magazines including* THE SHADOW.

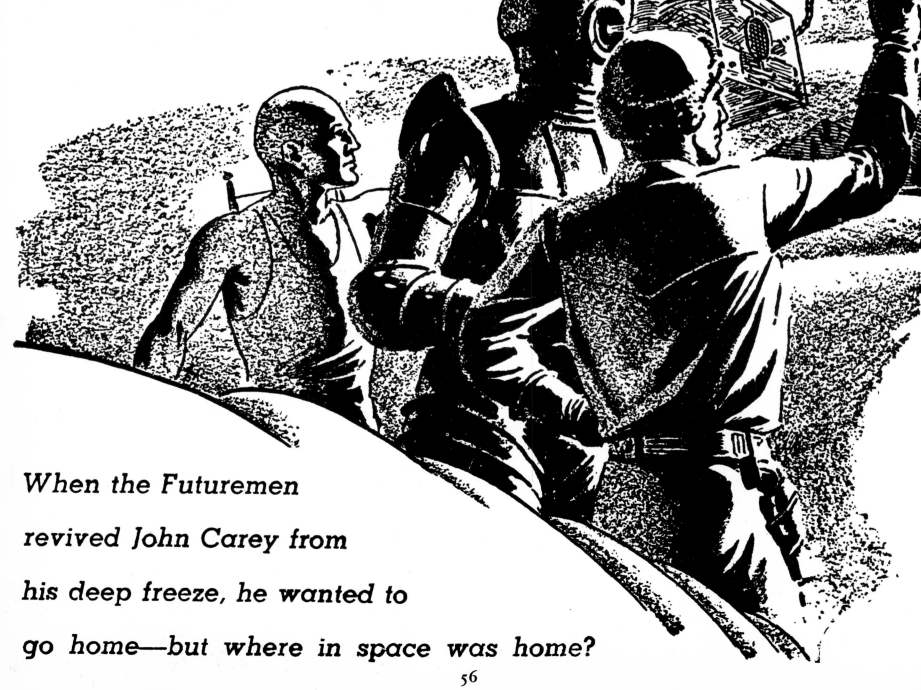

When the Futuremen revived John Carey from his deep freeze, he wanted to go home—but where in space was home?

**Startling Stories,
March 1951**
"Earthmen No More"
by Edmond Hamilton

**Astounding Science Fiction,
May 1948**
"The Rull"
by A. E. Van Vogt

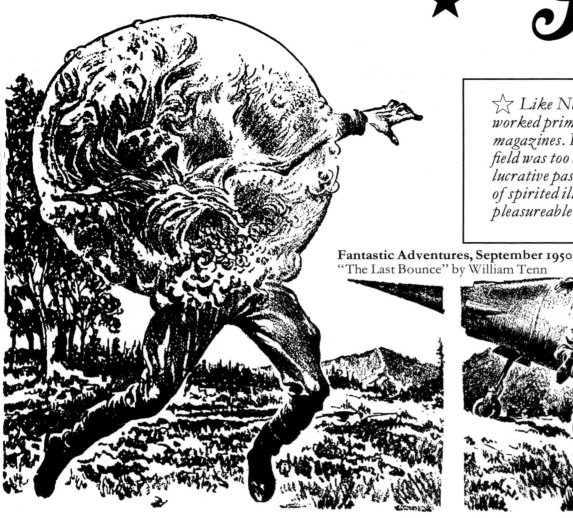

Like Naylor and Ruth, Henry Sharp worked primarily for the Ziff-Davis magazines. His stay in the science fantasy field was too brief. He moved on to more lucrative pastures, leaving behind a number of spirited illustrations which relied to a pleasureable degree on bare female flesh.

Fantastic Adventures, September 1950
"The Last Bounce" by William Tenn

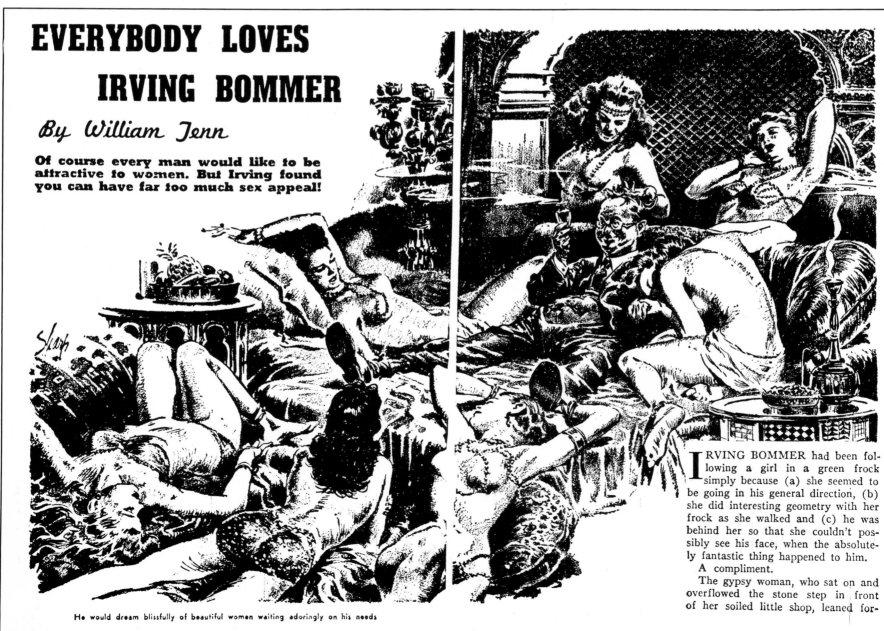

EVERYBODY LOVES IRVING BOMMER

By William Tenn

Of course every man would like to be attractive to women. But Irving found you can have far too much sex appeal!

He would dream blissfully of beautiful women waiting adoringly on his needs

IRVING BOMMER had been following a girl in a green frock simply because (a) she seemed to be going in his general direction, (b) she did interesting geometry with her frock as she walked and (c) he was behind her so that she couldn't possibly see his face, when the absolutely fantastic thing happened to him.

A compliment.

The gypsy woman, who sat on and overflowed the stone step in front of her soiled little shop, leaned for-

In the old days, fans were more puritanical than now. They were not sure how much titillation they wanted in their science fiction. Sharp was. But his illustration for Arnette's "Empire of Evil" merely follows the tone of the story, which begins in this appetising way:

"A blue Mercurian, arrogance in every line of his shell-covered body, was leading a white Earth-girl up the street. The Earth-girl was practically naked. She walked with head bent, shoulders drooping—a creature without hope. The rope around her slender waist, by which the Mercurian hauled her along, had raised a cruel, circular abrasion on her otherwise brown skin."

Now read on . . .

Amazing Stories, January 1951
"Empire of Evil" by Robert Arnette

Fantastic Adventures, June 1951
"The Brain That Lost Its Head" by Alfred Coppel

The catwalk twisted and writhed, and Meek looked down to find it had become a snake

★ *Stark* ★

☆ *Brief-lived but beloved by its readers, NEBULA (RIP, 1959) was Scotland's only sf magazine. It featured art work by many British artists, Alan Hunter, Quinn, Eddie Jones and Arthur Thomson among them. These brilliant and sterile visions by James Stark succeed in capturing the dream of a clean technology, born in the arid wastes of other worlds.*

NEBULA BI-MONTHLY 2/- SCIENCE FICTION NUMBER 18

November 1956

SIX TOP-LINE SCIENCE FICTION STORIES

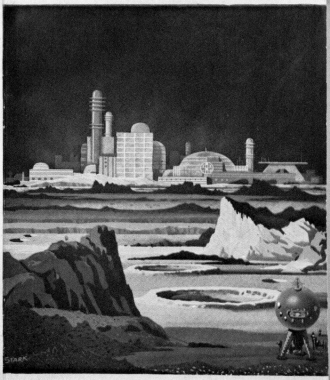

NEBULA BI-MONTHLY 2/- SCIENCE FICTION NUMBER 19

December 1956

SEVEN TOP-LINE SCIENCE FICTION STORIES

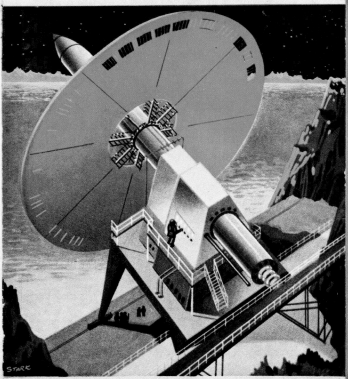

NEBULA MONTHLY 2/- SCIENCE FICTION NUMBER 21

May 1957

Stories by ERIC FRANK RUSSELL, BRIAN W. ALDISS, Etc.

NEBULA MONTHLY 2/- SCIENCE FICTION NUMBER 32

July 1958

NEW FOUR PART SERIAL BY KENNETH BULMER

★ Lawrence ★

Fantastic Novels, September 1948

☆ *Stephen Lawrence's real name was Lawrence Sterne Stevens. Most of his cover-work appeared on* FAMOUS FANTASTIC MYSTERIES *and* FANTASTIC NOVELS. *His début had been as a stand-in for Finlay, but he soon attracted a following of his own, on the strength of his excellent macabre work. The magazines accorded him and Finlay the unusual honour of issuing folios of their work which are now hard to come by.*

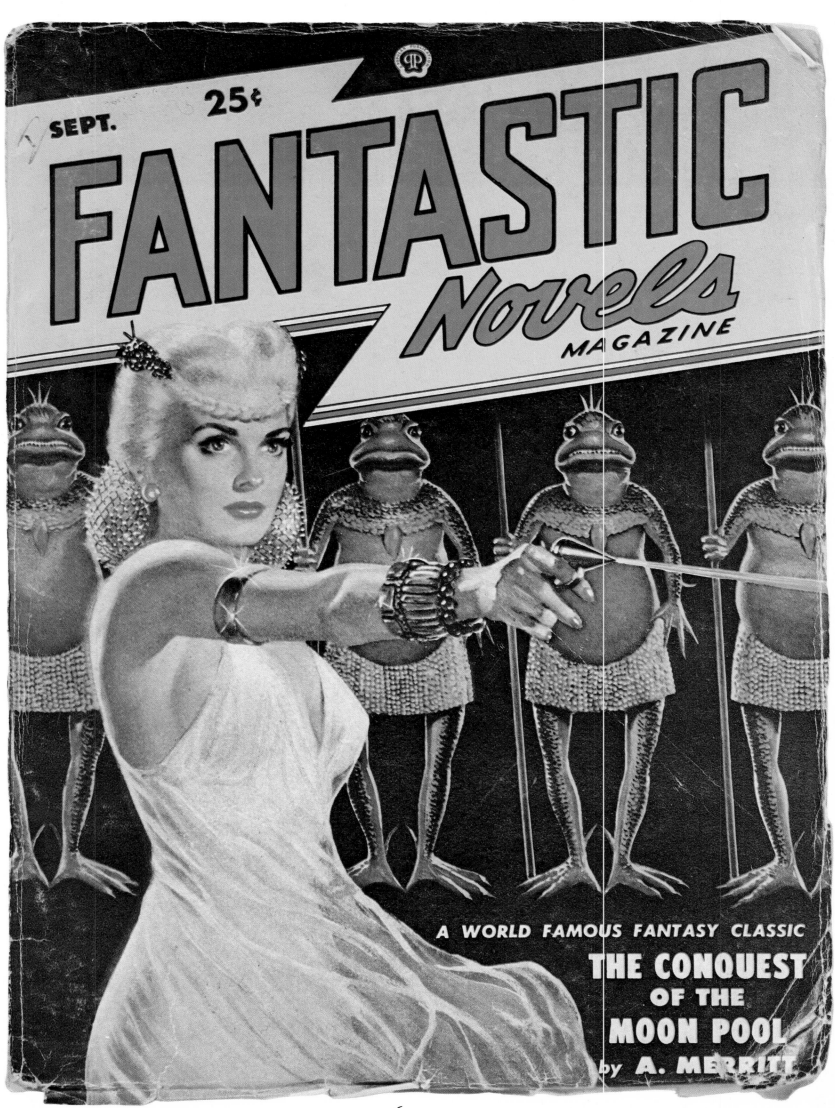

SEPT. 25¢

FANTASTIC

Novels
MAGAZINE

A WORLD FAMOUS FANTASY CLASSIC
THE CONQUEST OF THE MOON POOL
by A. MERRITT

Great Comic Strips

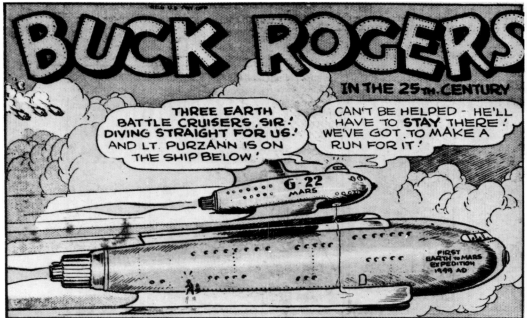

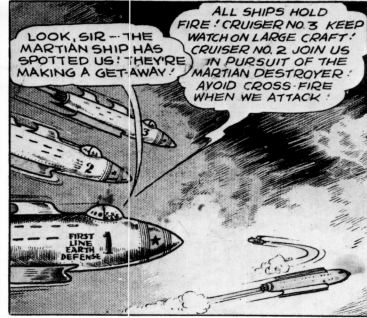

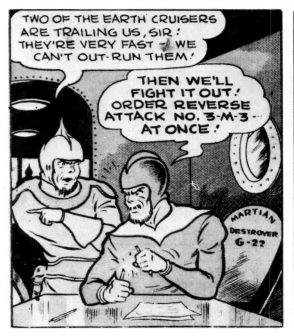

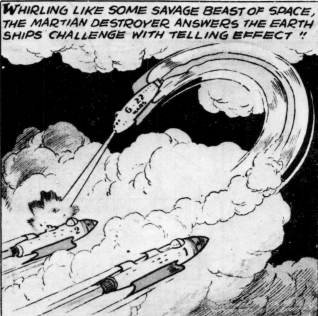

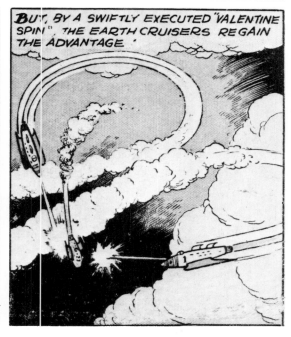

The "Buck Rogers", "Flash Gordon" and "Superman" strips were a feature of every good American childhood — not to mention less-favoured parts of the globe.

Alex Raymond's sensuous line and colour harmonies were the essence of his strip. The story-line of "Flash Gordon" is somewhat soppy. In many respects it is pure Ruritanian romance, but Raymond's style, together with the arrangement of his page and the exotic locations he depicted built him a great following. In the history of the comic strip, "Flash Gordon" holds an honoured place.

The influence of "Buck Rogers" on the sf field is even more direct. Dick Calkins' spaceships had an impact on the style of space-ships elsewhere (see for instance the STARTLING STORIES cover on page 68). The strip lasted from 1929 to 1968 and was born of two novellas on a Yellow Peril theme by Philip Francis Nowlan. The artwork, by Dick Calkins, was at its most professional during the 'Forties, when another artist, Rick Yager, was credited with Calkins.

Both "Buck Rogers" and "Flash Gordon" have been filmed, while the original strips have been collected in volume form.

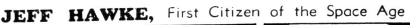

JEFF HAWKE, First Citizen of the Space Age by SYDNEY JORDAN

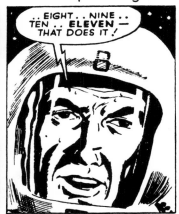

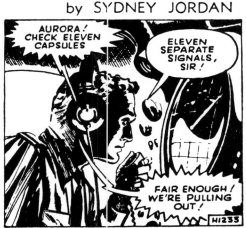

JEFF HAWKE, First Citizen of the Space Age by SYDNEY JORDAN

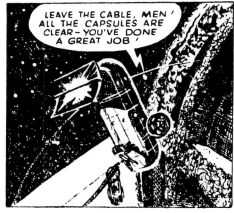

Jeff Hawke (1956) by Sydney Jordan

Superman (1942) by Jerry Siegel & Joe Shuster

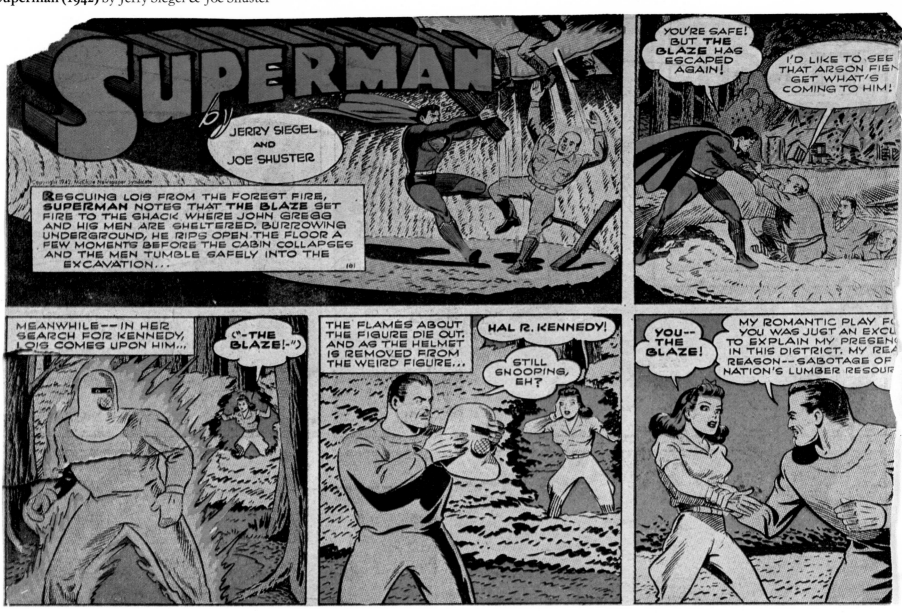

Dan Dare, Pilot of the Future (1950) by Frank Hampson

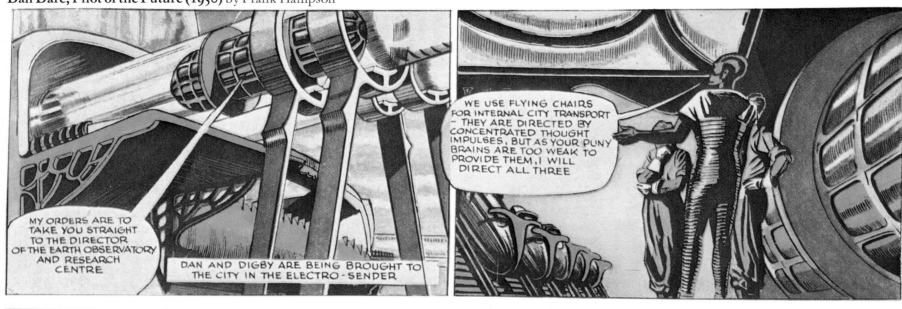

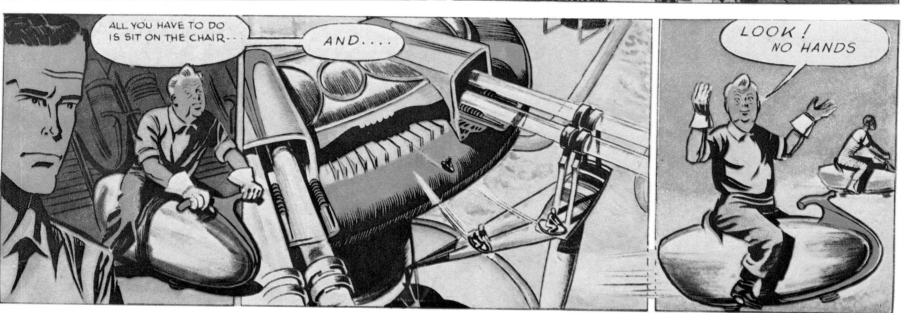

Both "Dan Dare" and "Jeff Hawke" are British strips. Dan appeared in colour in EAGLE, a boy's comic of the 'Fifties, with artwork mainly by Frank Hampson. It was more humorous than its American counterparts and served to direct many youthful enthusiasts to science fiction.

"Jeff Hawke" ran in a national daily newspaper, the DAILY EXPRESS. Cramped format and poor reproduction did little justice to Sydney Jordan's draughtsmanship. Probably the most• adult of sf's many strips, "Hawke" (page 63) introduced to an unversed audience such themes as anti-matter.

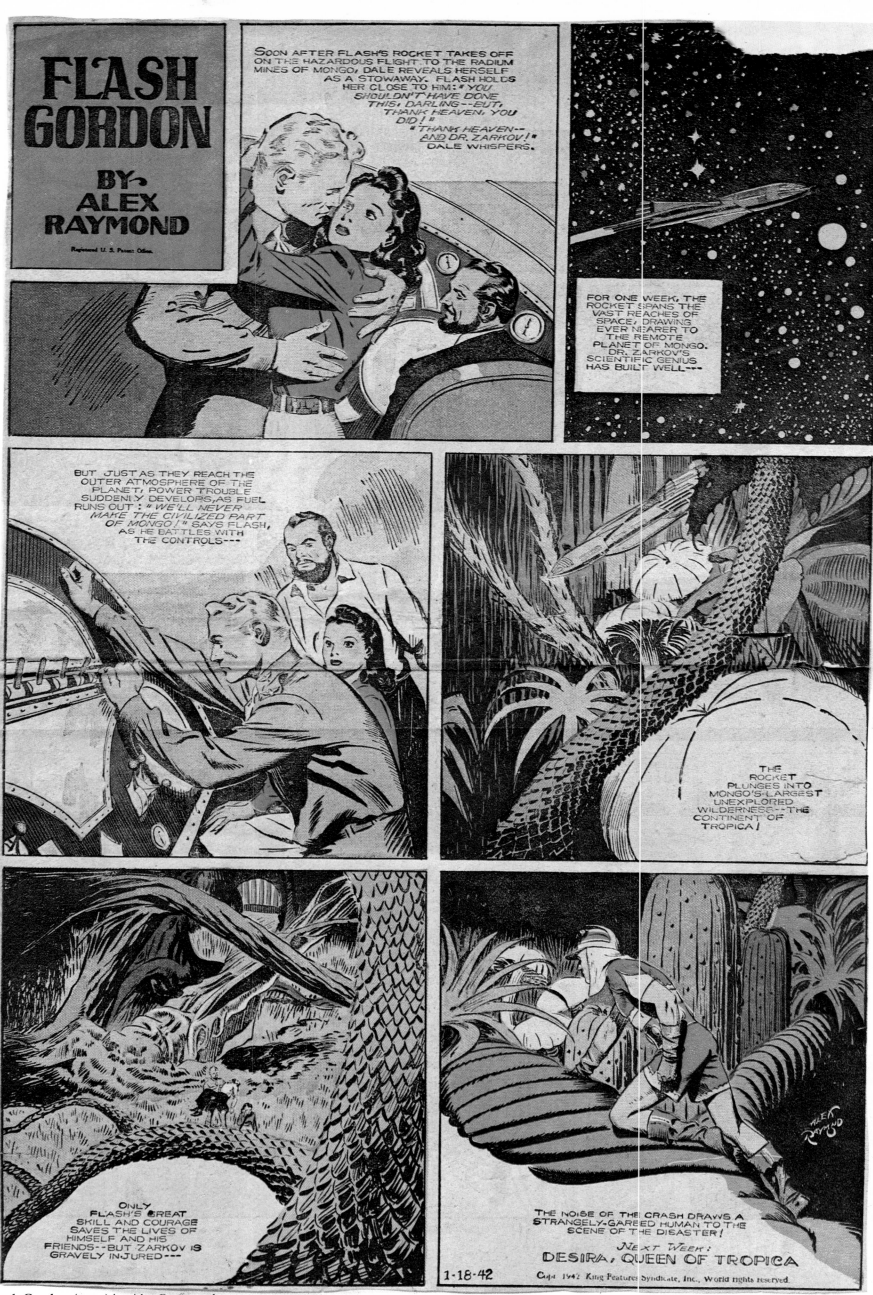

Flash Gordon (1942) by Alex Raymond

Themes in Science Fiction

Looking back from the 'Seventies, we see the earlier years of magazine sf as enclosing a comparatively small world. Indeed, ever since Hugo Gernsback launched his Science Fiction League, sf has exhibited some of the features of a secret movement.

One of the effects of this was to force writers, artists, editors and readers to conspire together in something like a collaborative effort. Many fans grew up to become writers, editors, artists, agents, critics or publishers – and sometimes all of these in turn.

Consequently, we find various themes developing, altering with the times but forming part of a dialogue which still continues and is such a striking feature of science fiction. Of the plethora of pulp periodicals, the sf magazines have proved the hardiest, the longest-lived; those that survive face ailing circulations in the main. But the sf field remains remarkably cohesive, its cohesion aided by frequent conventions and symposia all over the world.

On the following pages are presented some of the great sf themes on which many brilliant visual variations have been played. The array is far from being definitive, but it does indicate how various myths and obsessions continue to dominate the field.

My briefest-ever definition of science fiction is "Hubris clobbered by Nemesis". Catastrophe in many forms is a perennial theme in the genre.

On these pages, a British and an American artist – S. Drigin and Hubert Rogers – wreck their capital cities. The city has proved as indestructible a symbol as the rocket ship, but there's always fun in watching the Empire State Building suffer one more indignity.

In Drigin's picture, the lights of Piccadilly have attracted gigantic interstellar moths. Only jets of liquid plaster-of-paris can annihilate their progeny. A year or so later, those same old-fashioned London fire-engines were dealing with a real threat from the skies: Hitler's Luftwaffe.

DELIGHTFUL DOOMSDAYS

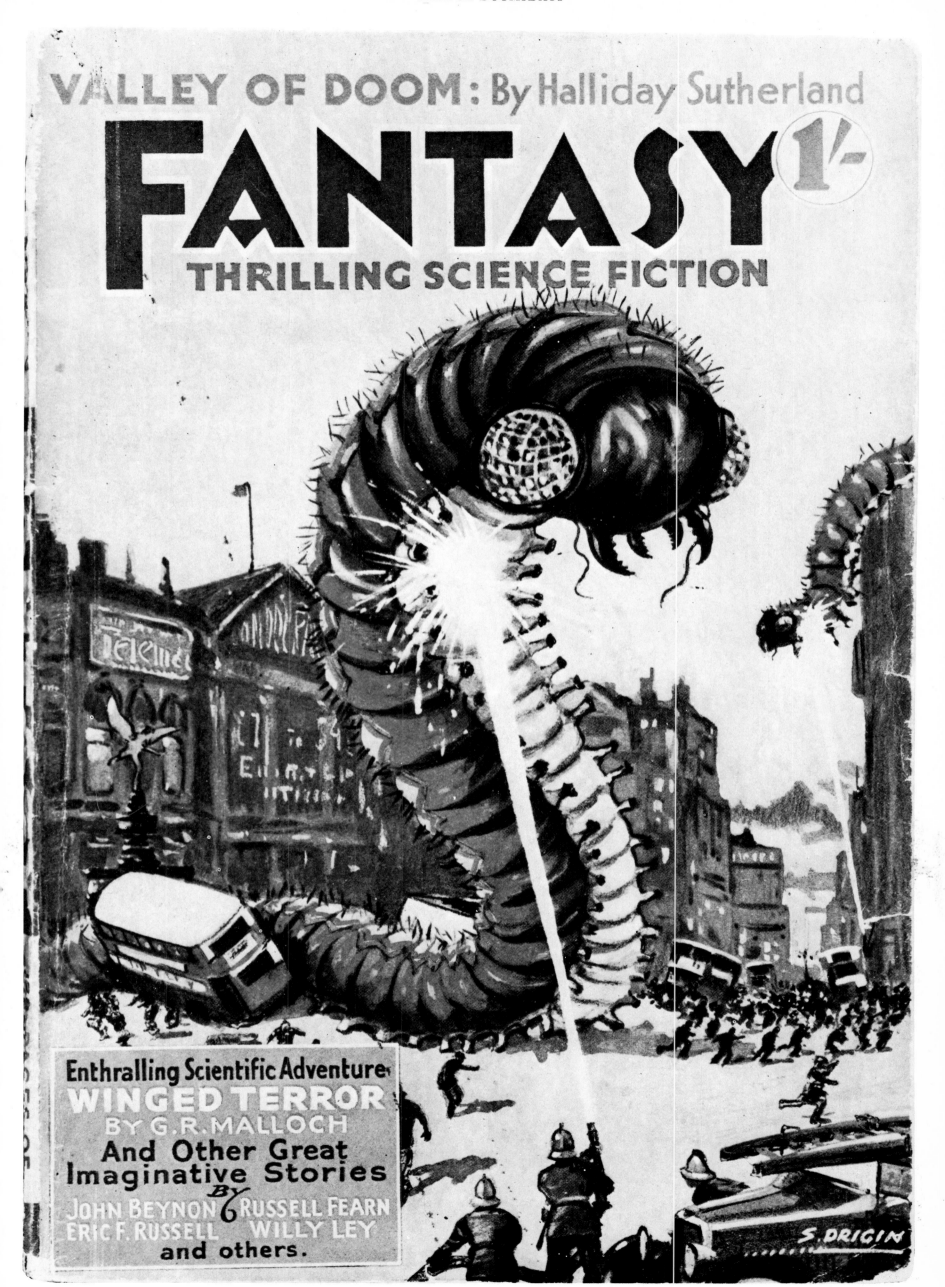

A NOVEL OF THE FUTURE COMPLETE IN THIS ISSUE!

STARTLING STORIES

NOV.

15¢

ARK OF SPACE

A THRILLING PUBLICATION

THE FORTRESS OF UTOPIA By JACK WILLIAMSON

A MARTIAN ODYSSEY By STANLEY G. WEINBAUM

Startling Stories, November 1939 (Howard V. Brown)

Fantastic Stories of Imagination, October 1961 (Alex Schomburg)

opposite page: **Marvel Stories, April 1941** (J. W. Scott)

Amazing Stories, March 1961 (Leo Summers)

Suppose there were another flood. Suppose there were another world war. Suppose we were invaded by men two hundred feet high. Sf is a language of supposition.

Lawrence was much possessed by images of death. In his illustration, the Grim Reaper comes for Adolf Hitler and confronts him with a world full of corpses created by the Third Reich – a remarkable composition drawn before the Nazi war ended, and published as the world was learning about the concentration camps.

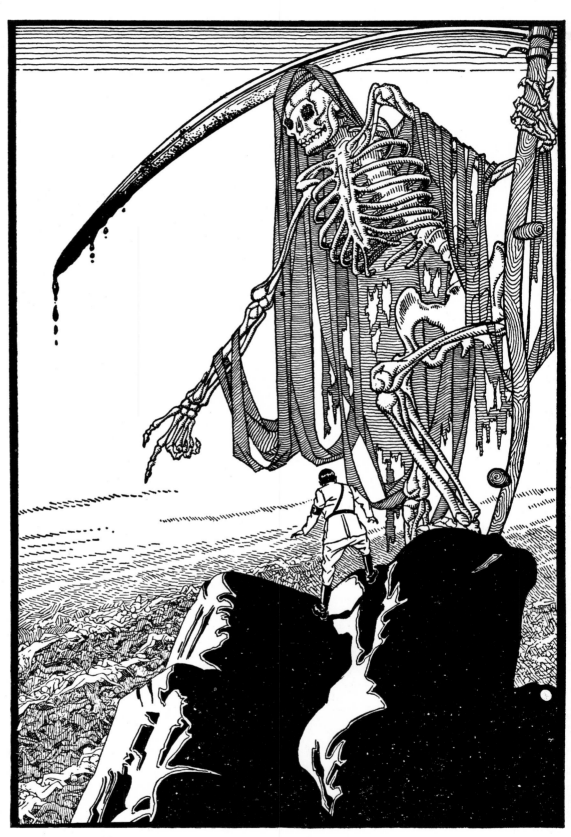

Famous Fantastic Mysteries, September 1945
"Heaven Only Knows" by Joe Archibald

Amazing Stories, March 1939
"The Raid From Mars" by Miles J. Breuer
(Robert Fuqua)

MARVEL STORIES

15¢

APRIL

LAST SECRET WEAPON

unusual book-length science novel by POLTON CROSS

THE THOUGHT MACHINE
by RAY CUMMINGS

PLUS OTHER GREAT STORIES

IRC'S GOD smashing feature novel JACK WILLIAMSON

VACUUM-BUSTERS

It would have been easy to fill this book with rockets and men who rode in them, the knights of the paper spaceships.

Opposite, looking like some fascist secret policeman, is Rogers' version of the Grey (or Gray!) Lensman, with the lens of Arisia glowing on his wrist.

Quinn's cover for the short-lived VISION OF TOMORROW shows his sense of style, as well as a feeling for colour.

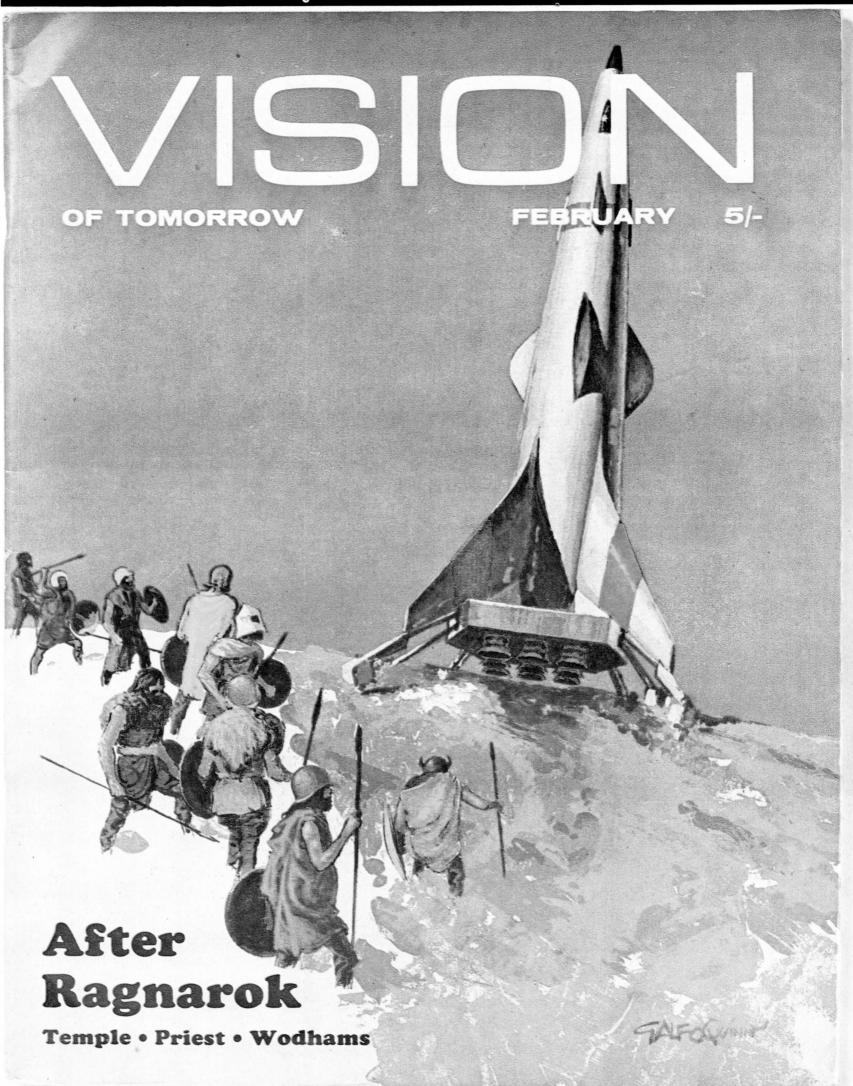

VISION
OF TOMORROW FEBRUARY 5/-

After
Ragnarok

Temple • Priest • Wodhams

Vision of Tomorrow, February 1970

opposite page: **Astounding Science Fiction, October 1939**

ASTOUNDING

SCIENCE-FICTION

A STREET & SMITH PUBLICATION

20¢

OCT. 1939

"SKYLARK" SMITH

"GREY LENSMAN"
by E. E. SMITH, Ph.D.

LORD of a THOUSAND SUNS

A Man without a World, this 1,000,000-year-old Daryesh! Once Lord of a Thousand Suns, now condemned to rove the spaceways in alien form, searching for love, for life, for the great lost Vwyrdda.

Planet Stories, September 1951
"Lord of a Thousand Suns" by Poul Anderson

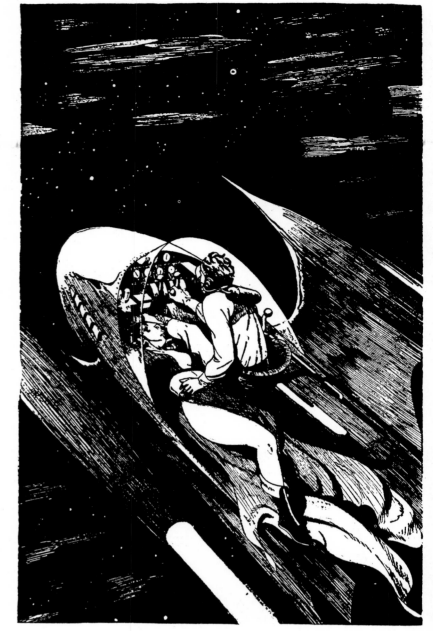

Vestal's space pilot is having the best of several worlds.

A lust for the gigantic is endemic in sf. John Schoenherr, one of the best of the later artists on ANALOG (ex-ASTOUNDING), conveys a sense of the vast with his rocket ship.

Bob Clothier's highly stylised cover for an early NEW WORLDS depicts spaceship repair in deep space. An effective economy of printing colour was used: red, yellow and blue inks only.

THE MESSAGE
"Stupid" means the failure to learn from experience. And one of the lessons he had learned was the useful one that if an answer is sufficiently way-out wrong, it can be right!

PIERS ANTHONY *and* FRANCES HALL
Illustrated by John Schoenherr

Analog, July 1966 "The Message" by Piers Anthony & Francis Hall

opposite page: **New Worlds Science Fiction, March 1953**

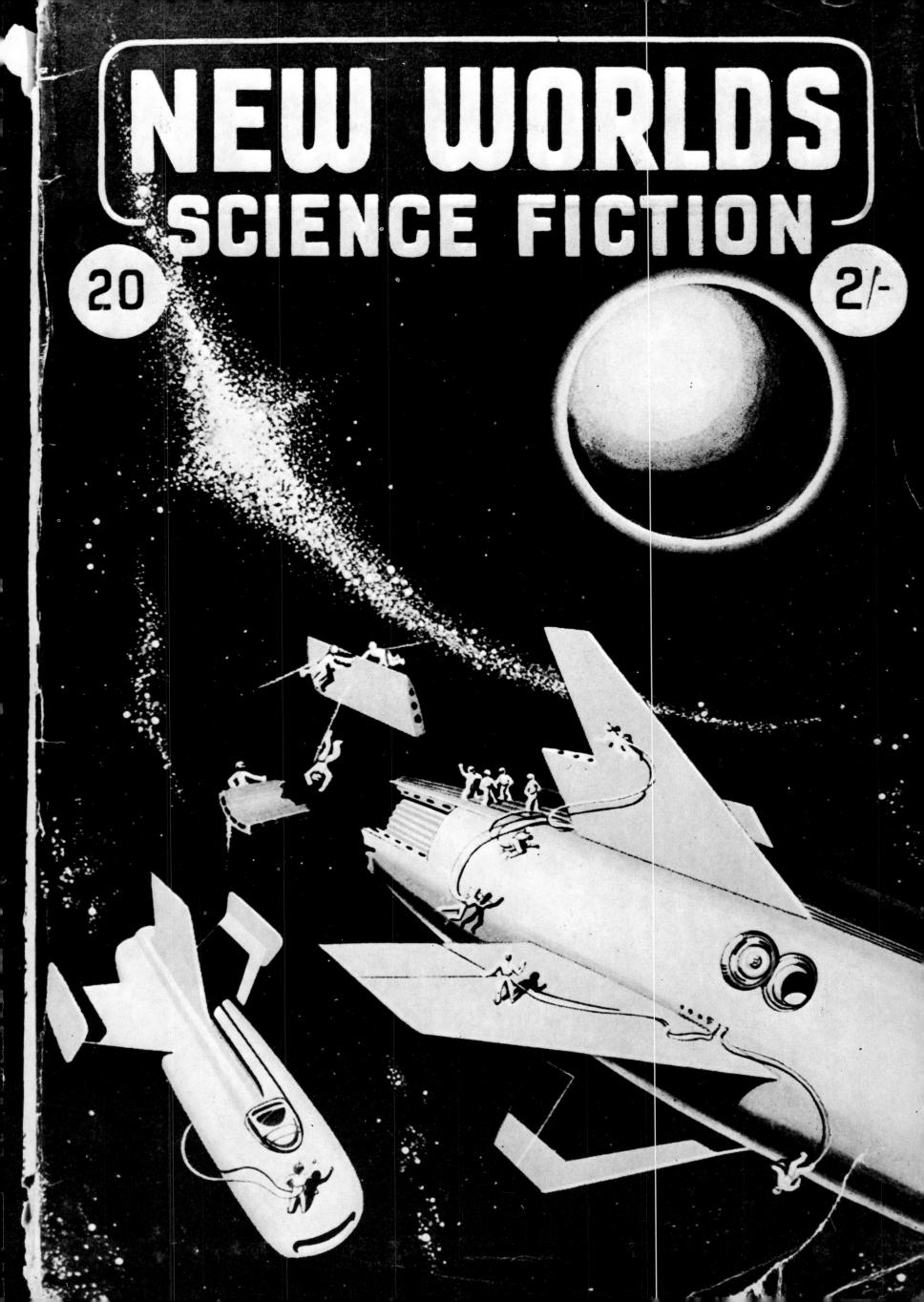

NEW WORLDS
SCIENCE FICTION

20

2/-

Schneeman's haunting cover for a 1953 ASTOUNDING conveys something of the loneliness of what we now accept prosaically as EVA (Extra-Vehicular Activity).

As this painting indicates, the idea that all craft had to be aerodynamically streamlined persisted almost until the first sputniks were launched. Meanwhile, Earle Bergey and Schomburg had fun with wacky designs. Space catamarans, anyone?

FEATURING

THE STAR WATCHERS
An Interplanetary Novel by
ERIC FRANK RUSSELL

THE GAMBLERS
A Novelet by
M. REYNOLDS
AND F. BROWN

A STREET AND SMITH PUBLICATION

Astounding
SCIENCE FICTION

BRITISH 9D. EDITION

APRIL

THE LAST BLAST BY ERIC FRANK RUSSELL

Astounding Science Fiction, April 1953

Startling Stories, November 1951 (detail; Alex Schomburg)

15¢

A THRILLING PUBLICATION

THE RED DIMENSION
A Hall of Fame Classic
By ED EARL REPP

Startling Stories, Summer 1945 (detail; Earle Bergey)

AUGUST

25 CENTS
IN CANADA THIRTY CENTS

AMAZING STORIES

SKYLARK THREE
By
Edward E. Smith, Ph.D.

Other Scientifiction Stories by:
**Capt. S. P. Meek, U.S.A.
Peter van Dresser
Edmond Hamilton**

Amazing Stories, August 1930

On an early AMAZING, Wesso shows that vacuum-busting was not all fun. You could easily get clobbered – particularly in the universes of Doc Smith.

Beyond the Beyond

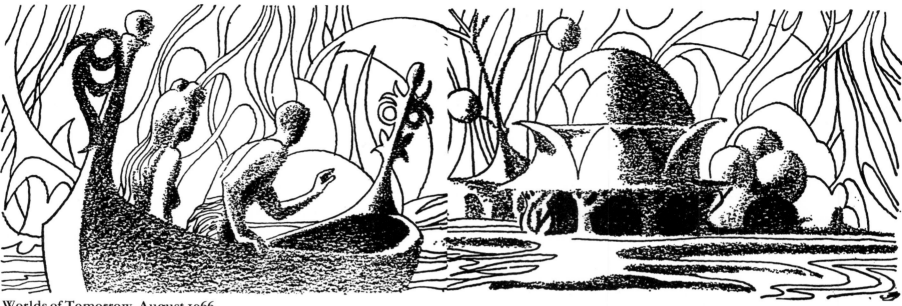

Worlds of Tomorrow, August 1966
"Heavenly Host" by Emil Petaja (Jack Gaughan)

*A sample of unfamiliar life emerged onto the platform . . . proud
. . . disdainful . . . magnificently indifferent to all around him.*

DESIGN FOR GREAT-DAY
By ERIC FRANK RUSSELL

All hail Lawson of the Solarian Combine. Lawson the impudent peacemaker. Lawson the mighty-minded egotist. Lawson who was man plus men plus other creatures . . . who believed . . . who knew . . . that wits top warheads; that tactics surpass instruments; that a super-glib tongue rules the Galaxies.

The question of where the intrepid space crew arrived was a vital one.

Many of the visions were intensely romantic. Romance gave way to realism as space-travel became a fact and its many difficulties – not least the financial ones – better understood.

Above, Gaughan – one of the most lauded of a newer generation of artists – conveys a mystery by means of swirling line. Emsh (here signing himself Emshler) uses grotesque comedy, fittingly enough since he illustrates a story by Eric Frank Russell, one of the rare sf comedians. As for Mayan (*opposite*), he tells you precisely what one entire aspect of space fiction is all about.

Planet Stories, January 1953 (Emsh)

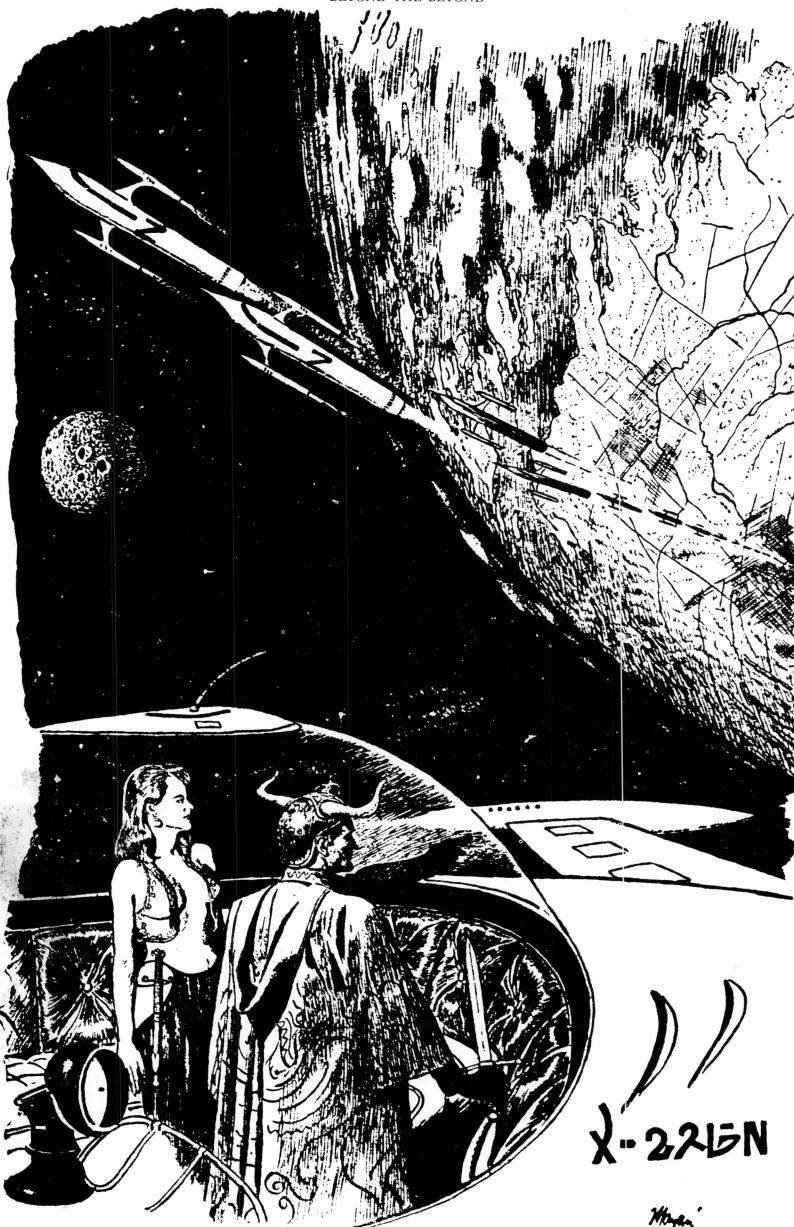

Like great silver fish leaping up into the bowl of night, the ships of the Valkyr fleet rose from Kalgan . . .

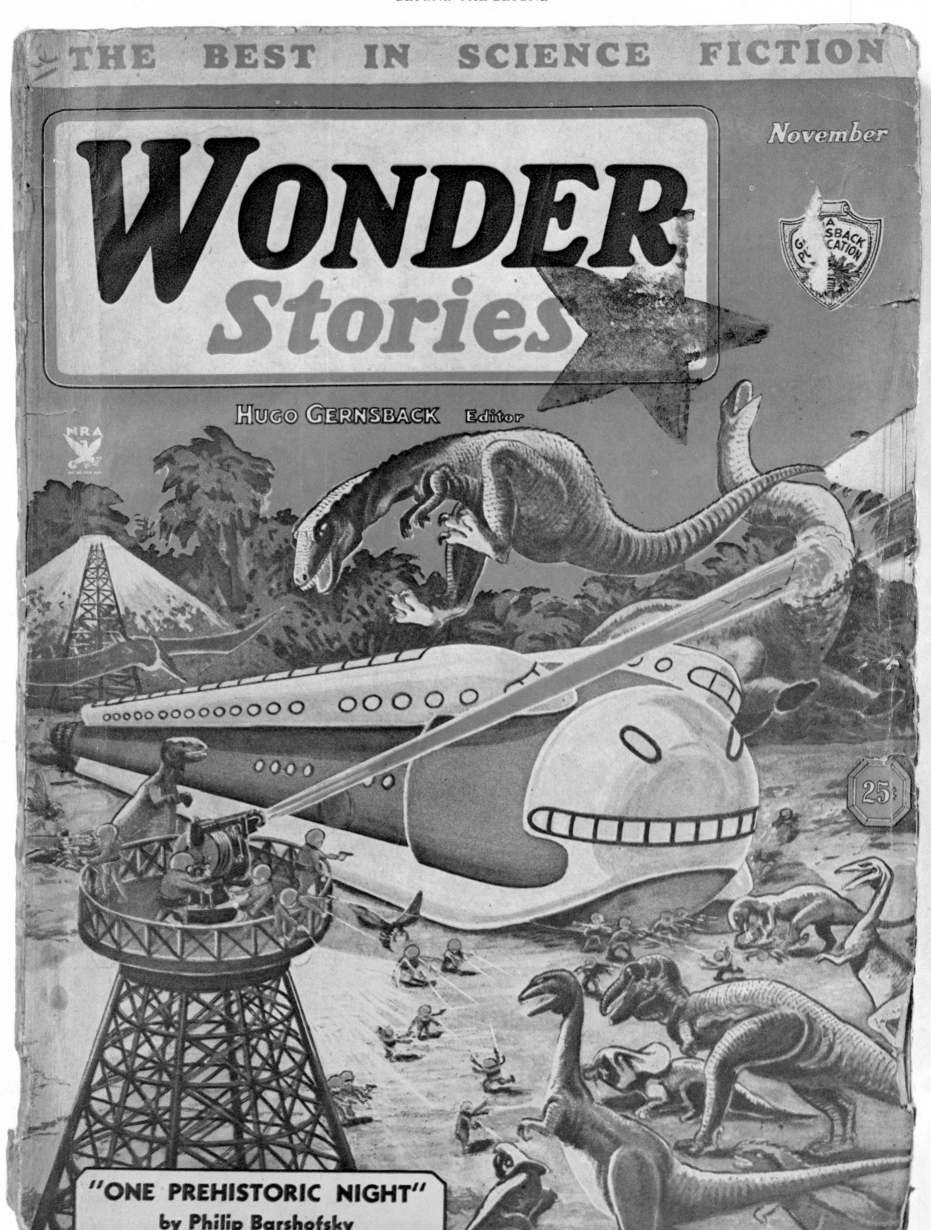

Wonder Stories, November 1934 (Frank R. Paul)

TODAY'S FICTION CAN BE TOMORROW'S FACT! **164** PAGES!

PRICE IN GT. BRITAIN 2/-

AMAZING STORIES

ANC

The ILLUSION SEEKERS
By P. F. Costello

Amazing Stories, August 1950 (R. G. Jones)

There was one golden rule to be followed when coping with the inhabitants of other planets: "If it's chitinous, winged, leathery, or all three, blast first and ask questions afterwards. Preferably a long time afterwards". Emsh and Robert Fuqua show how it worked in practice.

Planet Stories, September 1953
"Bunzo Farewell" by Charles V. De Vet

Almost tonelessly Tang counted as he burned the stick-insects one by one: "One for you, Bill. Two for you, Bill...."

Devil Birds of Deimos

By FESTUS PRAGNELL

Don Hargreaves finds that fighting huge birds of space who fly as fast as light is simple if you know how...!

IN the end I got back to Usulor's court. bringing Bommelsmeth's Evolution Machine and Bommelsmeth himself. turned into an imitation sea-lion. with me. I don't mean that Bommelsmeth really was turned into a sea-lion. I mean he was more like a sea-lion than any other animal I ever saw. He followed me like a dog. He had to. He still had the mind of a man. He could not live like a sea-lion among sea-lions. He didn't know how to. He was reduced to a condition of complete helplessness.

And so I arrived back in Usulor's court, Vans Holors, wrestling champion of Mars and a really good fellow. even though he is rather dumb, carrying the Evolution Machine. Before I could tell my story we had an accident with the machine. In spite of warnings Vans' wife blundered into the ray and got turned into a sort of flamingo. In view of the way that female had been behaving it seemed to me that trusting, honest Vans had not lost much, but he was very upset about it. She flew off, and he went after her in an airplane.

Then, as I said. the whole of Mars was very soon in a ferment of excitement. Not because Bommelsmeth was captured and helpless. But because here was a machine that could turn a living human being into a weird animal. Come to think of it, I suppose, a machine like that would cause a lot

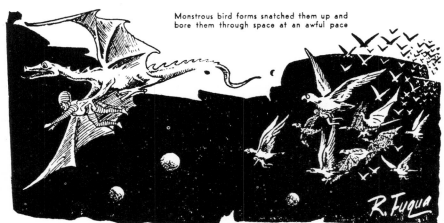

Monstrous bird forms snatched them up and bore them through space at an awful pace

Amazing Stories, April 1942

HERE BE MONSTERS

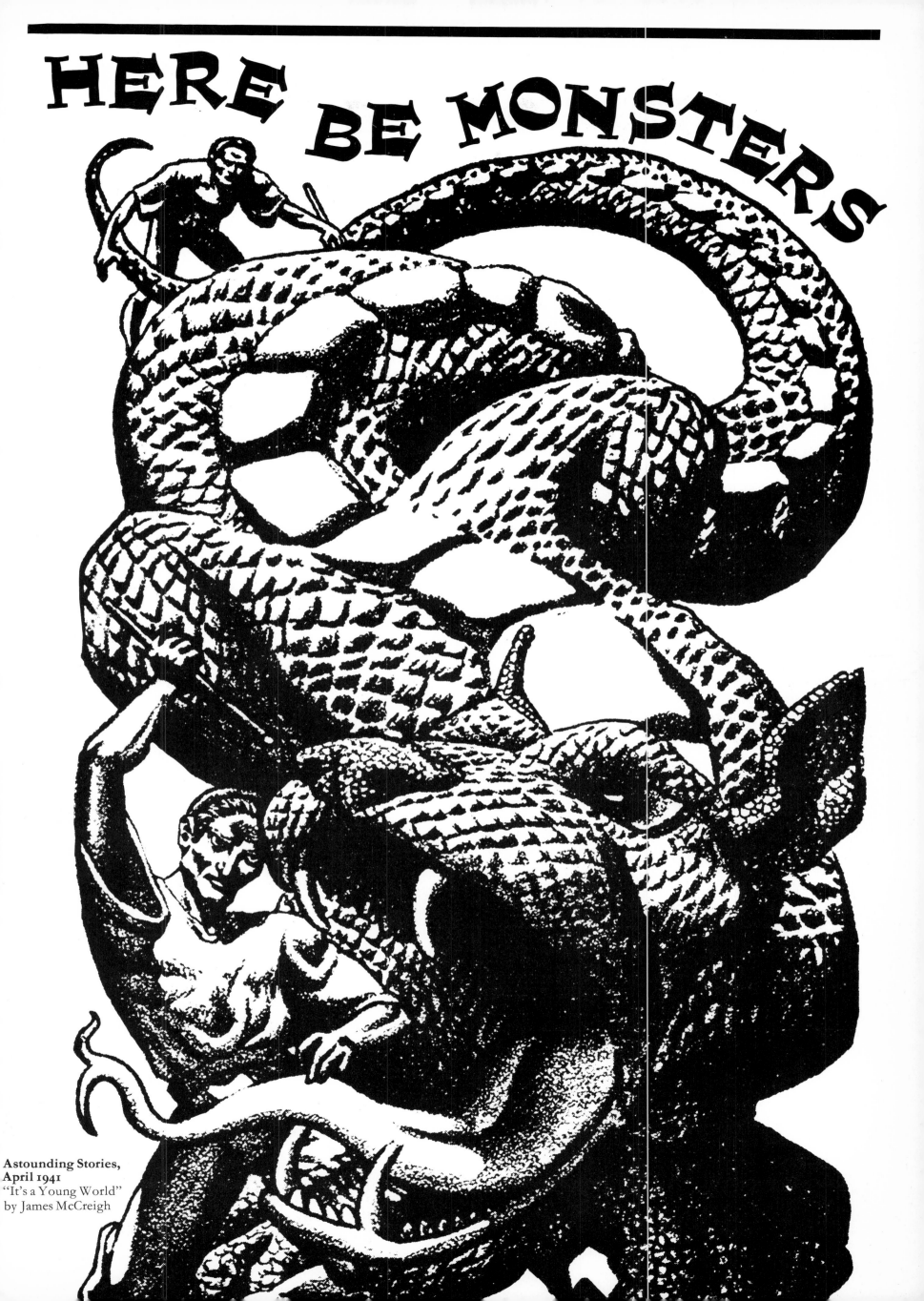

Astounding Stories,
April 1941
"It's a Young World"
by James McCreigh

Mankind's simultaneous fear of and delight in monsters has found ideal contemporary expression in science fiction. Hannes Bok (page 83) uses his scaly monster decoratively.

Bertram Chandler's story, "Giant Killer", featured a special kind of monster. Rats aboard an interstellar vessel developed intelligence through genetic mutation because of radiation seeping through the hull. The results are strikingly depicted by Timmins.

For a change, the Martian depicted by Paul was friendly, even going so far as to clasp our young friend's hand. A helpful explanatory diagram (*right*) was provided for FANTASTIC ADVENTURES' readers.

Astounding Science Fiction, October 1945

KEY TO BACK COVER ILLUSTRATION

A Erectable natural telepathic antenna for extra sensory communication.

B Enormous shell shaped ears to catch sound waves in Mars' rarefied atmosphere.

C Retractable eyes and nose to protect against freezing in extreme cold.

D Huge lung development, to provide sufficient oxygen for a large body.

E Heavy, closely knit white fur, to protect the frail body against extreme cold.

F Atomic weapon, utilizing advanced atomic science of the power in the atom.

G Synthetic water and food pellets to provide nourishment on the desert.

H Scientifically constructed clothing, impervious to cold, electrically warmed.

I Disc shaped feet, equipped with natural suction cups and valve openings.

J Protective glassite helmet, since Mars' air is too thin for Earthmen.

K Amplifiers to pick up sound vibrations in the thin atmosphere inaudible to us.

L Oxygen purifyer, to cleanse our air supply, and remove carbon dioxide.

M Oxygen tank to supplement meagre supply present in Martian atmosphere.

N Repulsion hand rockets, to aid in moving about on shipboard or in space.

O Heavy, air-tight, insulated suit, to protect against both cold and empty space.

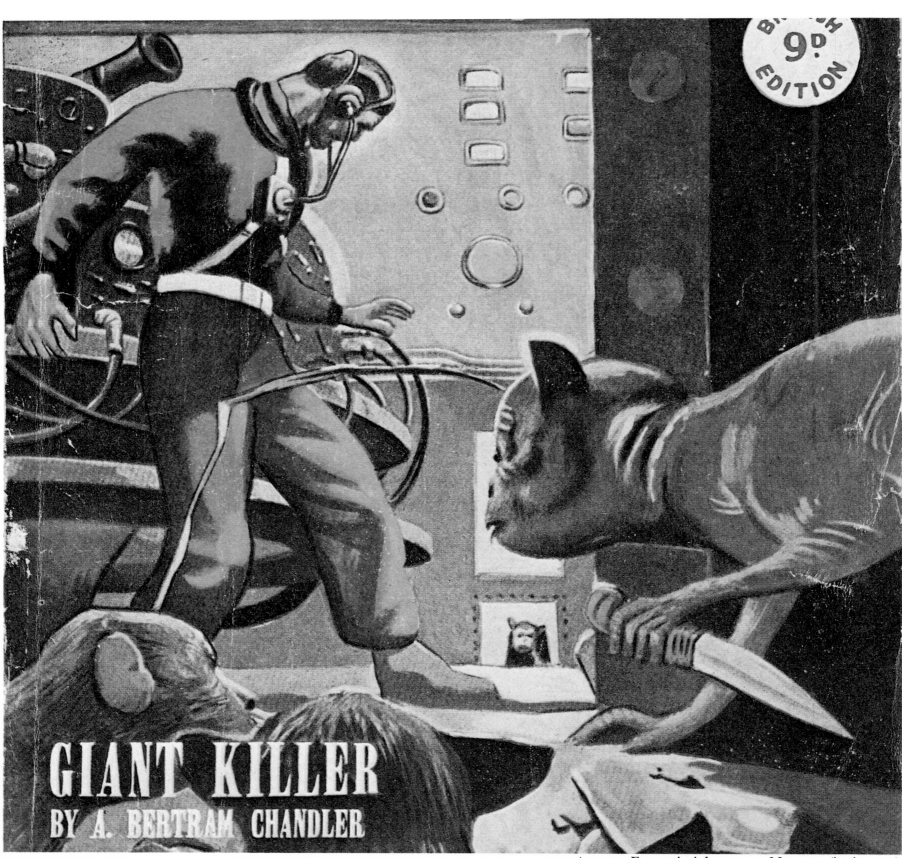

GIANT KILLER
BY A. BERTRAM CHANDLER

opposite page: **Fantastic Adventures, May 1939** (back cover)

The MAN from MARS

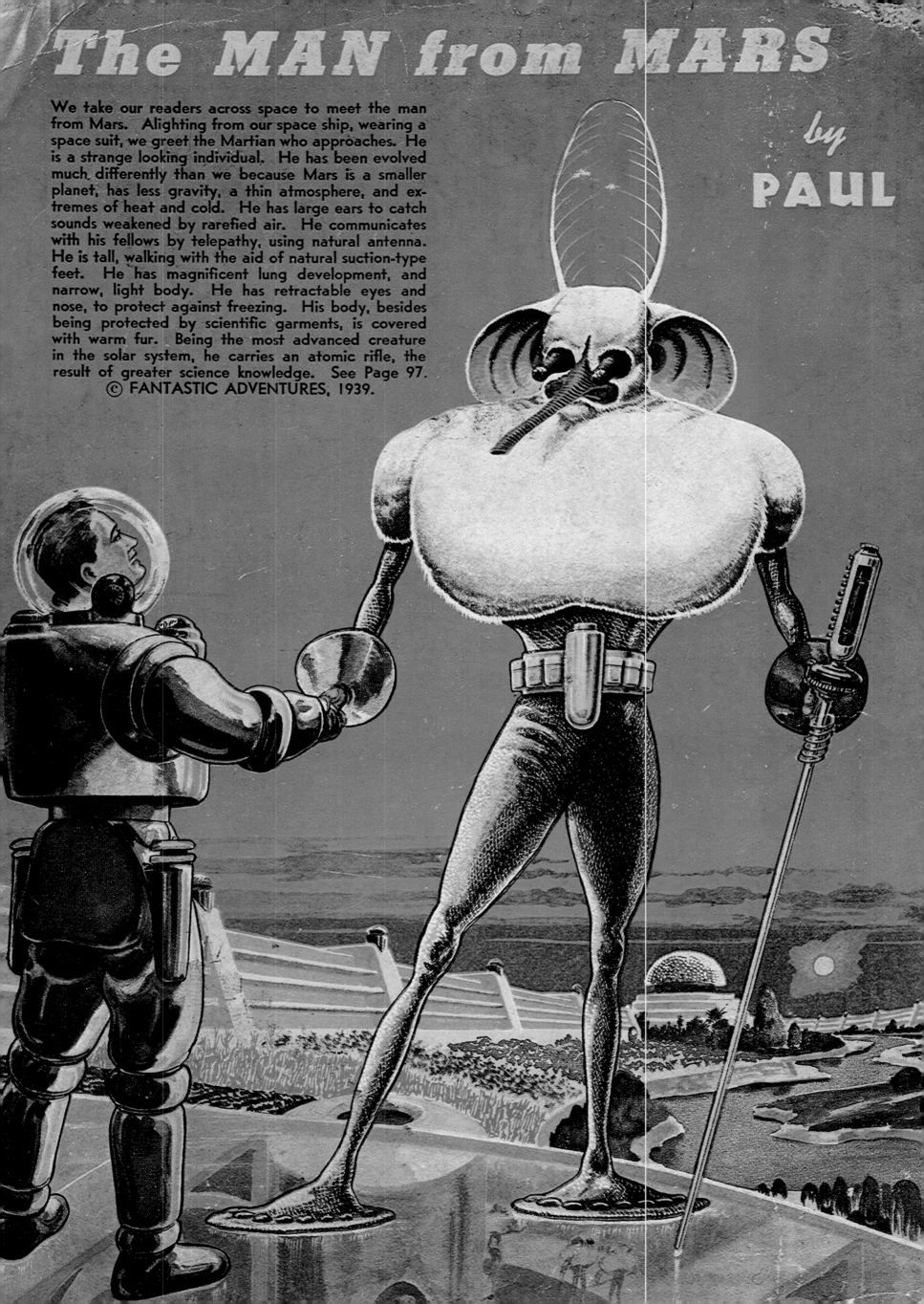

by PAUL

We take our readers across space to meet the man from Mars. Alighting from our space ship, wearing a space suit, we greet the Martian who approaches. He is a strange looking individual. He has been evolved much differently than we because Mars is a smaller planet, has less gravity, a thin atmosphere, and extremes of heat and cold. He has large ears to catch sounds weakened by rarefied air. He communicates with his fellows by telepathy, using natural antenna. He is tall, walking with the aid of natural suction-type feet. He has magnificent lung development, and narrow, light body. He has retractable eyes and nose, to protect against freezing. His body, besides being protected by scientific garments, is covered with warm fur. Being the most advanced creature in the solar system, he carries an atomic rifle, the result of greater science knowledge. See Page 97.
© FANTASTIC ADVENTURES, 1939.

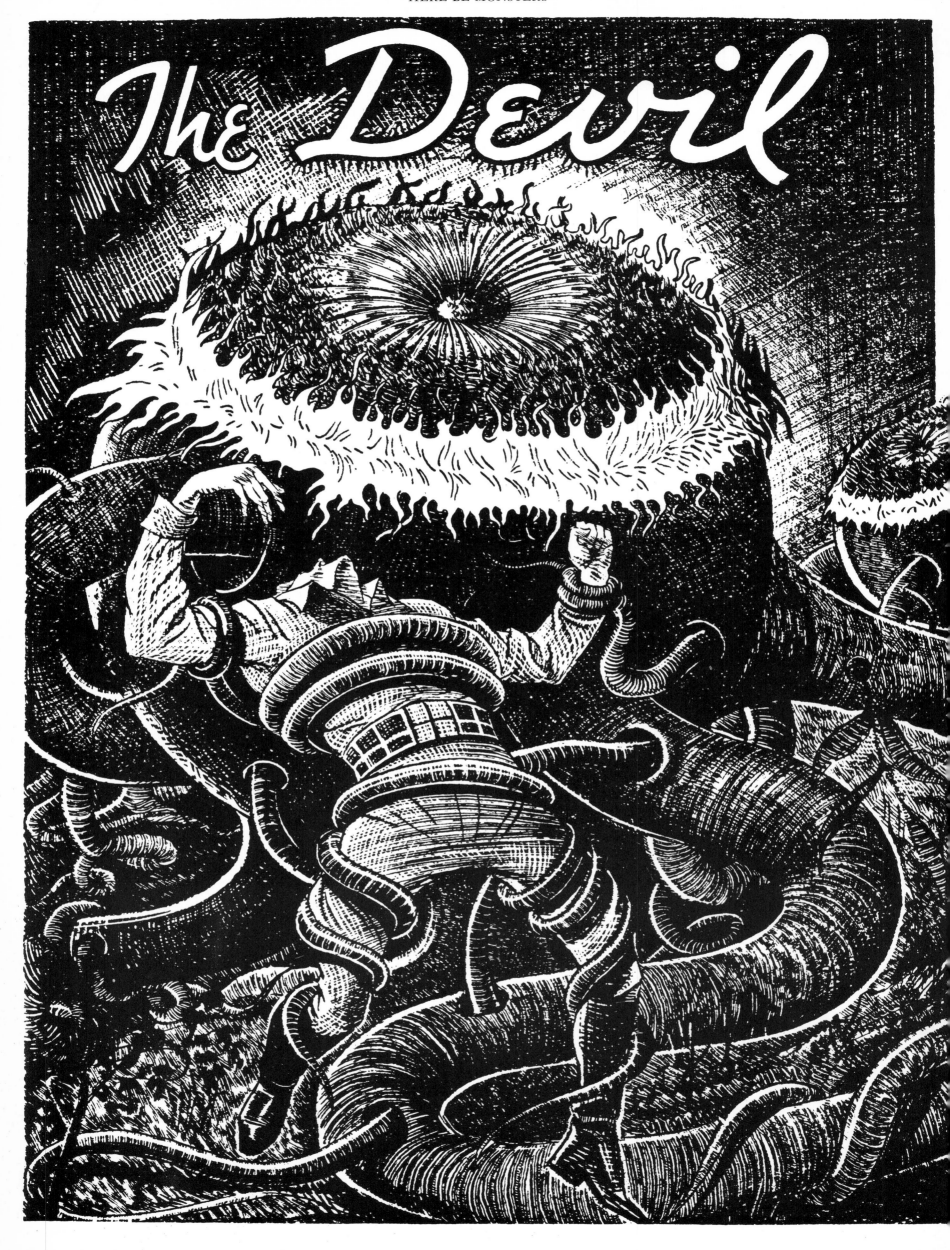

Fantastic Adventures, May 1939
"The Devil Flower" by Harl Vincent

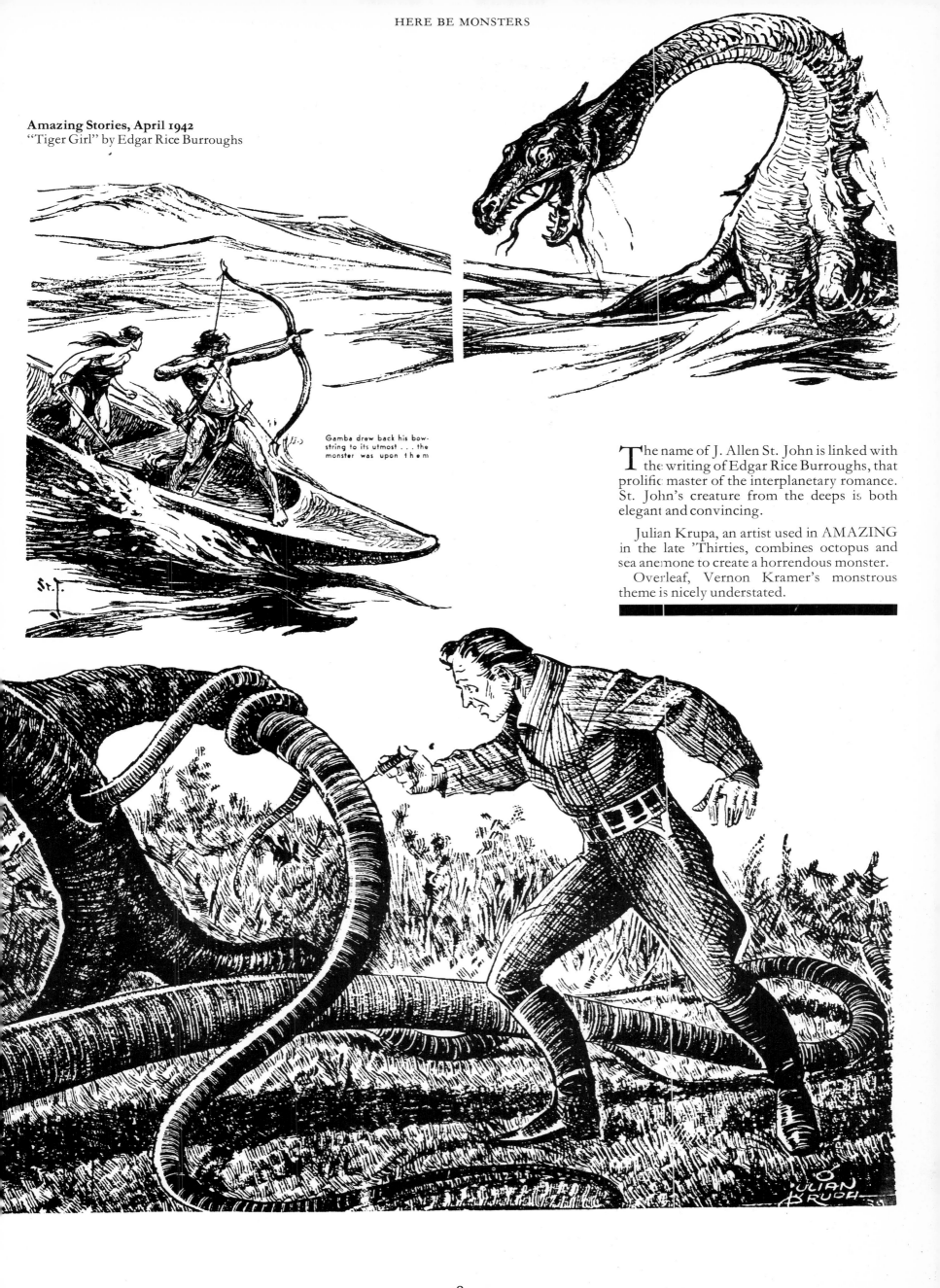

Amazing Stories, April 1942
"Tiger Girl" by Edgar Rice Burroughs

Gamba drew back his bowstring to its utmost . . . the monster was upon them

The name of J. Allen St. John is linked with the writing of Edgar Rice Burroughs, that prolific master of the interplanetary romance. St. John's creature from the deeps is both elegant and convincing.

Julian Krupa, an artist used in AMAZING in the late 'Thirties, combines octopus and sea anemone to create a horrendous monster.

Overleaf, Vernon Kramer's monstrous theme is nicely understated.

RECOVERY AREA
by Daniel Galouye

HOW DEEP THE GROOVES
by Philip J. Farmer

SF Profile:
ARTHUR C. CLARKE

Amazing Stories, February 1963 (Vernon Kramer)

Spires and Sewers

Science fiction is a literature of cities, and the city of tomorrow is an everlasting theme. Krupa, with possibly a nudge from the model sets of the Fritz Lang film "Metropolis" depicts an elaborate multi-level megalopolis.

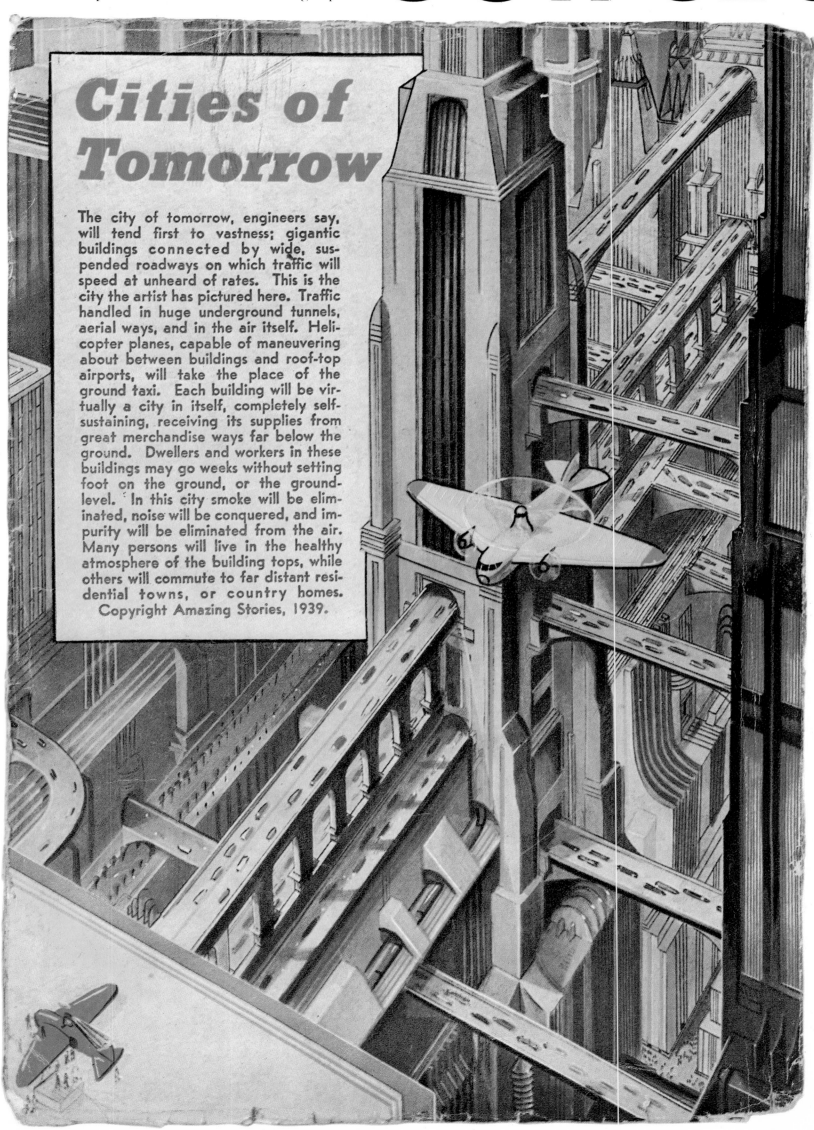

Cities of Tomorrow

The city of tomorrow, engineers say, will tend first to vastness; gigantic buildings connected by wide, suspended roadways on which traffic will speed at unheard of rates. This is the city the artist has pictured here. Traffic handled in huge underground tunnels, aerial ways, and in the air itself. Helicopter planes, capable of maneuvering about between buildings and roof-top airports, will take the place of the ground taxi. Each building will be virtually a city in itself, completely self-sustaining, receiving its supplies from great merchandise ways far below the ground. Dwellers and workers in these buildings may go weeks without setting foot on the ground, or the ground-level. In this city smoke will be eliminated, noise will be conquered, and impurity will be eliminated from the air. Many persons will live in the healthy atmosphere of the building tops, while others will commute to far distant residential towns, or country homes.
Copyright Amazing Stories, 1939.

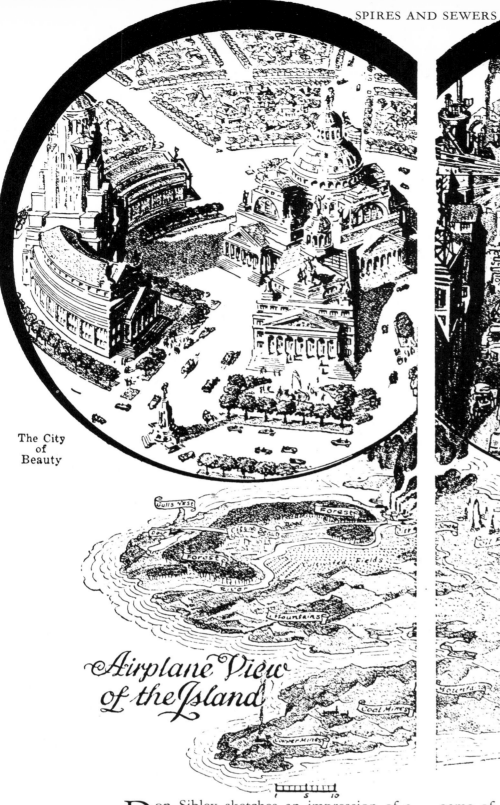

The City
of
Beauty

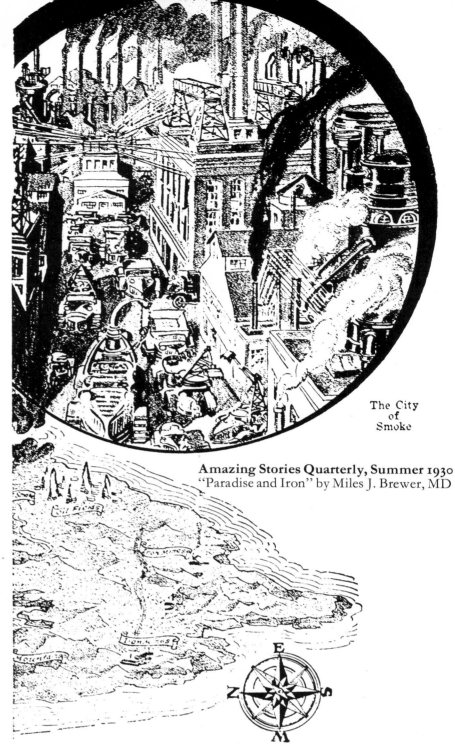

The City
of
Smoke

Amazing Stories Quarterly, Summer 1930
"Paradise and Iron" by Miles J. Brewer, MD

Airplane View of the Island

Don Sibley sketches an impression of a future metropolis with freeways wheeling about it (*below*).

The two Wessos on this page and the next are interesting. Here, he contrasts paradise and purgatory in stone. Opposite, he shows a game of the future in full blast, while the multitudes watch.

Paul's city is subterranean, and is about to suffer one of those periodic spots of bother which afflict fantasy cities.

Galaxy Science Fiction, April 1951
"The Marching Morons" by C. M. Kornbluth

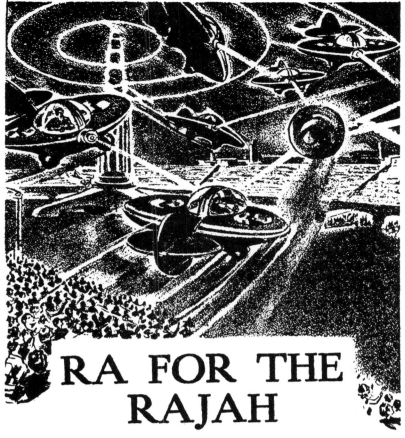

RA FOR THE RAJAH

By John Victor Peterson

A new type of story—a tale of rivalry at a college of the future—told in a unique and appropriate style.

MANY of the so-called intelli- gentsia will laud a Martian as a gentleman and a scholar. Personally, I catalogue him as a dis- tinctly anti-Hoyle dimwit of the *genus homo sap*—which is neither robotypist's error nor ultra-modern abbreviation for *sapiens*—and—— Well, the typer won't handle that.

Take that fop of a Rajah from Syrtis Major, for instance—a Beau Brummell from the feminine viewpoint. Wisp of

Astounding Science Fiction, May 1938

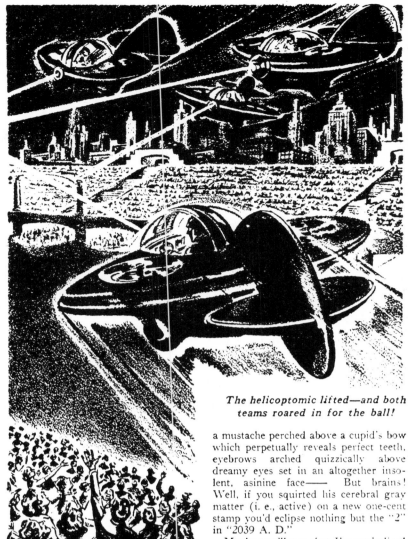

The helicoptomic lifted—and both teams roared in for the ball!

a mustache perched above a cupid's bow which perpetually reveals perfect teeth, eyebrows arched quizzically above dreamy eyes set in an altogether inso- lent, asinine face—— But brains! Well, if you squirted his cerebral gray matter (i. e., active) on a new one-cent stamp you'd eclipse nothing but the "2" in "2039 A. D."

Maybe you'll say that I'm prejudiced and therefore not a qualified judge; but I graduated from Royal Astrotech in the upper tenth, copped the Specialization Prize in Atomic Engineering, rubbed

In Response to Your Insistent Demands—A Great Book-Length Sequel to Mr. Burks Now Famous Novel "Survival"!

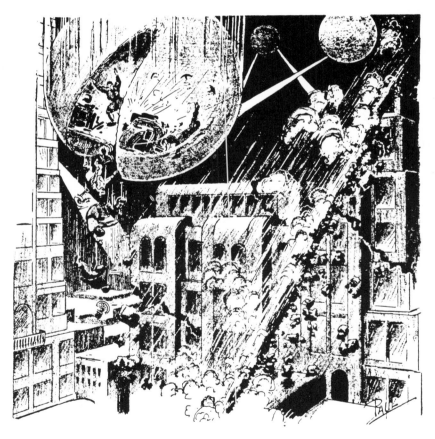

Marvel Stories, November 1938
"Exodus" by Arthur J. Burks

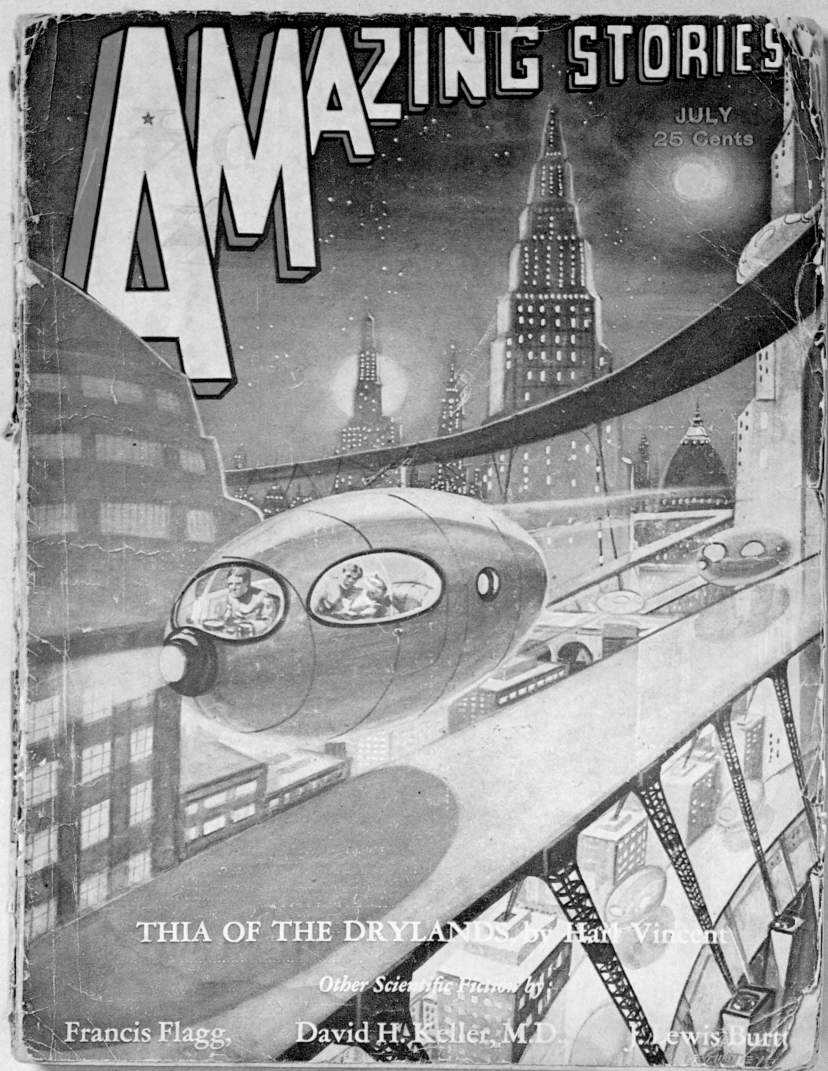

Amazing Stories, July 1932

THE LION'S MOUTH BY STEPHEN MARLOWE

PRICE IN 1/-
GT. BRITAIN

Fantastic

ANC

ADVENTURES

atred of the Green Menace
turned Mary into **THE WOMAN IN SKIN 13**
By Gerald Vance

On Sibley was an excellent black-and-white artist, working here in a difficult format which spread across two pages. His line is sensuous although, by bowing to the conventions of the time, he does incidentally illustrate the Great Nipple Shortage of 1954.

One of the first writers to break the sex-embargo in the magazines was Philip José Farmer (he has been at it ever since). "The Lovers" – a story of love between human and alien – was an immediate success. Finlay's drawing shows not only the guy and the gal but the symbolic disruption of technology and the casting off of spectacles.

Working a while before "Barbarella", Walter Popp made use of another dream activity often incorporated in sf: the dream of flying.

A relay-team of beautiful women took the torch from Dirrul's hand, to carry it across the field . . .

Science Fiction Quarterly, February 1954
"The Children of Thon" by Irving E. Cox jr

Startling Stories, August 1952
"The Lovers" by Philip José Farmer

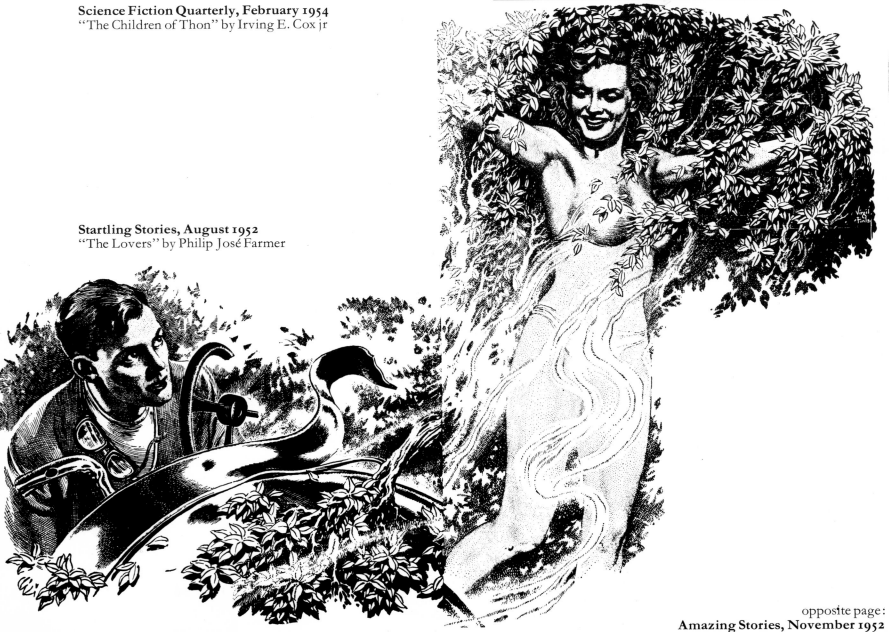

opposite page:
Amazing Stories, November 1952

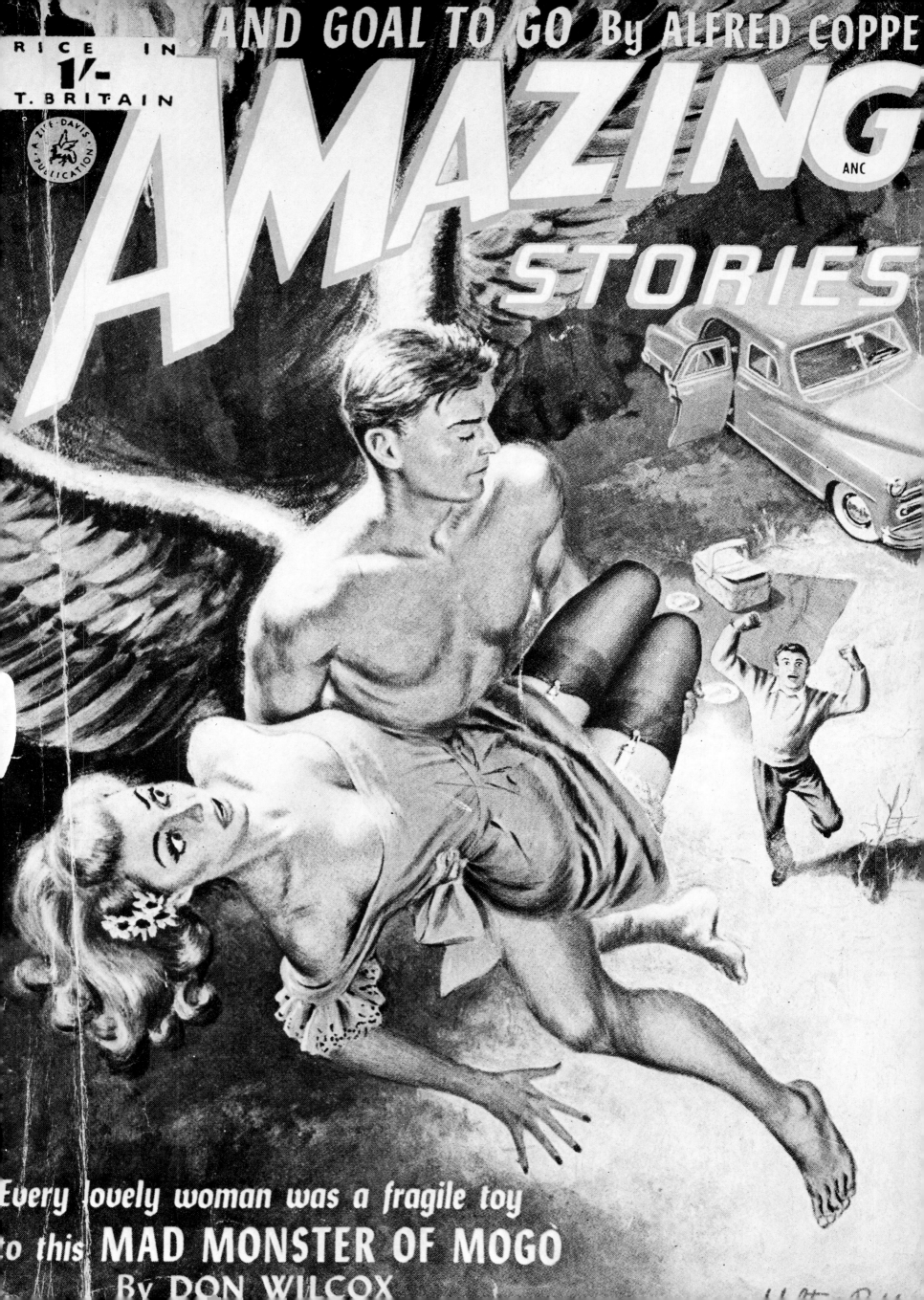

One of the most remarkable artists to enter the British field, and leave it all too soon, was a woman, R. M. Bull. She produced several covers for Ted Carnell's magazines.

Two of them are reproduced here in a larger format than the one in which they originally appeared. Their style might be called post-Vorticist. Both carry high sexual charges.

The phallic symbols in the background of the picture below are strictly contemporary with the painting: the Skylon and the Dome of Discovery in the 1951 Festival of Britain.

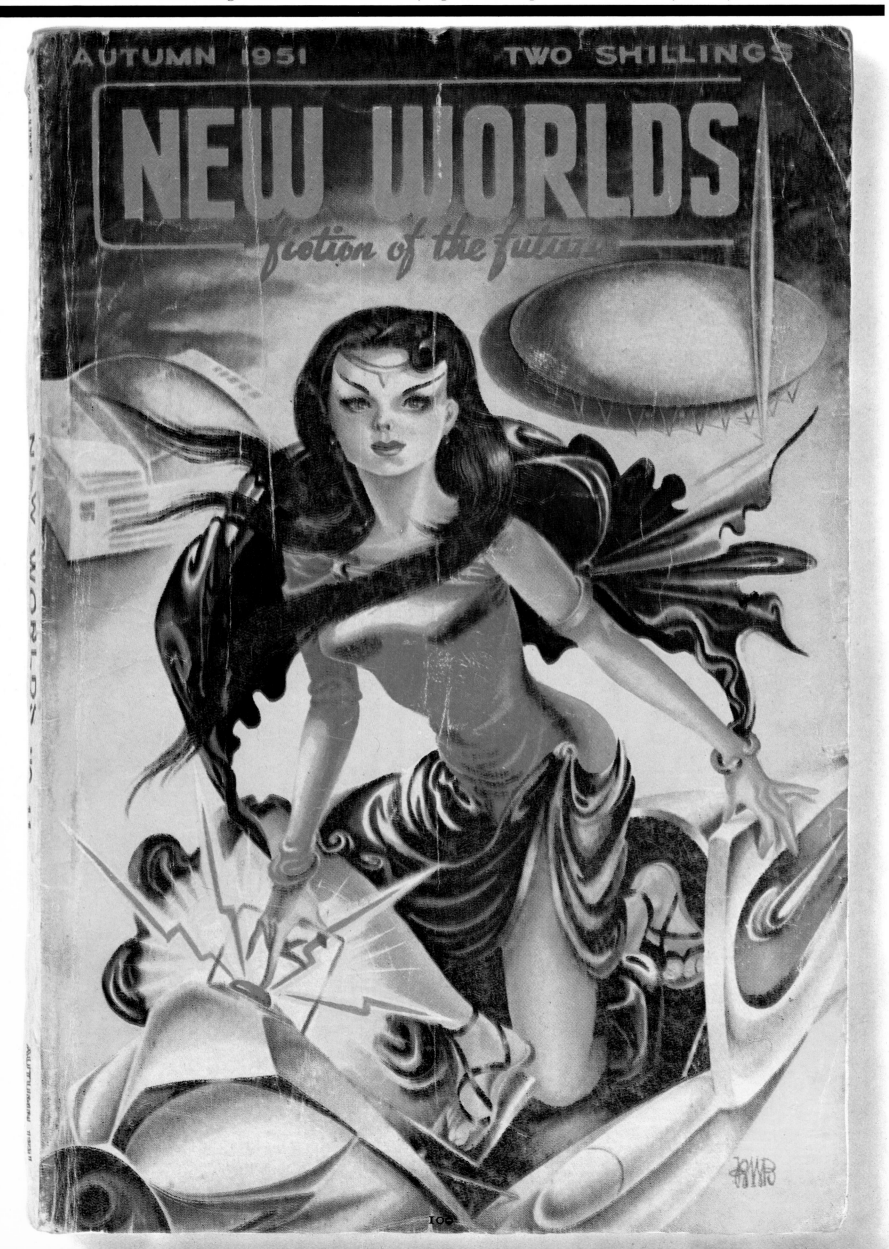

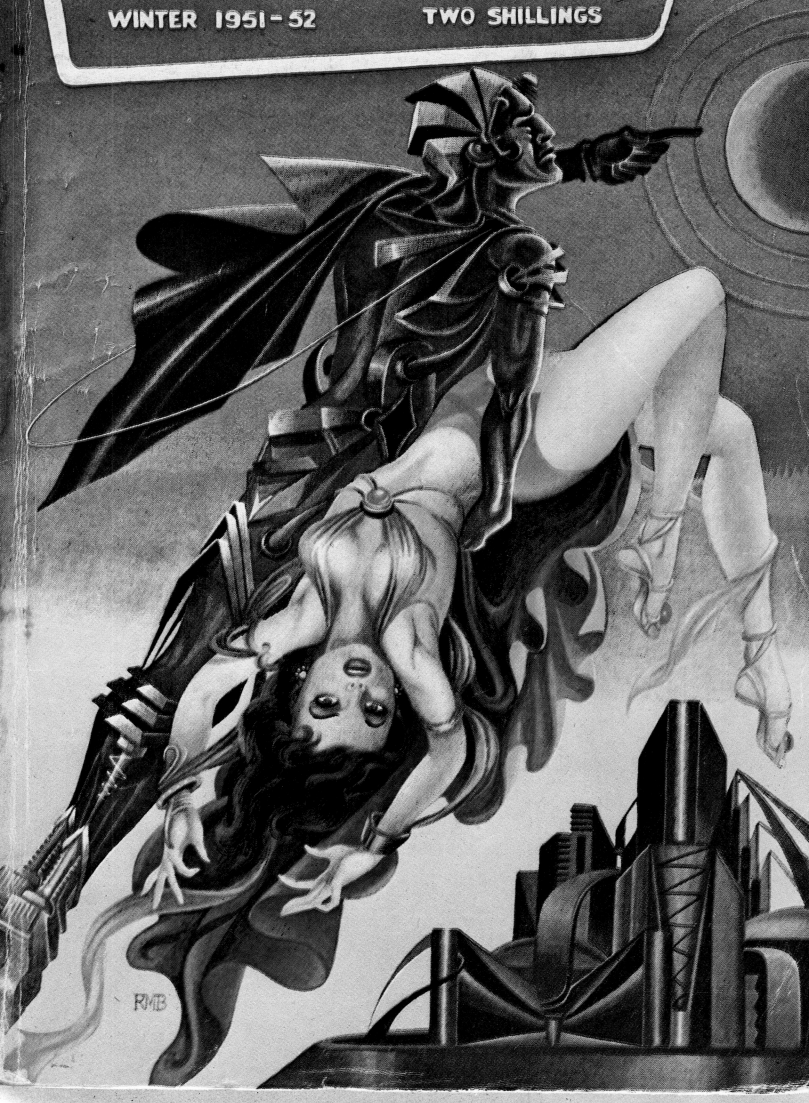

HANDS WITHOUT HEADS

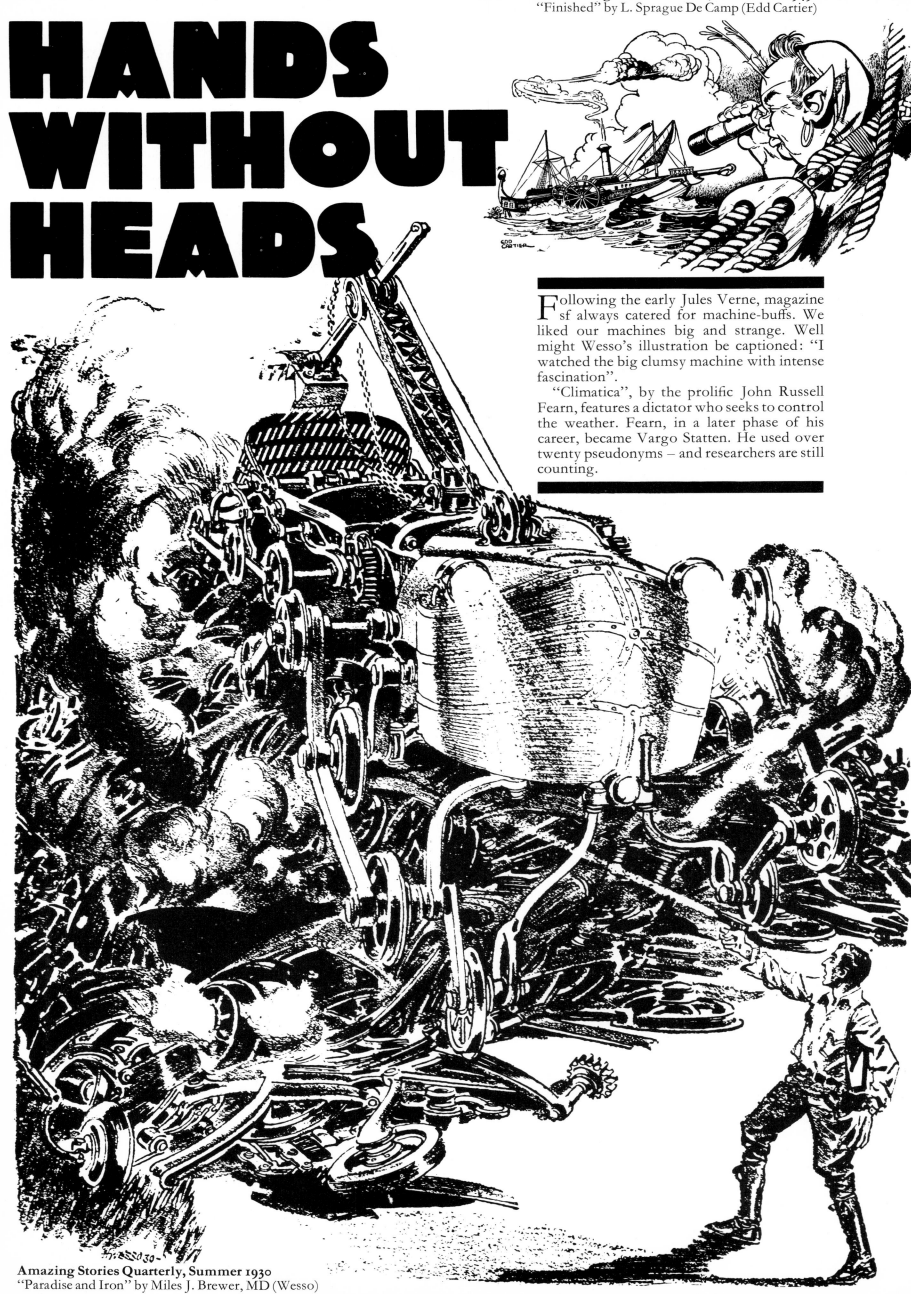

Astounding Science Fiction, November 1949
"Finished" by L. Sprague De Camp (Edd Cartier)

Following the early Jules Verne, magazine sf always catered for machine-buffs. We liked our machines big and strange. Well might Wesso's illustration be captioned: "I watched the big clumsy machine with intense fascination".

"Climatica", by the prolific John Russell Fearn, features a dictator who seeks to control the weather. Fearn, in a later phase of his career, became Vargo Statten. He used over twenty pseudonyms – and researchers are still counting.

Amazing Stories Quarterly, Summer 1930
"Paradise and Iron" by Miles J. Brewer, MD (Wesso)

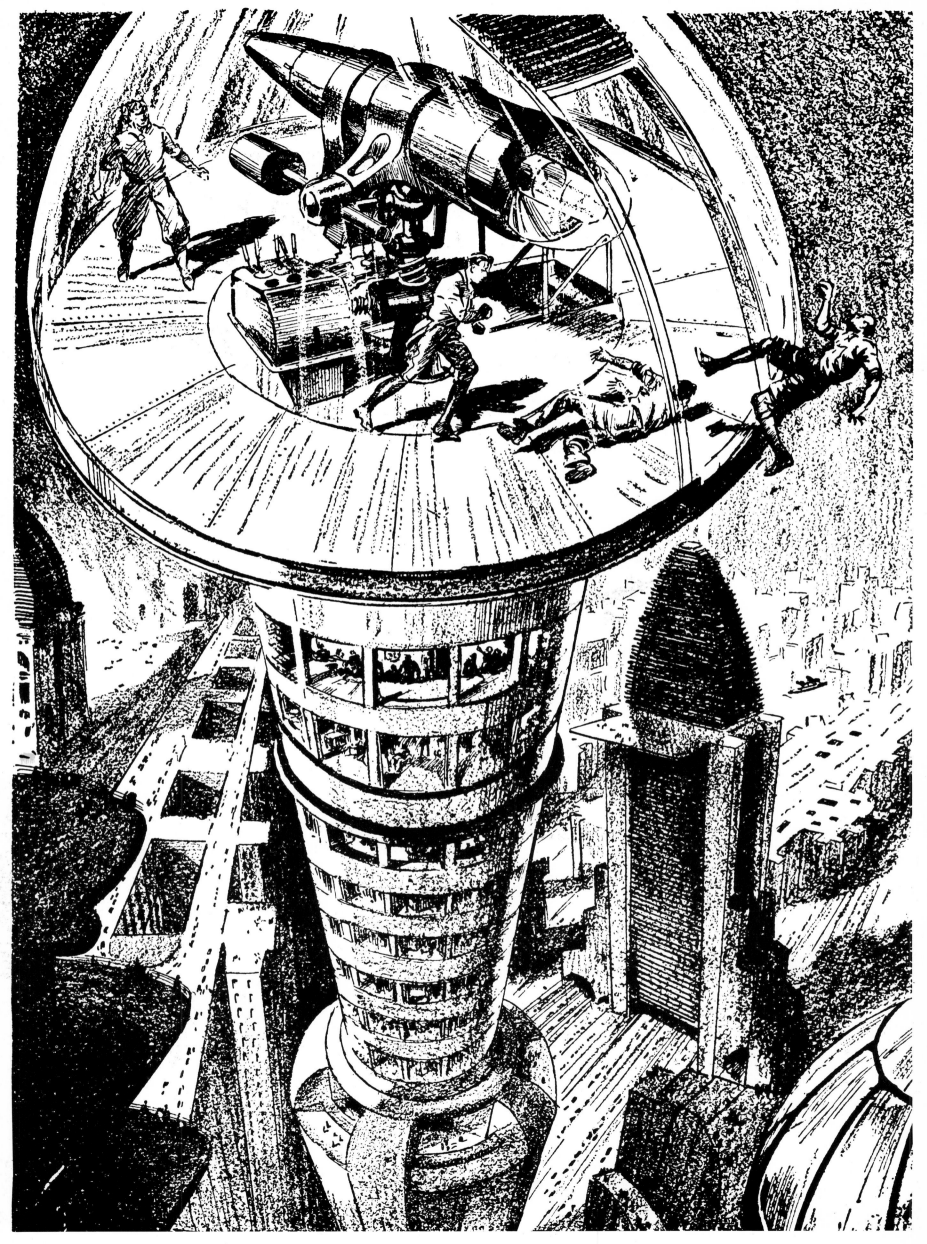

Fantasy, No. 2 1939
"Climatica" by John Russell Fearn (S. Drigin)

Of all the many sf magazines, SCIENCE FICTION MONTHLY has concentrated most on the art side, using old illustrations side-by-side with illustrations by new names. On the cover shown here, one of the brightest of those names, David Pelham, uses cannibalised space hardware to striking effect, at once comic and sinister. It bears an affinity with some of the machine caricutures by Boris Artzybasheff which appeared on TIME covers and elsewhere. Pelham's painting first served as a cover for Alfred Bester's novel, "Tiger, Tiger" (previously "The Stars My Destination"), published in the UK by Penguin.

Frank Kelly Freas has won acclaim for his sf artwork, which is frequently humorous.

Opposite, he joins forces with one of greatest humorists to write sf, Harry Harrison, to show the construction of the tunnel from Cornwall to New York.

"A Transatlantic Tunnel, Hurrah!" is an Alternate World saga in which George Washington was killed early in his career and America still belongs to an Imperial Britain.

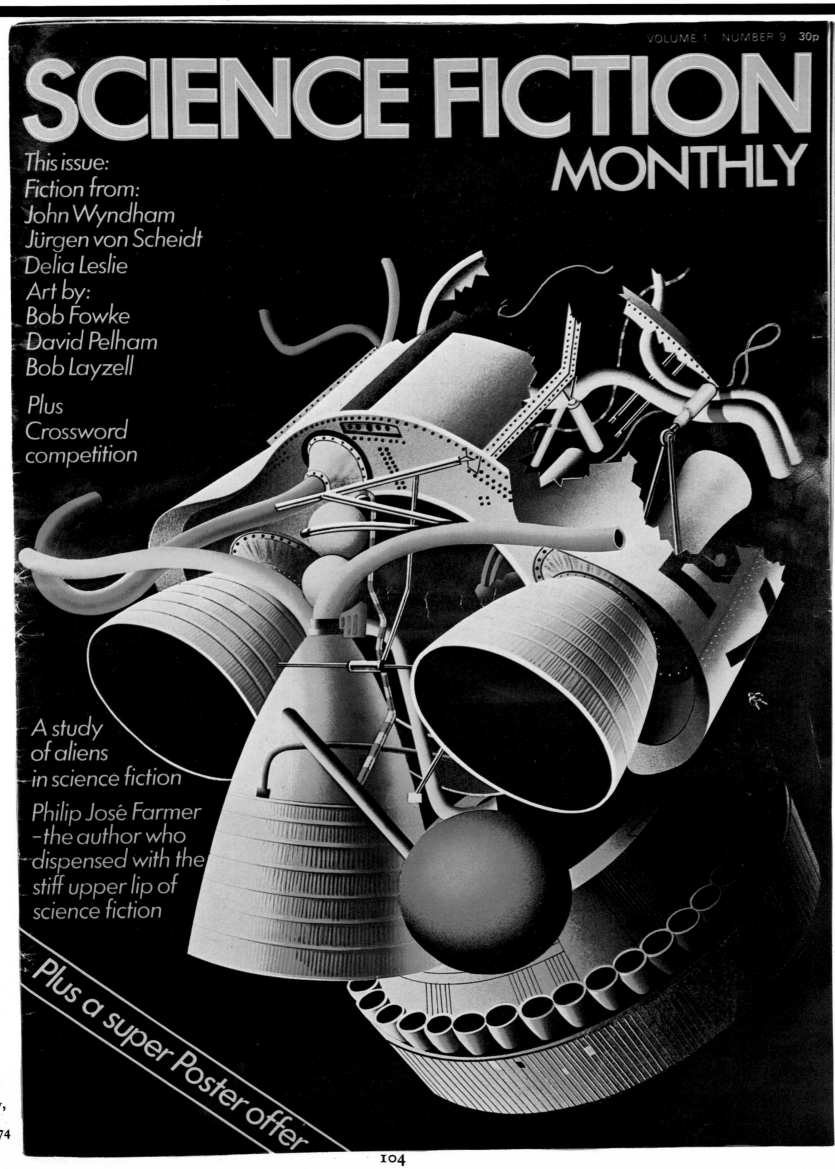

VOLUME 1 NUMBER 9 30p

SCIENCE FICTION
MONTHLY

This issue:
Fiction from:
John Wyndham
Jürgen von Scheidt
Delia Leslie
Art by:
Bob Fowke
David Pelham
Bob Layzell

Plus
Crossword
competition

A study
of aliens
in science fiction

Philip José Farmer
–the author who
dispensed with the
stiff upper lip of
science fiction

Plus a super Poster offer

Science
Fiction
Monthly,
Vol. 1
No. 9 1974

CCC

SCIENCE FICTION
analog
SCIENCE FACT

APRIL 1972 60c 30p

A TRANSATLANTIC TUNNEL, HURRAH!
Harry Harrison

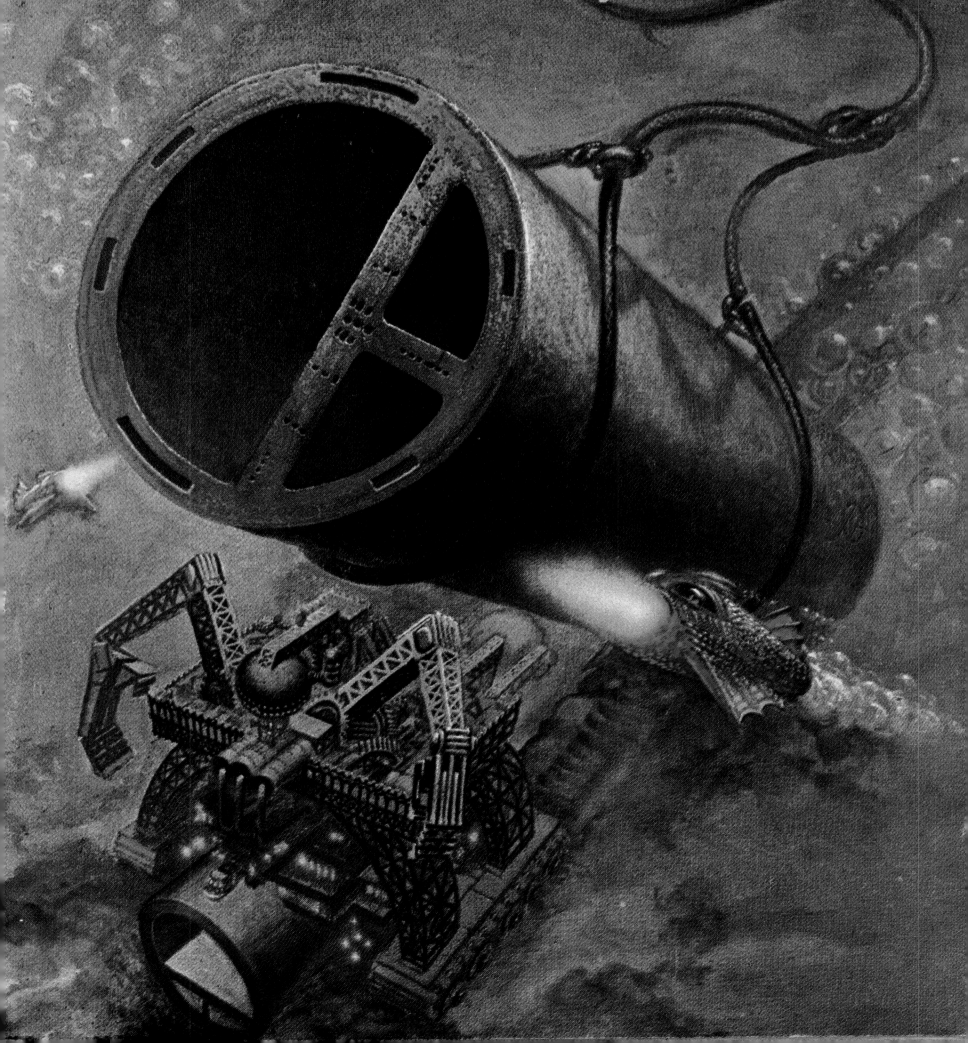

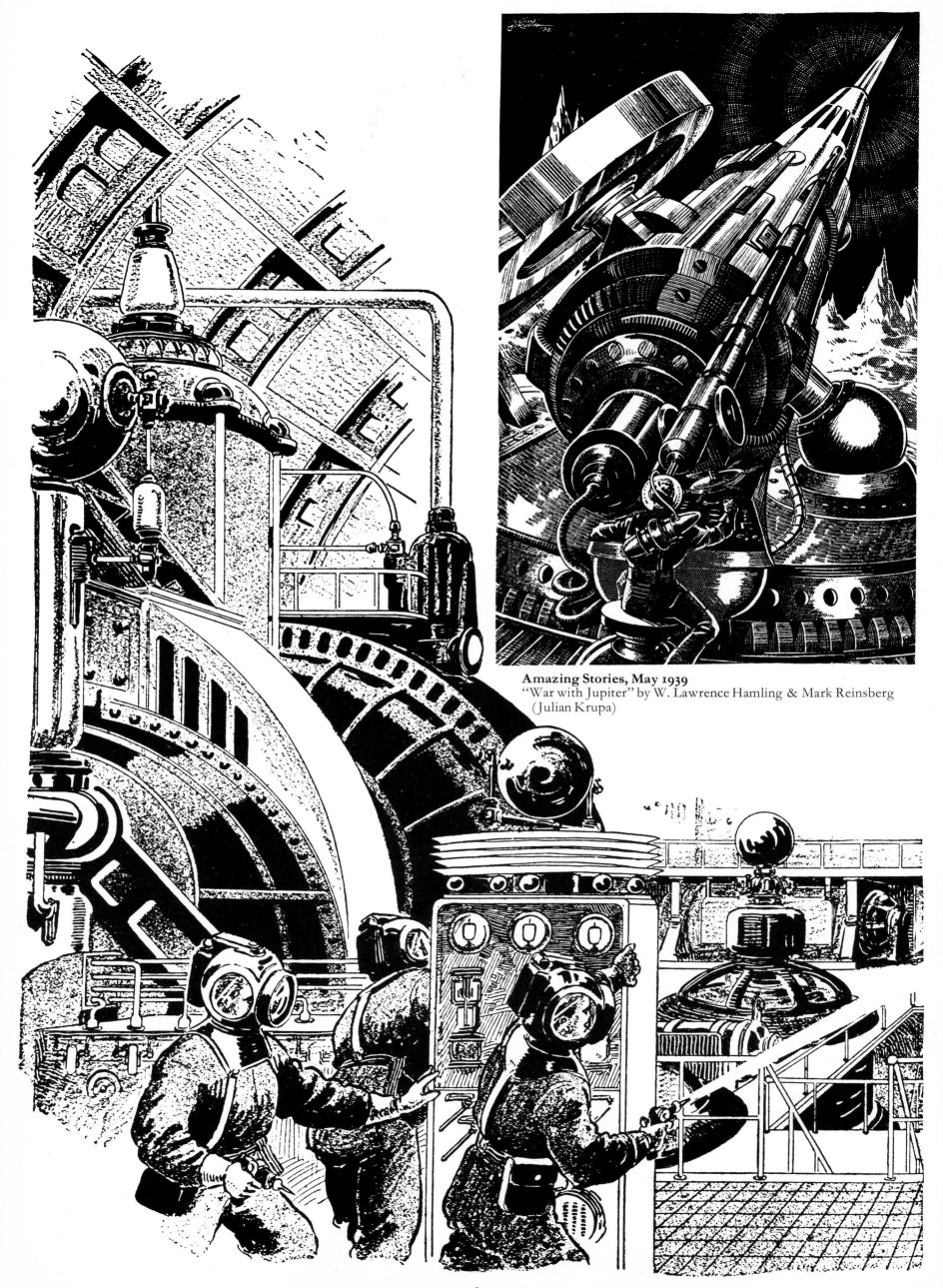

Amazing Stories, May 1939
"War with Jupiter" by W. Lawrence Hamling & Mark Reinsberg
(Julian Krupa)

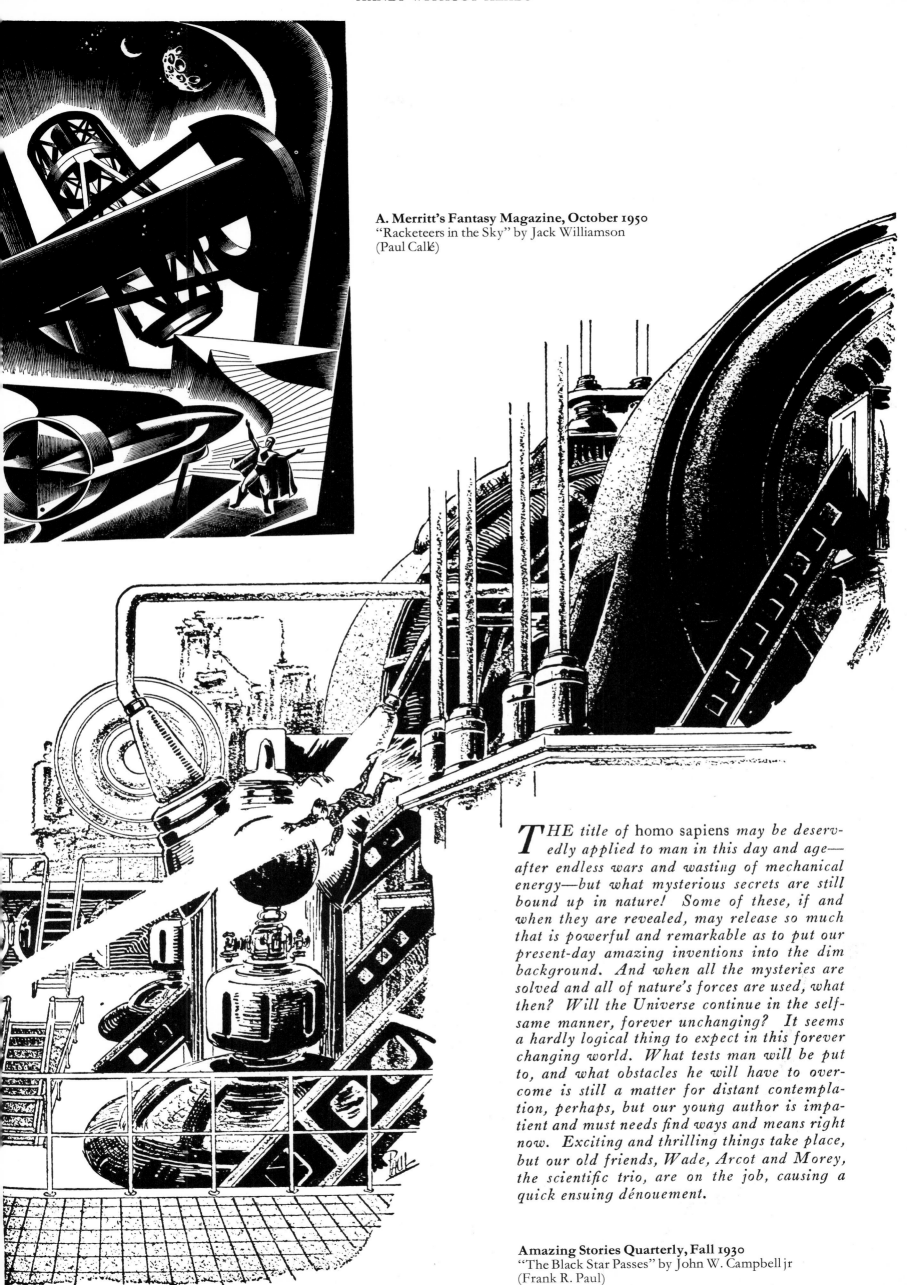

A. Merritt's Fantasy Magazine, October 1950
"Racketeers in the Sky" by Jack Williamson
(Paul Callé)

THE title of homo sapiens may be deservedly applied to man in this day and age—after endless wars and wasting of mechanical energy—but what mysterious secrets are still bound up in nature! Some of these, if and when they are revealed, may release so much that is powerful and remarkable as to put our present-day amazing inventions into the dim background. And when all the mysteries are solved and all of nature's forces are used, what then? Will the Universe continue in the self-same manner, forever unchanging? It seems a hardly logical thing to expect in this forever changing world. What tests man will be put to, and what obstacles he will have to overcome is still a matter for distant contemplation, perhaps, but our young author is impatient and must needs find ways and means right now. Exciting and thrilling things take place, but our old friends, Wade, Arcot and Morey, the scientific trio, are on the job, causing a quick ensuing dénouement.

Amazing Stories Quarterly, Fall 1930
"The Black Star Passes" by John W. Campbell jr
(Frank R. Paul)

MEN OF METAL

Between man and machine moves the strange figure of the Robot. In the early years of sf, the robot was perpetually running amok; it was left to Isaac Asimov to civilise the beast by introducing his Three Laws of Robotics. Yet the function of the robot generally remains ambivalent, something between a golem and a knight in shining armour.

Freas (*below*) shows the robot almost as father-figure. Anton Kurka makes it godlike. The title of his symbolic IF cover is "The Ultimate Re-sowing of the Human Race – 4000 AD". The robots must have been looking after the plough while we were away.

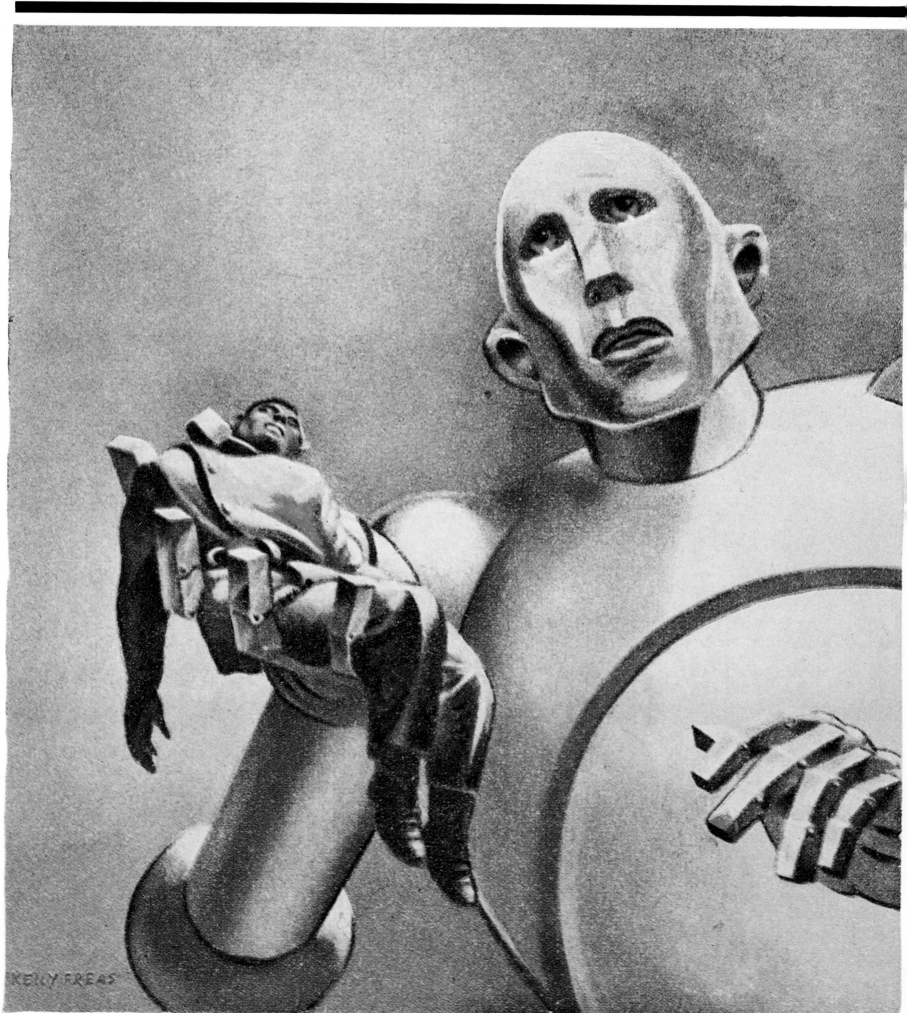

Astounding Science Fiction, March 1954 (detail)

A rare cover (*right*) by Sydney Jordan, creator of "Jeff Hawke". His robot on NEW WORLDS is decidedly not of flesh-and-blood, yet it manages to squeeze out a tear for mankind. When robots take on more human attributes (including synthetic flesh), they become androids: more liable to tears, less prone to rust.

Clarence Doore executed only two covers for AMAZING, both in 1954 when it had shrunk to digest size. His painting embodies dramatically the encounter between man and robot – and emphasises, incidentally, the role of robots and androids as intruders into white American society.

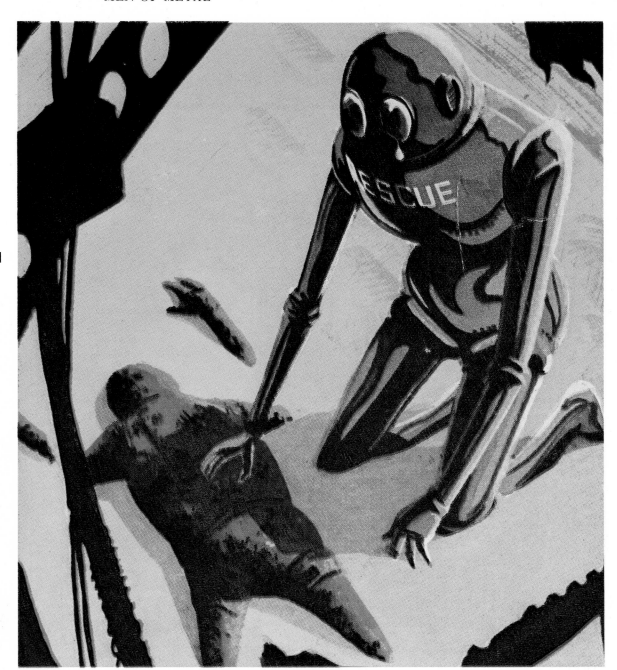

If – Worlds of Science Fiction, January 1953

New Worlds Science Fiction, August 1961 (detail)

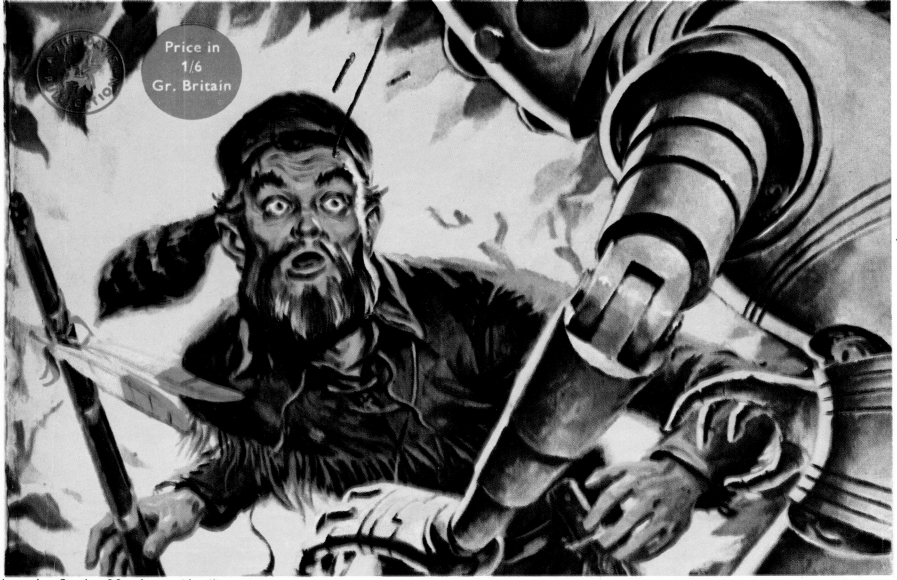

Amazing Stories, March 1954 (detail)

Future Science Fiction, November 1953
"Ultimatum!" by Robert Sheckley

**Startling Stories,
Spring 1955**
"Dark Destiny"
by William Morrison

Fantastic Adventures, May 1939
"Revolt of the Robots" by Arthur R. Tofte

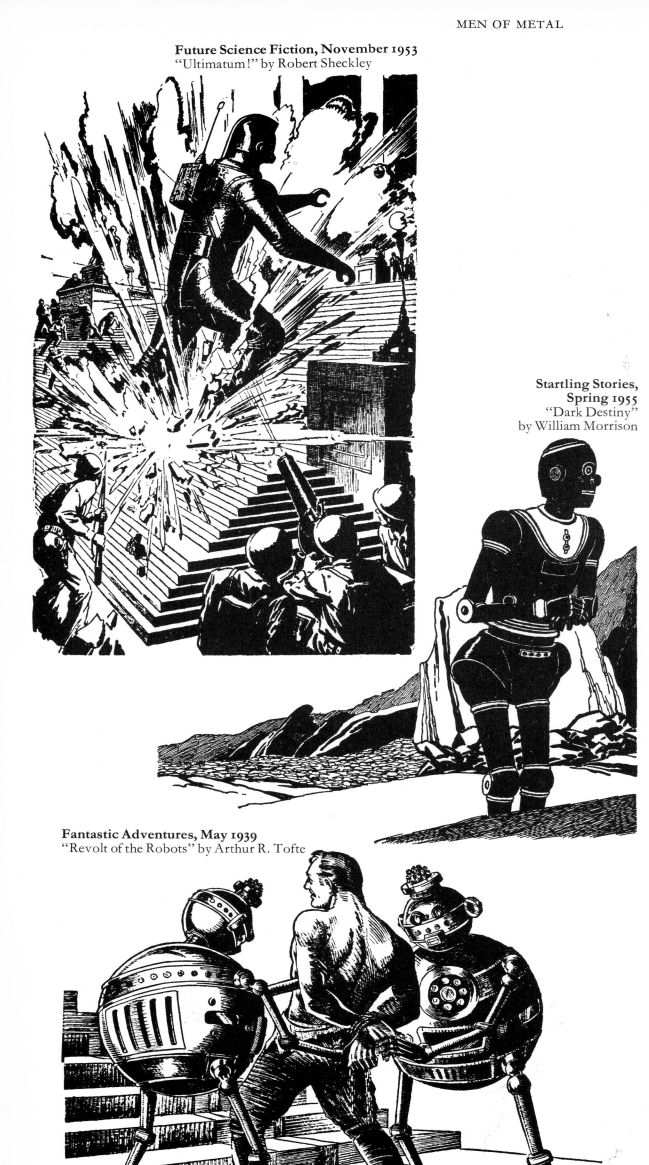

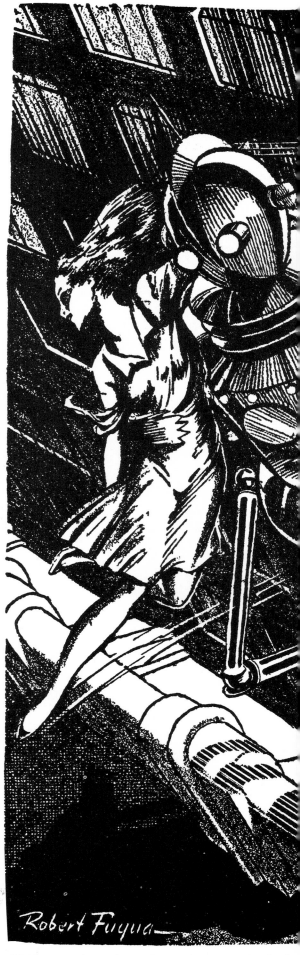

Robert Fuqua

Here, robots intrude again – massively in the case of Orban's robot, where classicism, represented by steps and columns, is threatened by modern technology and man's attempts to counter that technology.

Julian Krupa's barrel-bodied robots are much more fun, and probably coal fuelled, to judge by the rear ash-grill. Orban's little black robot, waiting in humble stance, is unique.

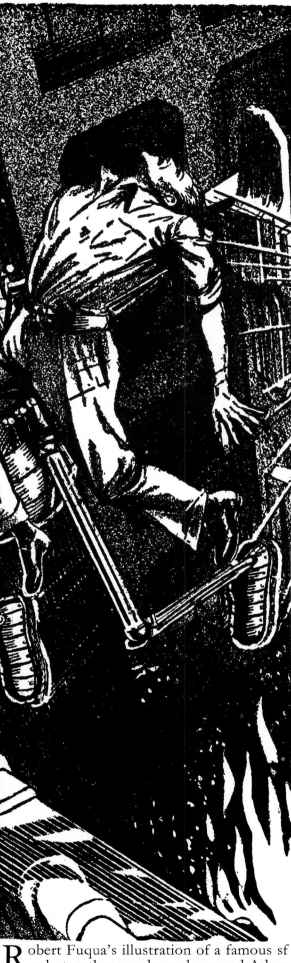

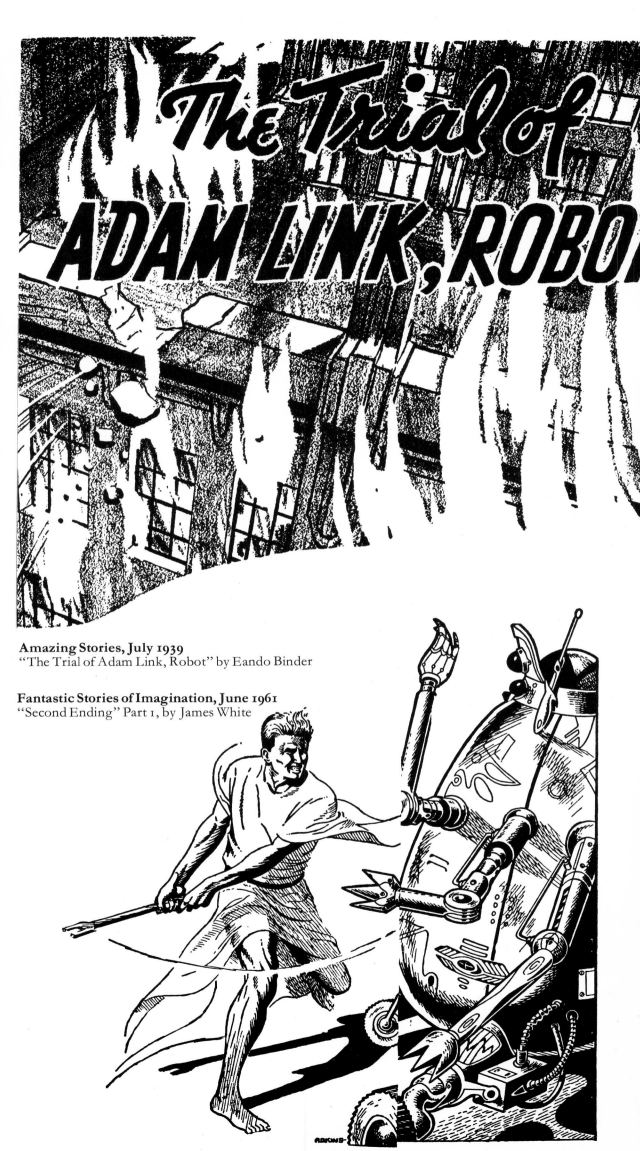

Amazing Stories, July 1939
"The Trial of Adam Link, Robot" by Eando Binder

Fantastic Stories of Imagination, June 1961
"Second Ending" Part 1, by James White

Robert Fuqua's illustration of a famous sf robot, rather ponderously named Adam Link, shows that do-gooders could be metal as well as human. Eando Binder's benevolent man of metal was rare for its time.

Binder and, more effectively, Asimov, showed how robots could be controlled so as not to harm men. As Adkins reminds us, we still have to discover how to control men so that they do not harm robots.

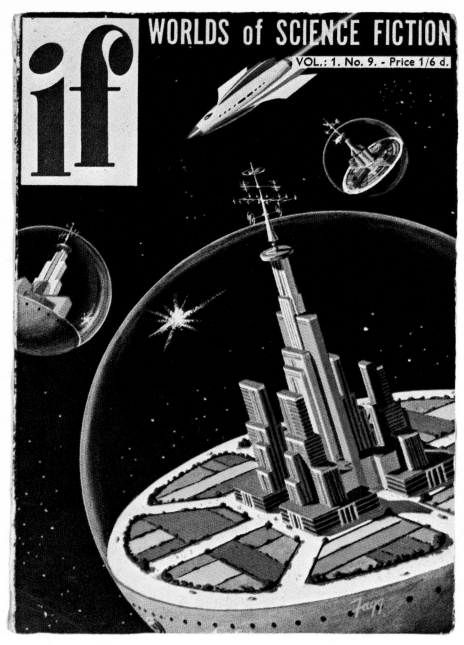

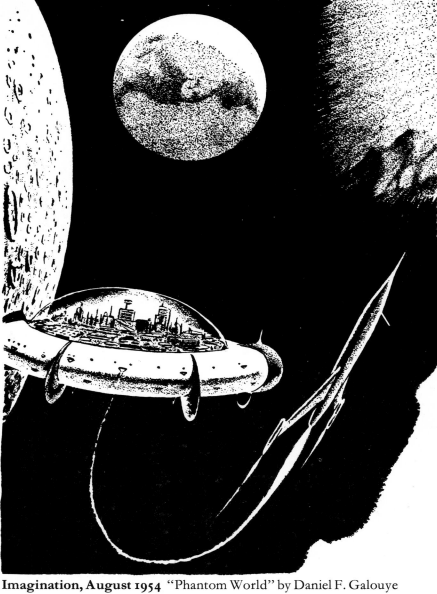

If — Worlds of Science Fiction, April 1954

Imagination, August 1954 "Phantom World" by Daniel F. Galouye

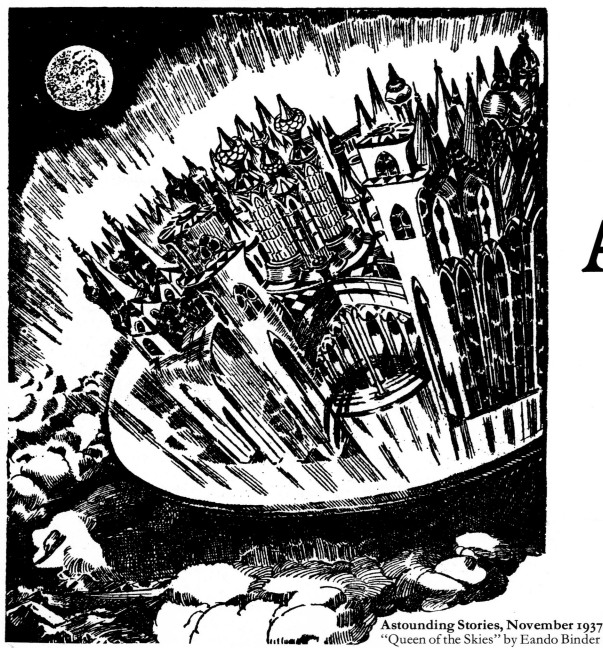

Astounding Stories, November 1937
"Queen of the Skies" by Eando Binder

IDEAS IN ACTION

Here, all too briefly, we show a single idea as developed by various hands. Two of sf's perennial playthings, the city and the spaceship, were combined in the concept of the space-going city, developed most fully by James Blish in his long-running series known as Cities in Flight. Solonevich's beautiful 1962 ANALOG cover for Blish's "A Life for the Stars", a part of his saga, embodies Blish's concept, complete with magnetic fields.

The contributions on this page are less sophisticated but as pleasing. Jack Binder's "tinsel and multi-hued city" dates from 1937. W. E. Terry, one of the stalwarts of IMAGINATION, illustrates Daniel Galouye's Satellite City in a story entitled "Phantom World", before its destruction.

During the period when James Quinn was editing IF, Ken Fagg executed many interesting covers for him. This one has a title: "A Space Nation Composed of Independent City Planets".

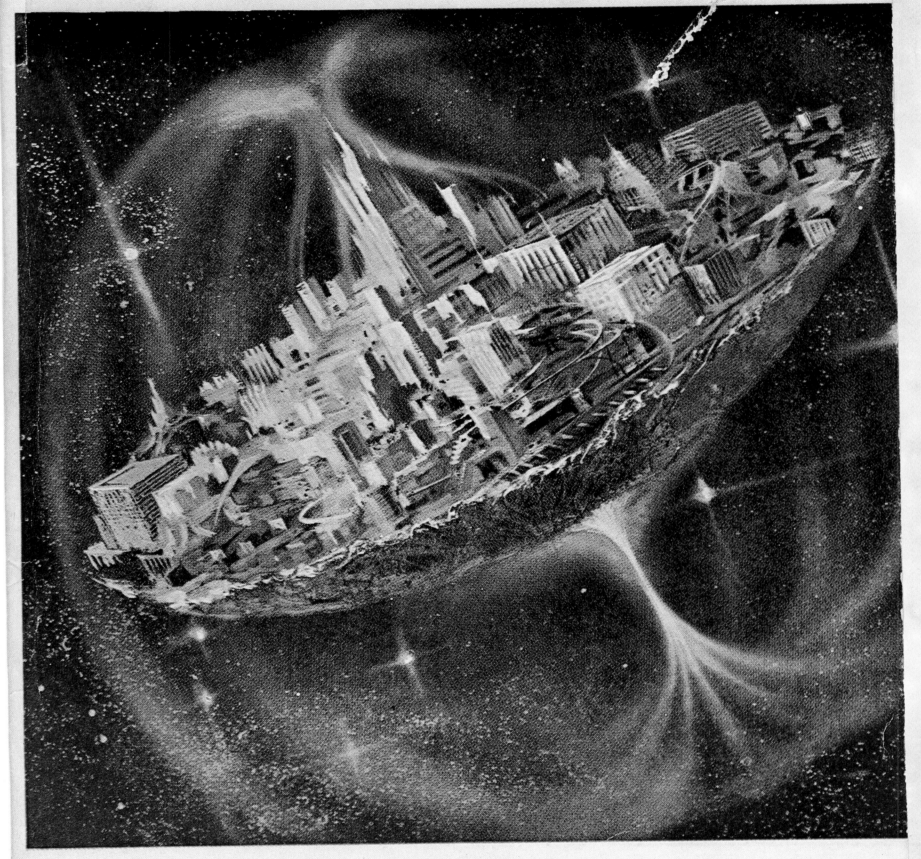

September • 50 cents

analog

SCIENCE FACT ⌒ SCIENCE FICTION

A LIFE FOR THE STARS by James Blish

A story of the industrial cities of space

H.G. Wells, together with Jules Verne and Olaf Stapledon, was one of the great trio of originators of ideas. His novel, *The War of the Worlds*, was serialised in PEARSON'S WEEKLY in 1897.

The serial was illustrated by Warwick Goble. Those strange tripedal machines were to attract later artists. The Belgian, Alvim-Correa, produces a notably atmospheric interpretation.

Frank Paul's interpretation is more eccentric. It looks as if the location has been moved from London to the Mexican desert. Yet there is much to be said for the verve of his design, which gains from the otherwise stulifyingly monolithic logo of AMAZING.

Perhaps it was editorial insistence which made Lawrence add the girl in the foreground of his design. Otherwise, his machines are certainly nasty enough, as they plonk their metal boots over the English countryside.

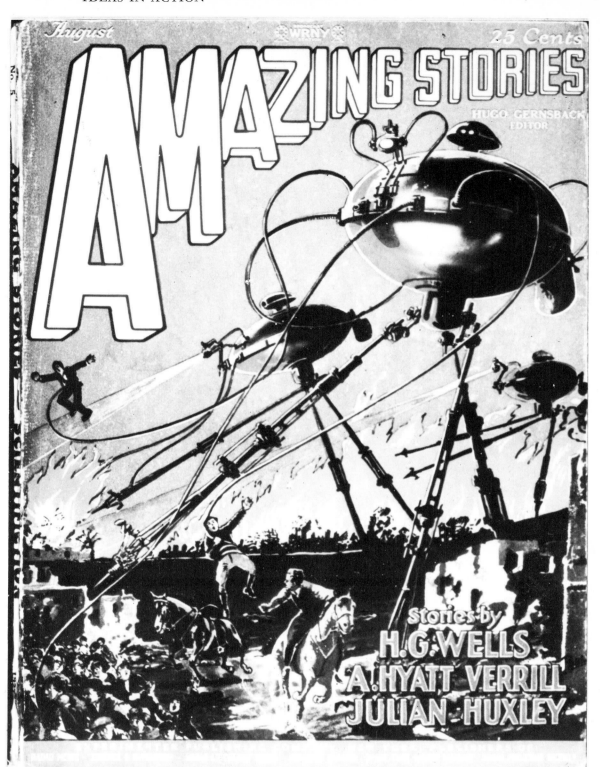

Amazing Stories, August 1927

Martian war vehicles illustrated by Alvim-Correa (Brussels, 1906)

Martian war vehicles illustrated by Warwick Goble for the original serialisation of *The War of the Worlds* in Pearson's Magazine, 1897

FAMOUS

fantastic

MYSTERIES

July 25¢

The War Of
The Worlds
A MATCHLESS
FANTASY CLASSIC
by H. G. WELLS

The Magazine Gallery

In the hurly-burly of the pulp field, magazines came and went, or were amalgamated, with great speed. Science fiction was a late category to arrive among the cow-boys, romances, airmen, G-men and all varieties of cops and robbers; yet in the end sf proved to be the most durable category. Not that that made any difference to the fate of individual titles.

One factor which could guarantee the survival of a magazine was striking covers. PLANET STORIES (1939–55) began amateurishly but soon got into its stride with covers by Paul, Leydenfrost and this beauty by Gross. COMET quickly descended on a vanishing parabola. This is the scarce first number, with a Morey cover, for December 1940. Its fifth and last issue was dated July 1941.

FUTURE lasted from November 1939 until the 'Sixties. Its permutations on the way are a fan's despair, though a bibliographer's delight, since it underwent several title changes and amalgamations. This Schomburg cover was designed to attract the rape-and-miscegeny buffs.

Earle Bergey died in 1952, after a long career of cover work. Among his most curious is this example from STARTLING STORIES (1939–55). STARTLING was among the most popular of the magazines, specialising, like PLANET, in interstellar adventure. VERTEX is a product of the 'Seventies, a hazardous period for magazines. It has now turned into a tabloid with less emphasis on sf. The beautiful H. W. Scott design appeared on the first issue of UNKNOWN (1939–43). Though comparatively short-lived – there were only thirty-nine issues – this was one of the most admired magazines in the field, presenting such novels as Jack Williamson's "Darker Than You Think", which still remain popular.

Planet Stories, Winter 1943
Gross

Comet, December 1940 (1st issue)
Leo Morey

Future Science Fiction, January 1954
Alex Schomburg

Startling Stories, November 1948
Earle Bergey

Vertex, June 1973
Kevin Davidson

Unknown, March 1939 (1st issue)
J. W. Scott

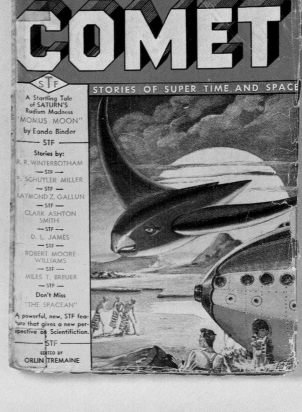

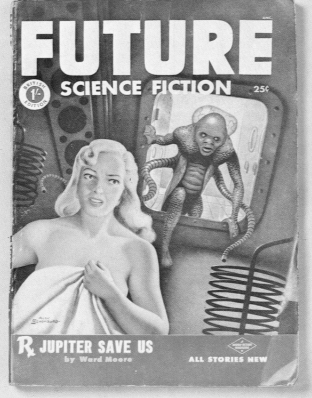

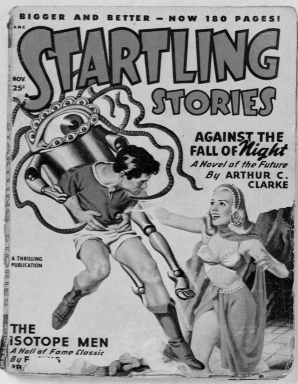

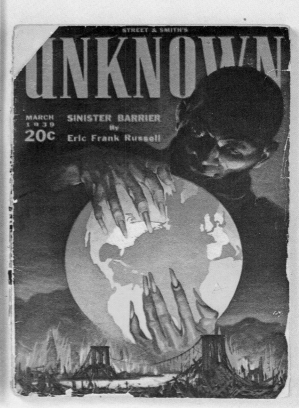

The Magazine Gallery

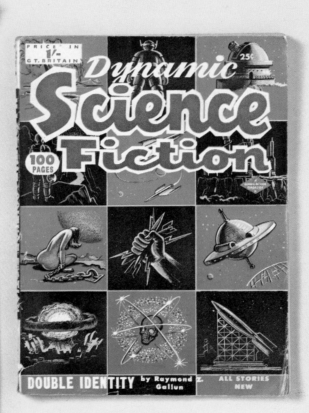

SUPER SCIENCE STORIES (1940–51) had a strong following. Its motto, "Read It Today—Live It Tomorrow", reads ironically when coupled with Van Dongen's well-coordinated cover of New York in flames. VISION OF TOMORROW lasted only a year. This striking cover by Stanley Pitt for the September 1970 issue makes one wonder why; it appears to have everything. But many titles fell victim to distribution problems. Under its various metamorphoses, AMAZING—launched in 1926 and still going comparatively strong—carried some stylish designs by Al Sigmond.

DYNAMIC SCIENCE FICTION (1952–4), not to be confused with DYNAMIC STORIES, was a victim of amalgamation. This cover is by Milton Luros. TOPS IN SCIENCE FICTION (two issued in 1953) contained reprints. The terrifying illustration by Leydenfrost reproduces the Spring 1942 PLANET STORIES cover (see page 37). The Against-all-Odds theme was ever-popular. Here Paul uses it on SCIENCE FICTION (1939–43, with interruptions) to show a honeymoon couple taking a break to deal with a tree-wielding alien.

Super Science Stories, January 1951
Van Dongen

Vision of Tomorrow, September 1970
Stanley Pitt

Amazing Stories, June 1933
A. Sigmond

Dynamic Science Fiction, June 1953
Milton Luros

Tops in Science Fiction, Spring 1953 (1st issue)
A. Leydenfrost

Science Fiction, October 1939
Frank R. Paul

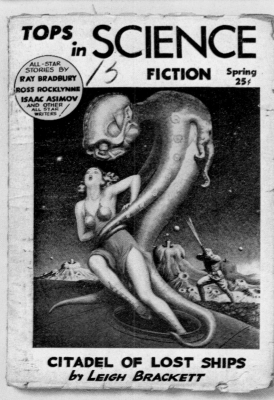

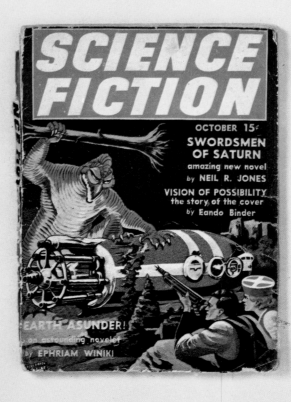

The Magazine Gallery

SCIENCE-FANTASY was born in 1951, edited by Walter Gillings. Later it came under other editors (notably Ted Carnell), turned into IMPULSE, then into SF IMPULSE, and eventually petered out in the late 'Sixties. A cover here from an early phase by Norman Partridge. THE VARGO STATTEN SF MAGAZINE ran through several titles and contortions in its brief career from 1954 to 1956. No credit was given to the artist of this undistinguished cover; it is, in fact, by John Richards. VANGUARD (June 1958) managed only this one issue. It was killed before it appeared. Emsh was the artist. The origins of ORIGINAL (1955–63) are entangled with SCIENCE FICTION STORIES and FUTURE. Kelly Freas shows a rare phenomenon on sf covers, a rainy day.

Martin did the covers for the two issues of VORTEX in 1953. (No relation to VERTEX!) WORLDS BEYOND (1951) also lasted only two issues, both carrying covers by Van Dongen. Damon Knight was the editor who lived to fight another day. SCIENCE FICTION ADVENTURES began life as an American title in 1956, but the American edition died in 1958, almost as soon as a British edition was established. This continued until 1963. The cover is by Brian Lewis for one of the magazine's most distinguished contributions, J. G. Ballard's "The Drowned World". SATELLITE SCIENCE FICTION (1956–9) ran to an uneasy formula and managed only eighteen issues. This cover is by Schomburg.

Science Fantasy, September 1954
Norman Partridge

The British Science Fiction Magazine, January 1955
John Richards

Vanguard Science Fiction, June 1958 (only issue)
Emsh

The Original Science Fiction Stories, June 1958
Frank Kelly Freas

Vortex Science Fiction, May 1953 (1st issue)
Martin

Worlds Beyond, February 1951
Van Dongen

Science Fiction Adventures, January 1962
Brian Lewis

Satellite Science Fiction, February 1957
Alex Schomburg

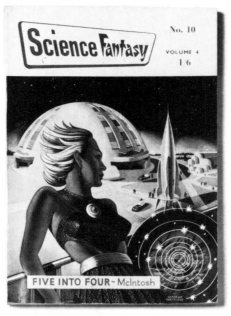

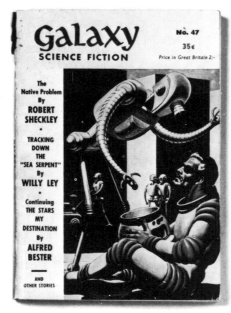

The Magazine Gallery

The NEW WORLDS cover is by Sydney Jordan. First published in 1946, this magazine got off to a shaky start. It still exists today as a quarterly paperback. British writers owe to it what American writers do to ASTOUNDING. BEYOND INFINITY (1967), on the other hand, came and went fast. Cover by an unidentified artist. FORGOTTEN FANTASY (1971) is a semi-professional publication. Cover by Tim Kirk. Finlay executed the cover for the February 1957 GALAXY, with a special and touching composition entitled "Help for Mankind" – the charitable, affluent robot is dropping a coin in the blind astronaut's helmet – instead of the normal story-illustration. First published in 1950 and edited by H. L. Gold, GALAXY enjoyed tremendous popularity from the start, and is still in existence.

IMAGINATIVE TALES ran from 1954 to 1958. Cover by Malcolm Smith. SUPER SCIENCE FICTION was launched in 1956 and ran till the 'Sixties. This cover is one of Emsh's more lurid efforts. An early NEBULA (1952–9) with a cover by Bob Clothier. Ebel's unusual design decorates SPACE SCIENCE FICTION edited by Lester del Rey during its brief but enjoyable career in 1952 and 1953 (eight issues).

New Worlds Science Fiction, April 1961
Sydney Jordan

Beyond Infinity, December 1967 (1st issue)
Anon.

Forgotten Fantasy, April 1971
Tim Kirk

Galaxy Science Fiction, December 1956
Virgil Finlay

Imaginative Tales, March 1956
Malcolm Smith

Super Science Fiction, February 1957
Emsh

Nebula Science Fiction, Summer 1953
Bob Clothier

Space Science Fiction, May 1953
Ebel

The Magazine Gallery

THE MAGAZINE OF
FANTASY AND SCIENCE
FICTION, popularly known as
F & SF, first appeared in the fall of
1949 and is still flourishing. Like its
contemporary, GALAXY, it was an
immediate success and
demonstrated that there was a
readership for a more sophisticated
type of sf. This lunar panorama by
Ron Cobb appeared on the July
1959 issue. With various title-
changes, AUTHENTIC SCIENCE
FICTION ran throughout most of
the 'Fifties, dying with issue No. 85
late in 1957. This attractive cover is
by Josh Kirby, who has since made
a successful transition to paperback
work. FANTASTIC, which still
survives the years, must also be
hunted through several title
changes. In this avatar, edited by
Cele Goldsmith, it carried several
unusual Schomburg covers, of
which this is one.

IF met with success, vicissitudes
and changes of publisher and heart
before merging with GALAXY in
1975. This memorable Fagg cover
for March 1953 adorned the first
British reprint edition a few months
later. The cover for WORLDS OF
TOMORROW, launched in 1963
and merged with GALAXY in the
'Seventies, is by Wenzel.
INFINITY was a favourite with the
fans from its inception in 1955. It
ran for twenty issues before being
folded in 1958. This striking Emsh
cover dates from 1956.

Bruce Pennington's tremendous
design for Arthur C. Clarke's
"2001" adorned the first issue of
SCIENCE FICTION MONTHLY
in 1974. Large and attractive
artwork guaranteed SFM an instant,
wild success – the circulation rose to
125,000 copies until paper shortages
forced a cut-back. It is owned by the
British paperback firm, New
English Library. Pennington has
done very effective work for their sf
paperback series.

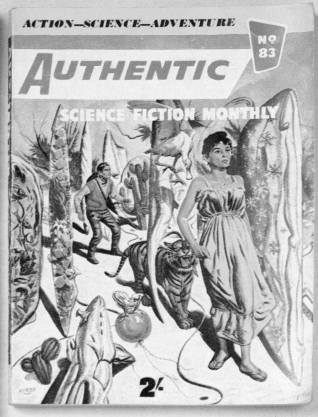

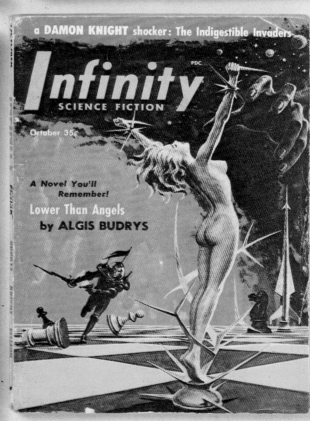

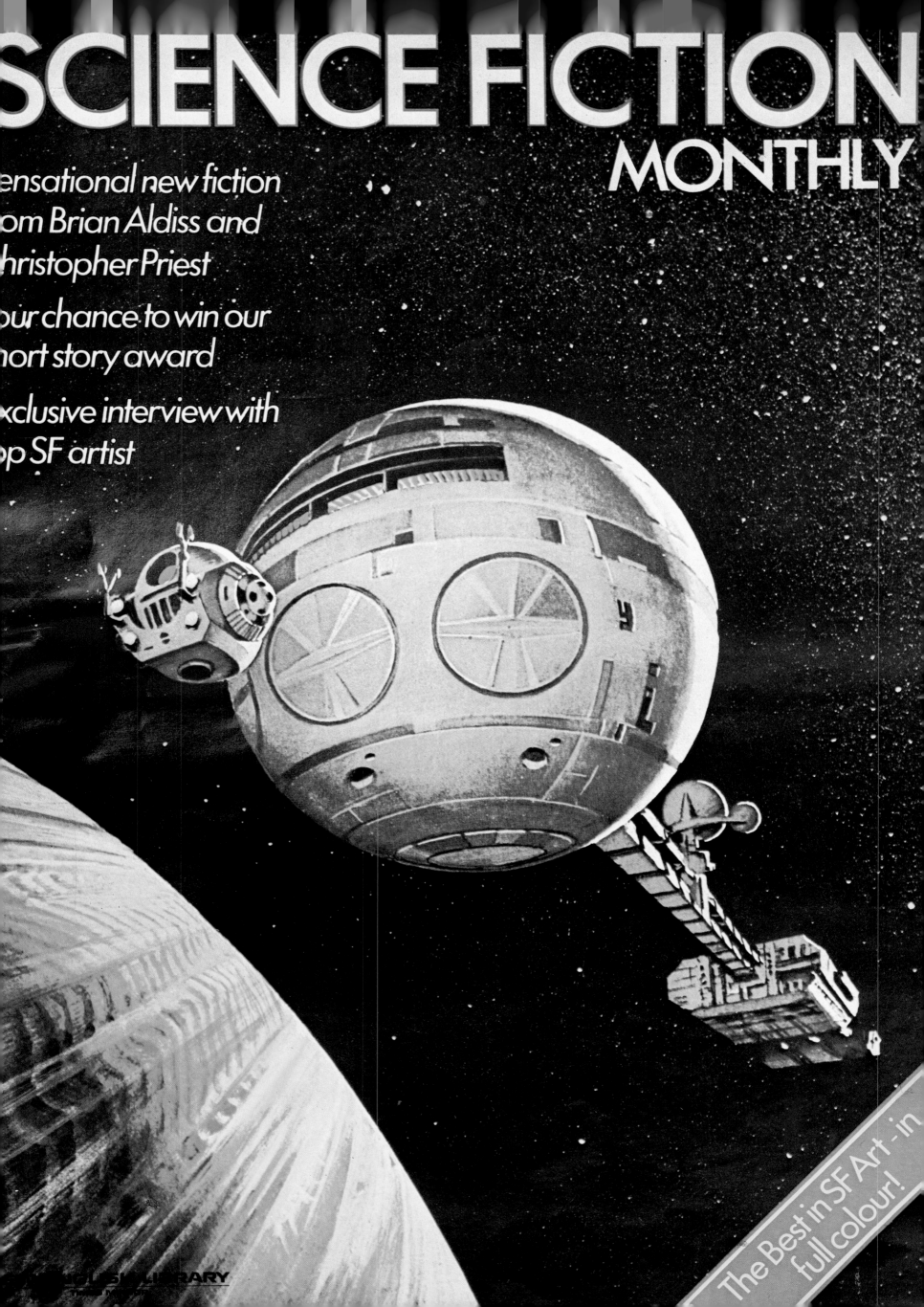

The Magazine Gallery

ALIEN WORLDS, despite Eddie Jones's spaceship, never quite achieved escape velocity. Published in Manchester in 1966, this was its only number. UNIVERSE lasted slightly longer, managing ten numbers before merging with OTHER WORLDS in 1955. This cover is by R. G. Jones, whom we have met elsewhere in more romantic mood (see page 49). IMAGINATION (1950–8) used Malcolm Smith extensively for its cover art. This example dates from 1952.

SCIENCE FANTASY is seen in another mode of its existence. It has changed publishers and editors and is about to change titles. Cover by Keith Roberts, who is also well-known as a writer. STAR SCIENCE FICTION, edited by the energetic Frederick Pohl, managed only one issue in magazine format, in January 1958. It then turned into highly commended paperback series. This rather weak cover is by Richard Powers, a revered artist, who also enjoyed more success in the paperback field, and is now collected intensively. Mel Hunter is another distinguished name. His work for GALAXY and F & SF is particularly fine; this cover for SPACEWAY (1963–5) may possibly suffer in reproduction.

Alien Worlds, 1966 (only issue)
Eddie Jones

Universe Science Fiction, September 1953
Robert Gibson James

Imagination, March 1952
Malcolm Smith

Science Fantasy, June 1965
Keith Roberts

Star Science Fiction, January 1958 (1st issue)
Richard Powers

Spaceway, December 1953 (1st issue)
Mel Hunter

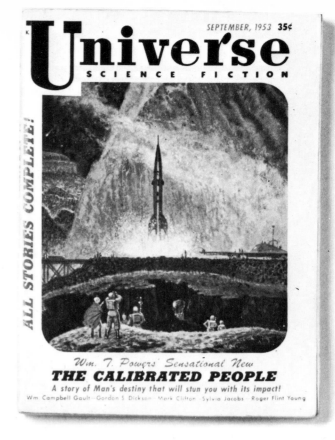

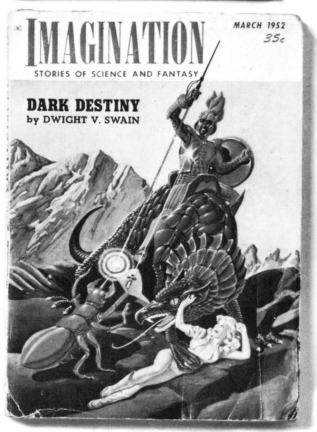

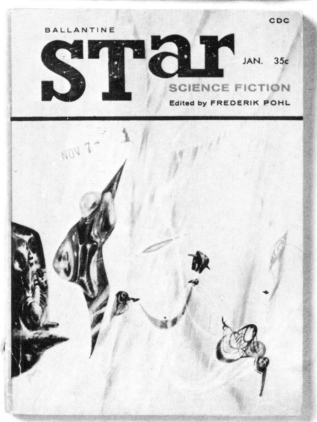

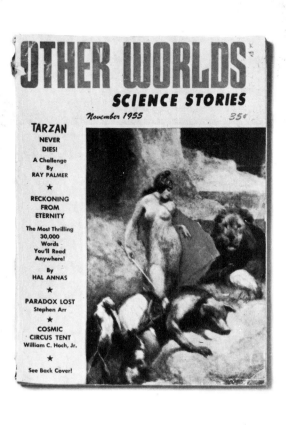

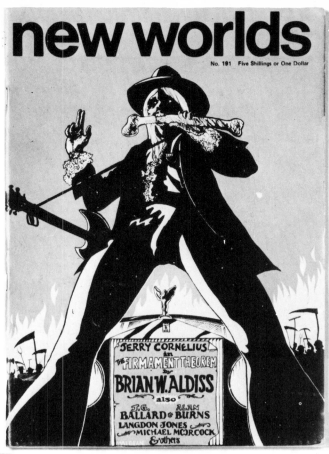

OTHER WORLDS (1949–57) was edited by the flamboyant Ray Palmer. This cover, blurrily printed, is by J. Allen St. John. The late Mal Dean executed the cover for NEW WORLDS in its most maverick phase, when Michael Moorcock was editing. Jerry Cornelius is depicted. SCIENCE FICTION PLUS was a 1953 attempt to return Hugo Gernsback to editing. But there is a time for all things, and SFP folded after only seven issues. Cover by Schomburg.

CAPTAIN FUTURE, Edmund Hamilton's eponymous hero, battled out seventeen issues as a quarterly, from 1949 to 1944. This cover for Fall 1940, is one of Earle Bergey's less distinguished efforts. A modern Frankenstein's monster has considerable impact on Drigin's cover for FANTASY, a British magazine which managed one issue in 1938 and two in 1939, collapsing with the advent of war. COSMIC STORIES also managed only three numbers, all in 1941. This is the first issue; Morey's uninspired design cannot have helped sales.

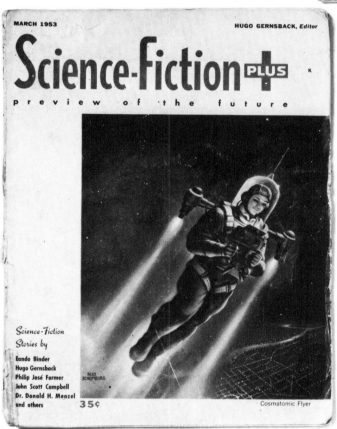

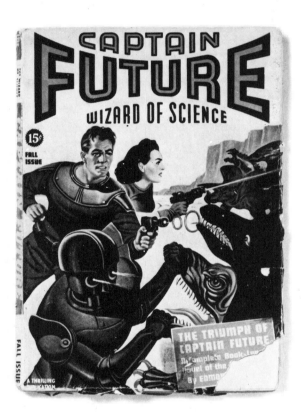

Other Worlds Science Stories, November 1955
J. Allen St. John

New Worlds, June 1969
Malcolm Dean

Science Fiction Plus, March 1953
Alex Schomburg

Captain Future, Fall 1940
Earle Bergey

Fantasy Thrilling Science Fiction, No. 1 1938 (1st issue)
S. R. Drigin

Cosmic Stories, March 1941
Leo Morey

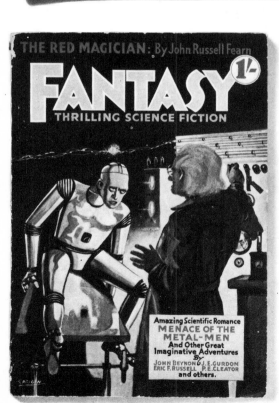

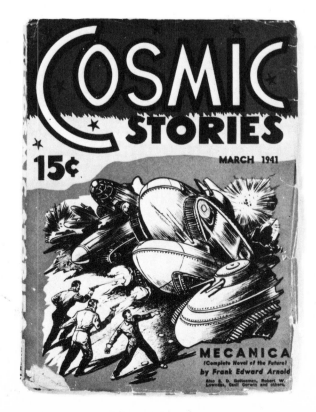

The Magazine Gallery

Schomburg's cool colours shone forth from this AMAZING cover in 1961. The editor at this period was Cele Goldsmith. In its many adventures through title, editor and publisher changes, ASTOUNDING/ANALOG, from 1930 until the present day, has rarely produced a more memorable cover than Miller's for "Incommunicado". Richard Powers executed this first cover for BEYOND, which was designed as a sister magazine to GALAXY. It ran for only ten issues, between 1953 to 1955.

VENTURE was designed as a sister to F & SF – a rather sexy sister, as this Emsh cover indicates. During 1957 and 1958 it published only ten issues before closing, to the regret of many readers. The ferocious first issue of the VARGO STATTEN SCIENCE FICTION MAGAZINE in January 1954 carried this cover by John Richards, although he was given no credit. The fairly recent cover of ANALOG, now edited by Ben Bova in succession to John W. Campbell, is painted by Leo Summers, who has worked in the field for many years.

One of Virgil Finlay's happiest colour designs, this appeared on FAMOUS FANTASTIC MYSTERIES in April 1942. This magazine ran from late 1939 till 1953 and served to reprint and reintroduce many favourite older stories. Covers were generally by Finlay or Lawrence.

Amazing Stories, September 1961
Alex Schomburg

Astounding Science Fiction, June 1950
Miller

Beyond Fantasy Fiction, September 1953
Richard Powers

Venture Science Fiction, January 1957 (1st issue)
Emsh

Vargo Statten Science Fiction Magazine, January 1954 (1st issue)
John Richards

Analog, July 1974
Leo Summers

opposite page:
Famous Fantastic Mysteries, April 1942
Virgil Finlay

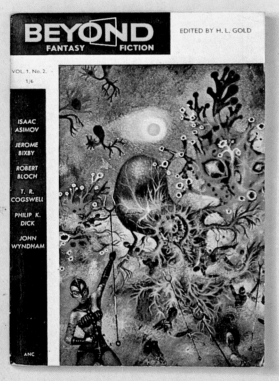

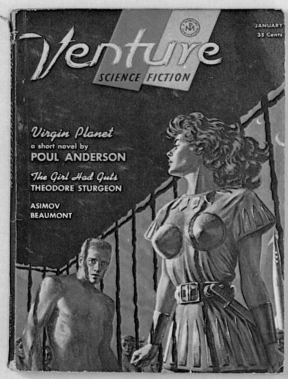

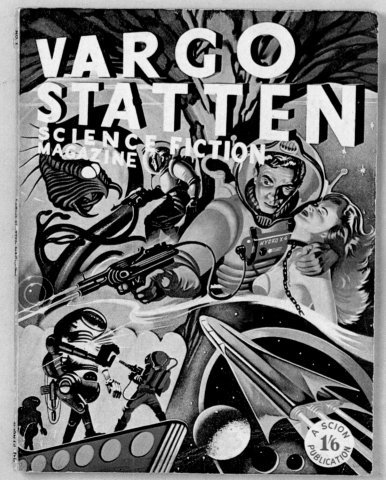

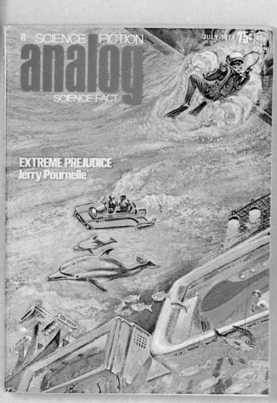

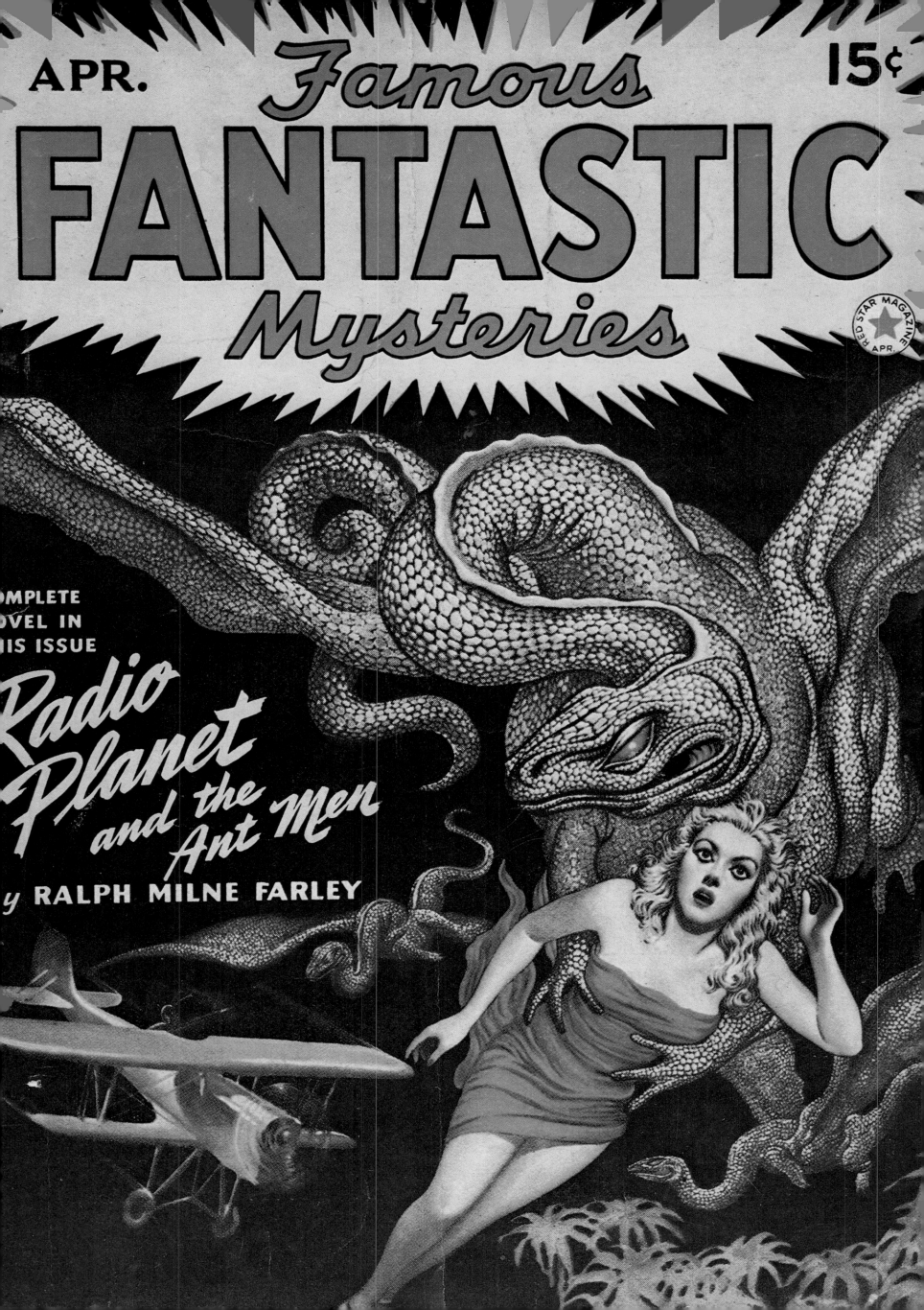

The Magazine Gallery

Norman Saunders was another well-known cover artist, often uncredited. MARVEL was launched in 1938 but soon underwent the usual history of publisher – and consequently title – changes. Editorial policies altered too. There was a timid attempt to capture the smut market. Ten numbers appeared altogether. After 1941, there was a pause of nine years before the final number arrived. SPACE STORIES ran for only five issues, starting in 1952. This cover shows Walter Popp not entirely at his best. TALES OF WONDER, edited by Walter Gillings, was another war casualty. First appearing undated in 1937, it achieved sixteen issues against all odds before dying of paper shortage. This cover is by W. J. Roberts.

Gernsback's SCIENCE WONDER STORIES left his control and eventually became THRILLING WONDER. In this form it expired in 1955, after a long life. This cover by Popp dates from 1952. Good old PLANET, which also died the death in 1955. F. Anderson's cover is typical of the period: brisk, preposterous, glossy, highly purchaseable. And here is R. G. Jones again, riding high on another 1951 cover. It may not really be sf but it's undeniably good theatre. FANTASTIC ADVENTURES was launched as a title in 1939 and continued on its way until 1953.

Marvel Science Stories, April/May 1939
Norman Saunders

Space Stories, April 1953
Walter Popp

Tales of Wonder, No. 2 1938
W. J. Roberts

Thrilling Wonder Stories, December 1952
Walter Popp

Planet Stories, November 1951
F. Anderson

Fantastic Adventures, May 1951
Robert Gibson Jones

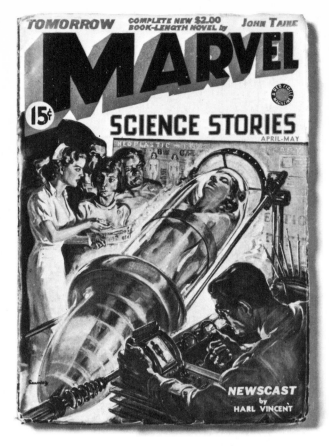

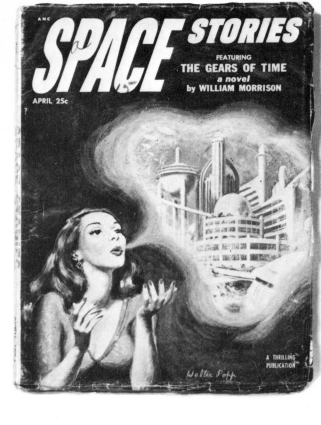

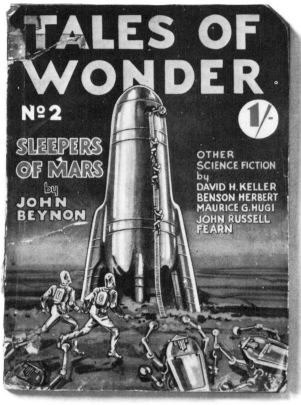

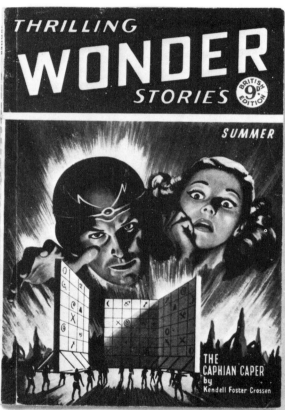

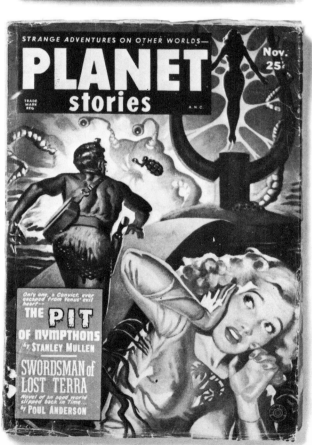

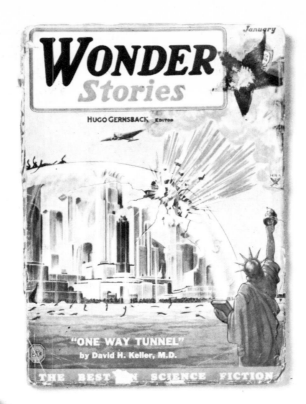

The Magazine Gallery

Another damsel in distress, this time being raped by Milton Luros's gigantic spinach plant. SCIENCE FICTION QUARTERLY existed from 1951 to 1958 as a title, and was edited by the indefatigable Robert Lowndes. Paul destroys New York once again for this WONDER STORIES cover. The magazine was launched as SCIENCE WONDER STORIES in 1929 and underwent the title change when it incorporated another of Gernsback's magazines, AIR WONDER STORIES, in 1930. Gernsback also published a bumper AMAZING STORIES QUARTERLY, which produced twenty-two issues between 1928 and 1934. The Morey cover here reproduced displays Gernsback's first term for sf, "scientifiction".

Morey was called in again to adorn a cover of a 1941 issue of ASTONISHING. This magazine, edited by Frederik Pohl, ran from 1940 to 1943. The 1934 SCOOPS cover is a stark design by S. R. Drigin. SCOOPS appeared in the early 'Thirties; it appeared weekly, and is generally rated as Britain's first sf magazine. There were many other science fiction titles. We have room here for only one more, DYNAMIC SCIENCE STORIES. Two numbers only appeared, in 1939. This is the rare first issue. Fittingly for our last picture, it is by Paul – a fine bold design of mighty ships heading beyond our little solar system.

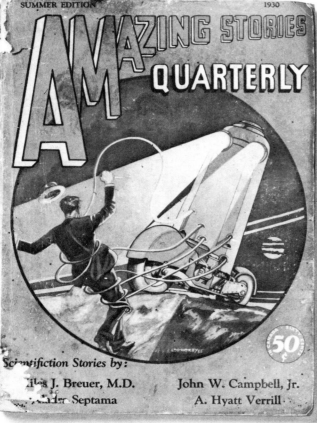

Science Fiction Quarterly, February 1954
Milton Luros

Wonder Stories, January 1935
Frank R. Paul

Amazing Stories Quarterly, Summer 1930
Leo Morey

Astonishing Stories, February 1941
Leo Morey

Scoops, 1934 (1st issue)
S. R. Drigin

Dynamic Science Stories, February 1939 (1st issue)
Frank R. Paul

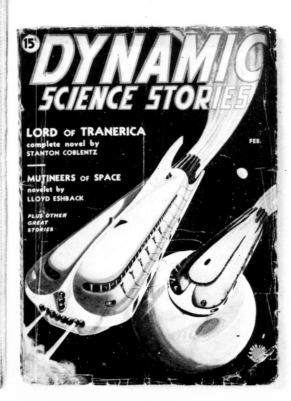

Index of Artists and Magazines

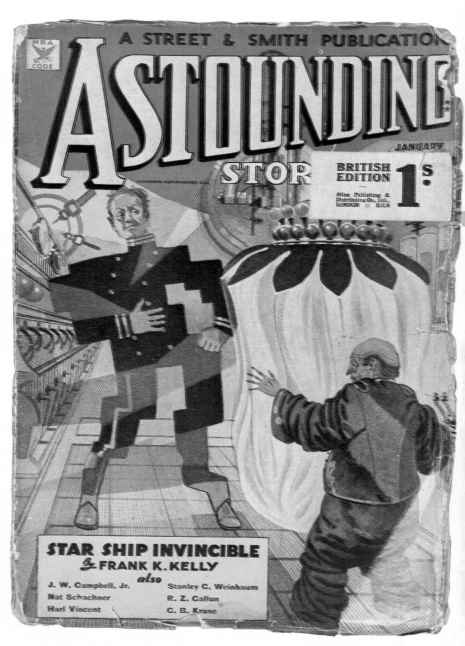

... and now, with the captain of the *Star Ship Invincible*, in Howard V. Brown's cover illustration for the story featured on ASTOUNDING STORIES, January 1935, it is time to activate the Dimensional Converter and vanish into the Sink Hole of Space ...